MODELLING AND SCULPTING ANIMALS

by

Edouard Lanteri

DOVER PUBLICATIONS, INC.
NEW YORK

Published in Canada by General Publishing Company, Ltd., 30
Lesmill Road, Don Mills, Toronto, Ontario.

Published in the United Kingdom by Constable and Company,
Ltd., 10 Orange Street, London WC2H 7EG.

This Dover edition, first published in 1985, is an unabridged
republication of Volume III of the three-volume work originally
published by Chapman & Hall, Ltd., London, under the title *Model-
ling*, in 1911. (Volumes I and II of the original set appear together in
a Dover reprint edition under the title *Modelling and Sculpting the
Human Figure*, 25006-7.)

Manufactured in the United States of America
Dover Publications, Inc., 31 East 2nd Street, Mineola, N.Y. 11501

Library of Congress Cataloging in Publication Data

Lanteri, Edouard.

Modelling and sculpting animals.

Originally published as v. 3 of Modelling: London : Chapman &
Hall, 1911.
 1. Animals in art. 2. Modeling. 3. Sculpture—Technique.
I. Title.
NB1940.L36 1985 731'.832 85-10379
ISBN 0-486-25007-5

For this last volume I owe much to the intelligent and devoted help of my friend and pupil A. E. Smith, and I wish here to thank him most sincerely.

I also wish to record with gratitude my indebtedness to Dr. Louis Vintras' experience for the entire supervision of the translation and of the general arrangement of the book

E. LANTERI.

Au Professeur Edouard Lanteri.

182, Rue de l'Université, Paris,
Août, 1910.

Mon Cher Maître—Mon Cher Ami,

Aucun n'a eu l'amour de ses élèves autant que vous. Après avoir été sculpteur d'action, vous avez été un professeur et tous deux ensemble ;—c'est a dire un professeur complètement organisé pour que vos paroles d'enseignement aient été constamment d'accord avec l'expérience. C'est ainsi que vous avez été, avec aussi votre bonté élégante et naturelle, un *homme précieux* pour vos nombreux élèves, pour le grand et noble pays d'Angleterre, qui aime le mérite, pour tous vos amis auxquels vous êtes dévoué. Vos amis Dalou, Boehm, Legros et moi, qui ai été si charmé de nos relations, vous ont toujours été fidèles. Ces artistes si travailleurs ont aimé le grand travailleur que vous êtes et qui publie sa science des formes anatomiques aujourd'hui, une de vos études—votre sollicitude continuelle.

Souffrez, cher ami, que je me joigne particulièrement à notre grand ami le peintre Legros, *l'illustre maître*, qui vous a toujours aimé ! Comme vous aussi, j'ai eu l'honneur de son affection ; j'ai eu la joie de parler en toute liberté avec ce très grand artiste, qui a professé comme vous, qui a fécondé des générations d' artistes de même que vous.

Hommes de bienfaits, de génial dévouement, je vous salue, avec tous ceux qui, soulagés de leur ignorance et admirateurs enthousiastes, vous seront toujours reconnaissants.

AUG. RODIN.

To Professor Edouard Lanteri.

182, RUE DE L'UNIVERSITÉ,
August, 1910.

MY DEAR MASTER—MY DEAR FRIEND,

None more than you has gained the affection of his pupils. You are at one and the same time a sculptor and a teacher of sculpture, that is to say, so equipped that your teaching has ever been in accordance with experience. It is thus that you have been, with your added natural and elegant kindness, an *invaluable man* to the numerous students, to England's great and noble country, which loves merit, and also to your friends to whom you have constantly proved your attachment. Your friends Dalou, Boehm, Legros, and myself, to whom our intercourse has been so charming, have ever been faithful to you. These artists and workers have ever loved the great worker in you, who to-day give to the public your science of anatomical form, one of your studies—your constant care.

Allow me, dear friend, to link myself here with our great friend, the painter Legros, the illustrious master, in the friendship he has ever had for you! Like you also, I have been honoured by his affection; I have had the joy of communing freely with that very great artist, who like you has been a teacher, and like you trained generations of artists.

Gifted men of genial devotion, I greet you, joining with all those who, freed from ignorance and now enthusiastic admirers, will ever be grateful to you.

AUG. RODIN.

CONTENTS

CHAPTER I

Contents

Contents

Contents

CHAPTER XVII

PAGE

MODELLING AND SCULPTING ANIMALS

CHAPTER I

INTRODUCTORY REMARKS

Symbolism is the striking and general interest embodied in the representation of animals in the early epochs of sculpture. Their forms were for the artist the means by which certain ideas received material expression : the lion, for example, was symbolical of courage ; the cat, of mysterious prudence and treachery ; the hawk, of avidity ; the cow was the sacred image of beneficent fecundity ; the serpent, the owl, were the emblems of watchfulness ; the soaring bird signified the upward flight of the soul.

Each country had its favourite animals, according to the symbolism attaching to them, or to the uses they could be put to. The Hindus, who had come to live with the elephant on terms of familiarity, were fond of representing it in their architecture, carrying the architrave of their temples, and typifying the power of inert and massive resistance. The Assyrians

studied the lion, which they had every occasion to observe in the royal menageries.

On the friezes of their temples the Egyptians represented all kinds of animals : the cat, the monkey, the vulture, etc. When they made isolated figures of animals, they chose in preference the lion, the bull, and the ram, but in the treatment of these subjects they did not strictly adhere to the copy of natural forms. Inspired by their priests, who delighted to surround the highest truths with mystery, and whose language was always figurative, this people's mind conceived monstrous beings, odd medleys of forms, strangers one to the other, but fraught with an obscure and dreadful meaning. Species of the utmost difference were associated in these chimerical images ; the ram assumed the claws and the tail of the lion ; the latter, in turn, assumed the head of a man or a woman, and became that figure which was to stand later as the emblem of every enigma—the Sphinx. In Egyptian sculpture, animals being only symbols, one must not be astonished that the imitation of nature, by the Egyptians, should have been limited to its bearing upon the idea, and have been seen from the larger point of view, that is to say, by insisting only on the characteristic points, on the more expressive and decided features.

When the sculptor is making one of these colosses, lion, bull, or elephant, as a part of some monumental scheme, his

aim is not to perpetrate the exact portrait of any one individual of the species, but to present to the eye from afar a strong and fine idea ; it is thus that the Egyptians understood it, and after them the Greeks of the first period.

It is necessary to distinguish between wild animals, whose forms are less familiar to us and those animals, the ordinary companions of man, such as the horse and the dog, which, better known to us, claim to be represented in such a way that it shall be possible to name even the particular variety to which they belong. The more the animal is mixed up with the everyday life of man, the more carefully must the sculptor present those features of its life which we are accustomed to notice, but such features can only be found in nature, so that an intimate study of their details becomes a necessity.

Without being an authority on the matter or a profound connoisseur of horsemanship, it is easy to understand that Grecian art, in the time of Pericles, had attained to the highest perfection in the sculptural representation of horses. To endow the ideal with life, to give to sublime beauty a simple and natural appearance, such was the problem, which the school of Phidias successfully dealt with. One comes across certain observations which appear almost trivial, but which are there to tone down the sublime, to prevent that it should be too tense and superhuman. Thus in the midst of the marvellous cavalry

of the frieze of the Parthenon we find a horse lowering and stretching its neck to drive away a fly that is irritating it. Here we have one of those ingenious details which are meant to perplex us and to make us believe that Grecian art is nothing more than nature in all its simplicity, while in reality it is the very essence of nature.

CHAPTER II

THE HORSE

Belonging to the genus mammalia, the horse is the type of the solidungulate [1] family, and is distinguished essentially by the existence of a single digit encased in a single undivided hoof for each foot. The metacarpal or metatarsal bone of this digit is very long and forms what is known as the "cannonbone," and is accompanied on the sides by two smaller bones known as the "splint-bones," which represent the rudiments of the second and fourth metacarpals or metatarsals. Each jaw has six incisors, which in young horses have a pit in the apex. There are on either side, in the upper and lower jaws, six molars, the square heads of which are well marked, this characteristic pattern being produced by the curved folded plate of the enamel of the teeth. The males have, moreover, two small canines in the upper jaw and sometimes in the lower, but these are mostly absent in the females. Between these canines and the first molars is an empty space, in which is

[1] Solidungulate—a quadruped, with a single hoof striking flat on the ground, which has no collar-bones.

placed the bit, by which man curbs the animal to his will and guides it.

In horses the organs of sense are generally highly developed. Their eyes are large and near the surface of the head. Their sense of hearing is very delicate, the concha of the ear being especially mobile : at the least unaccustomed sound, or when some unfamiliar object appears they stop, prick up their ears, and listen with the greatest attention. Their sense of smell is also very acute and they make frequent use of it, especially when they seek to recognise some object which excites their suspicion. Their nostrils, like their ears, are also very mobile. Their tongue is soft and their upper lip fairly flexible ; they appear to use the latter at times to feel foreign bodies, and use it to pick up their food. The entire surface of their skin is extremely sensitive and it quivers at the least touch. Their coats are composed of soft and flexible hairs and the crest and tails furnished with long hard hairs. Their eyes have several lashes and on their lips are rough hairs, but not disposed in any regular form. On each of four legs is an oval wart, situated on the inside, and these are known as the " chestnuts."

By their forms, their proportions, and their movements, these animals convey the idea of force linked with agility. Their bodies are thick without heaviness ; the croup is rounded, the shoulders set back on a wide chest, the thighs are muscular, the legs high and slim, the ham-strings are strong

and supple, and the head is well supported by the thick neck.

The designation of thoroughbreds given to the higher species of the equine races in England means nothing less, says Vaulabelle, "than the direct descendance without mixing of oriental stallions and mares, brought into that Kingdom." However this may be, it is certain that the English race of thoroughbreds have Arab blood as the dominant principle of their constitution.

The half-bred horse is the product of a thoroughbred horse or mare, crossed with a stallion or mare of a common species. The quarter-bred horse is a foal issued from a stallion or mare of a common species, crossed with a half-bred horse or mare.

In England thoroughbreds are only used for racing or for reproduction. Hunters are generally half-bred.

The equine races are generally divided into three categories: saddle horses, light draught horses, and heavy draught horses. Horses are again divided according to their places of origin, rather than to any particular characteristics which they possess.

The following is a short enumeration of principal breeds arranged topographically :

The English breeds: The thoroughbred, the hunter, the hackney, the dray-horse (shire and Clydesdale), the Suffolk, the

coach-horse (Yorkshire), the nag, the polo-pony, and the Welsh, Scotch, and Shetland ponies.

The French breeds: The "Boulonnaise," the "Bretonne," the "Percheron," the "Normand," the "Limousine," the "Landaise," and the Corsican.

Other breeds are the Arab, the Persian, the Turkish, the Tartar, the Circassian, the Hungarian, all of which have oriental blood. The Algerian breeds, the Numidian and the Kabyl; the Spanish or Andalusian breeds, and the breeds particular to the northern countries—Mecklenburg, Hanover, Denmark, Holland, Belgium (Flanders).

The bit and the spur are the two means which have been devised to oblige the horse to obey our will; the bit to ensure precision, the spur, promptitude in the movements.

The mouth did not appear to have been destined by nature to receive any other impression than those of taste and appetite; however, it is of such sensibility in the horse, that it is by the mouth, rather than by the eye or the ear, that one seeks to convey to it the signs of the will. The least movement or the slightest pressure of the bit suffices to warn and guide the animal, and this organ of sensation has no other fault than that which is found in its very perfection; its excessive sensibility requires great care, for if it is misused, the mouth of the horse becomes spoilt by being rendered insensible to the impression of the bit.

The senses of sight and hearing would not be subject to the same deterioration and could not be blunted in the same way ; but apparently it has been found inconvenient to use these organs in the management of horses, and it is also true that signs transmitted through the sense of touch have much more effect on animals in general than those transmitted to them through the eye or the ear. Again, the situation of the horse as regards its rider or driver, renders the eyes almost useless in this respect, since it is only by turning its head that it could see the signs made to it. Though the ear is an organ of sensation by which the horse is often animated and guided, it is only appealed to in the case of the rougher horses, since in the riding school, where the training of horses attains its greatest perfection, the voice is rarely used to horses, and where indeed it must even not be made apparent that they are guided. And so it should be, for, when well broken-in, the least pressure of the thighs of the rider, the slightest movement of the bit, suffice to guide them ; even the spur is useless, except when it is sought to urge them to some violent exertion ; and when through ignorance, it happens that the rider uses the spur and draws tight the bridle, the horse being urged on by the one action and restrained by the other, can only rear, making a bound without leaving its place.

When properly placed, the bridle gives an advantageous and dignified bearing to the head of the horse, and the least

sign, or the slightest movement of the rider, suffices to make
the horse take its different paces. The most natural is the trot,
but the walk and even the gallop are more comfortable for the
rider, and these are thus the two paces to which one seeks to
give the greatest perfection.

When the horse raises the foreleg in walking, the move-
ment must be done with decision and ease and the knee must
be flexed enough ; the raised leg must appear held for a
moment, and when it descends the foot must fall firm and bear
evenly on the ground without the head of the animal receiving
any impression from the movement. For when the leg
descends suddenly, and the head is lowered at the same time,
it is generally to relieve the other leg, which is not strong
enough to support the weight of the body. This is a serious
defect, as is also that of carrying the foot outwards or inwards,
for it will descend in the same direction. One must also notice
that when the hoof bears more on its hind part it is a sign of
weakness, and when on the fore-rim it is a fatiguing and forced
position which the animal cannot long sustain.

The walk, if the slowest of all the paces, should still be
brisk ; the stride must be neither too long nor too short, and
the bearing of the horse must be easy. This easiness depends
a good deal on the freedom of the shoulders, and is recognised
by the way in which the animal carries its head ; if it holds its
head firm and high, it is ordinarily strong and light ; but if
the movement of the shoulders has not the required freedom,

the leg will not be raised enough and the animal is apt to stumble or to give with the foot against the inequalities of the ground. When the shoulders are still further drawn together and the movement of the legs appears as though it were independent of the shoulders, the horse is easily tired, falls, and is incapable of any good service.

The horse should bear on its haunches; that is, raise the shoulders and lower the haunches in walking. It must also hold up its leg and raise it high enough; but if it is held up too long and descends too slowly, the movement loses all the advantage of ease and becomes hard.

It is not enough that the movements of the horse should be easy; it is also necessary that they should be equal and uniform in the fore and hind parts; for if the crup balances while the shoulders are held up, the movement is transmitted to the rider by jerks and becomes uneasy for him. The same thing happens when the horse carries the hind leg too far forward and places the foot beyond the point just left by the fore-foot. It is those horses whose bodies are short which are the more subject to these defects; those whose legs cross or reach each other are not surefooted and generally speaking those with long bodies are the more easy mounts, because on these the rider is placed at an equal distance from the two centres of movement, the shoulders and the haunches, and thus feels less the impressions and jerks.

Quadrupeds generally walk by carrying forward one fore-

leg and one hind-leg at a time : when the right fore-leg starts, the left hind-leg follows suit, the movement being synchronous ; this step taken the left fore-leg starts conjointly with right hind-leg, and so on. As the body bears on four points forming a quadrilateral, the easiest method of movement is to change at the same time two of these points placed diagonally, so that the centres of gravity of the animal's body should be only slightly shifted and remain always very nearly in the direction of the two bearing points.

In the three natural paces of the horse, the walk, the trot, and the gallop, this rule of motion is observed, but with slight variations.

In the walk there are four steps in the movement ; if the right fore-leg starts first the left hind-leg follows a moment later, the left fore-leg next starts, to be followed a moment later by the right hind-leg. In this way the right fore-foot is the first to be placed on the ground, the left hind-foot the second, the left fore-foot the third, and the right hind-foot the last. The movement is thus in four steps.

In trotting there are only two steps in the movement : if the right fore-leg starts, the left hind-leg starts at the same time without there being any interval between the movement of one and that of the other ; next the left fore-leg and the right hind-leg move together. So that in the trot there are but two steps : the right fore-foot and the left hind-foot are

placed on the ground together, and next the left fore-foot and the right hind-foot are also placed on the ground at the same time.

In the gallop there are ordinarily three steps; but as in this form of motion, which is a kind of jump, the fore parts of the horse do not move right away of themselves, but are propelled by the force of the haunches and hind parts, if of the two fore-legs the right one must advance more than the left, it is necessary beforehand that the left hind-foot be placed on the ground to serve as a bearing point in this springing movement. Thus it is the left hind-foot which makes the first step of the movement, and which is first placed on the ground; next the right hind-foot rises conjointly with the left fore-foot and they fall to the ground at the same time; then, finally, the right fore-foot, which has risen immediately after the left fore-foot and right hind-one, is placed on the ground the last, which makes the third step. Thus in the gallop there are three steps and two intervals, and in the first of these intervals when the movement is rapid, there is a moment when the four legs are all raised from the ground and when you see the four shoes of the horse at once.

In the walk the legs of the animal are only slightly raised, and the feet glide along the surface of the ground; in the trot the legs are raised higher and the feet well detached from the ground; in the gallop, the legs are raised still higher and the

feet appear to spring from off the ground. The walk, to be
perfect, must be brisk, light, easy, and sure. The trot must
be firm, brisk, and equally sustained ; the hind-quarters must
well propel the fore-parts. In this pace the horse should
carry its head high, and the loins should be straight; for if
the haunches rise and fall alternately at each step of the
trot, if the croup balances, and if the horse rocks, it is weak
and trots badly ; if it throws its fore-legs outwards, this is
also a fault; the fore-legs should be in the same line as the
hind ones.

The spring of the hamstrings plays as much part in the
movements of the gallop as that of the loins ; for while the
effort of the loins elevates and pushes forwards the fore-parts,
the bend of the hamstrings acts as a spring, which deadens
the shock and softens the shaking. The more binding and
supple the hamstrings, the easier is the gallop; it is also the
more brisk and rapid that the hamstrings are the stronger
and the more sustained, that the horse bears the more on its
haunches, and that the shoulders are the more supported by
the strength of the loins. However, horses that in the gallop
raise their fore-legs the highest are not those that are the
best; they do not go as swiftly as the others, and are more
easily fatigued, and the cause of this is generally to be found
in that the shoulders are not free enough.

The walk, the trot, and the gallop are the more ordinary

of the natural paces; but there are certain horses which have another pace, which is called the amble, and which is different from the three we have considered. In the amble the body of the animal is constantly carried on the two legs of the same side. Thus, while the two feet of the left side are on the ground, the two feet of the right side are elevated, and the instant these touch the ground is the instant at which the others are raised.

The amble is an exceptional pace. The giraffe, the bear, and the camel are perhaps the only species to which the amble is natural. One can train horses to the amble in submitting them, when young, to a prolonged system of fetters. In the amble, the body being supported in turn on either side, the centre of gravity must, at each step, bear successively on the line which joins the two feet of either side. The necessary effort to keep the centre of gravity inside this line makes the amble fatiguing to the shoulders of the horse; but this pace is easy and agreeable to ladies.

CHAPTER III

THE FIRST STAGES IN THE MAKING OF A SMALL
MODEL OF A HORSE

IF it is proposed to make a figure of a horse life-size or larger, it is necessary first of all to make a model, at least of a quarter the size of the proposed figure, the movement and proportions of which shall be absolutely exact. It is only on this condition that the enlargement can be made without difficulty by the system of pointing, of which I shall speak further. The sketch being absolutely correct and enlarged by pointing, one will avoid any changes in the attitude, proportions, etc., which would be almost impossible in a work on a large scale, where the armature must be very strong, and consequently cannot be pliable as in a quarter life-size model.

It is thus necessary that all the details of this sketch should be carried out as thoroughly as possible so that there should be no necessity for any big modification in the execution of the larger figure.

Armature :

For the sketch of a horse an armature measuring $17\frac{1}{2}$ inches from the ground to the summit of the head may be made in the following way.

Take a piece of iron of the shape indicated in Figure 1.

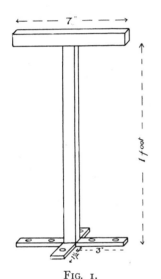

FIG. 1.

Figure 2 shows the disposition of the branches which form a base to this piece of iron.

Holes are made in these branches for the screws by which they are fixed to a board 1 foot 9 inches in length, 8 inches wide, and 1 inch thick. Underneath this

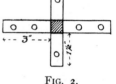

FIG. 2.

board are fixed two transverse pieces of wood, 1 inch thick and 4 inches wide, to prevent warping from the damp (Fig. 3).

FIG. 3.

Figure 4 shows the iron fixed to the board.

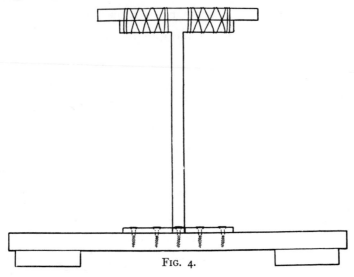

FIG. 4.

When the iron is fixed, a square piece of wood of the same width as the iron and 10 inches long is fixed on the upper surface of the horizontal part of the iron, by means of copper wire, bound tightly and projecting an equal distance beyond the iron at either extremity. (Fig. 4.)

Next fix on either side of this piece of wood another $10\frac{1}{2}$ inches long, 2 inches wide, and $\frac{1}{2}$ inch thick. The three pieces must be nailed together so as to form a solid body; for this constitutes the principal support of the remainder of the armature (Fig. 5).

FIG. 5.

It is also on these that the

Fig. 6.—Complete Armature for Sketch.

armature of the legs, of the neck and head, and of the tail will be fixed. For these take lead piping a $\frac{1}{4}$ of an inch in diameter, and fix them as indicated in Fig. 6.

The piping of the legs is suspended from fixed points near the extremities of the pieces of wood; those of the head and neck and of the tail should be strongly nailed.

This armature for a small model is very similar to that which I shall describe for the enlargement.

The armature finished, it must be given the desired attitude. As in the human figure, movement in the horse is always more accentuated in the cervical vertebræ than in the others; in the dorsal vertebræ there is, so to speak, no movement; in the lumbar, very little. To give to the armature its attitude one must first of all observe the line of the spinal column and turn the piping of the neck according to the direction to be given to the head; and in so doing it is necessary to view this line from above. (Fig. 7.)

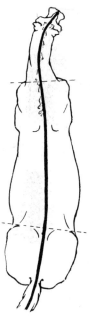

FIG. 7.

Next, looking at the model from the side, put the piping of the legs in place, taking care from the beginning so to put each that it occupies the stronger, or fore part, of

the leg. Fig. 6 gives the complete armature and the general movement.

This done, as in the case of the human figure, the armature should be covered with a slight layer of clay, which should not be too thick, for if this point is not observed it will be necessary to remove some of the clay afterwards to obtain the natural bulk, while, on the contrary, this result should be obtained by progressively adding to. Heaviness at the start blurs the movement, and it can be followed less easily than if the bulk is kept well under to begin with.

The armature being surrounded with clay the line of the spine is drawn on the clay by a deep furrow which becomes the guide for the symmetrical construction of the body seen

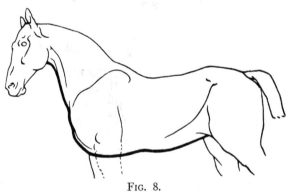

FIG. 8.

from above. Then a side view is taken of the great line starting from the nape of the neck (first cervical vertebra) and going to the root of the tail; it is the line given by

the vertebral column in its entirety. At the same time one will indicate the lower line of the body, which is formed by the anterior line of the neck, and of the pectoral and abdominal muscles. (Fig. 8.)

These lines fairly fixed on both sides, the next step is to establish from above, symmetrically on either side of the

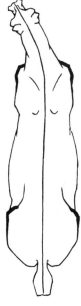

FIG. 9.

vertebral column, the anterior crest of the ilium, the line of the thorax, and the shoulder blade. (Fig. 9.)

These prominences indicated, the work must be begun

from the back to be continued by the muscular attachments of the legs. (Fig. 10.)

The front aspect will next claim attention. The central line verified will allow of the establishing of the volume of the neck and of the symmetry of the shoulders, and likewise of the head (Fig. 11).

FIG. 10.

FIG. 11.

Next, from either side, the head, legs, and tail will be indicated. Then all these indications must be bound together by large and very firm flat surfaces, observing attentively the contrasts and general movements of these planes ; the execution to be as simple as possible. (Figs. 12 and 12*a*.)

The movement of these large planes having been indicated, the measurements for the constructions and for the proportions must be taken as they are indicated by Fig. 13, and fixed by means of little pieces of wood stuck in the clay, as is done for the human figure.

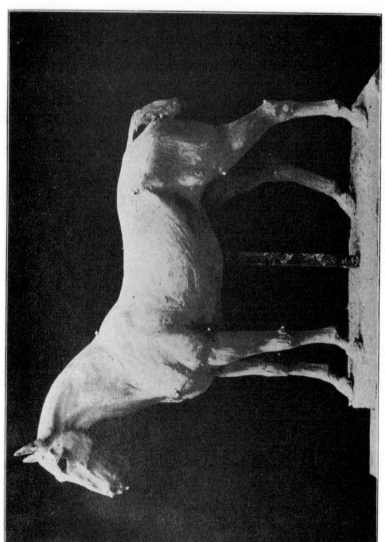

Fig. 12.—Modelling of the Horse. First Stage.

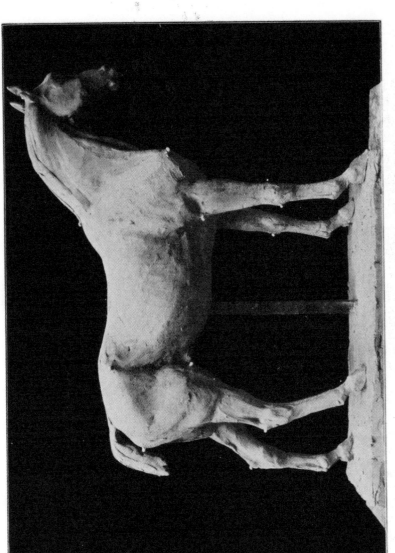

FIG. 12 A.—MODELLING OF THE HORSE. FIRST STAGE.

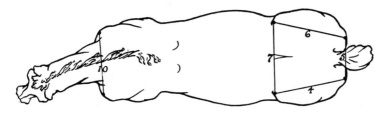

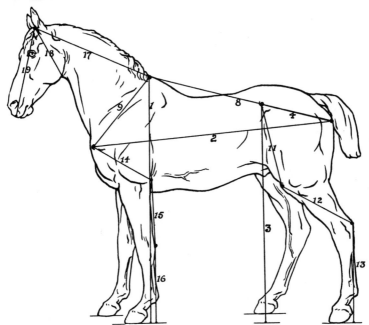

FIG. 13.—MEASUREMENTS OF CONSTRUCTION.

1.	Plinth to summit of withers.	11.	External iliac to patella.
2.	Point of arm to point of buttock.	12.	Patella to calcaneum.
3.	Plinth to external iliac.	13.	Calcaneum to plinth.
4.	External iliac to point of buttock.	14.	Point of arm to elbow.
5.	Between points of buttocks.	15.	Elbow to pisiform.
6.	Point of buttock to external iliac.	16.	Pisiform to plinth.
7.	Between external iliacs.	17.	Point of withers to nape.
8.	Point of buttock to point of withers.	18.	Thickness of neck.
9.	Point of withers to point of arm.	19.	Length of head.
10.	Between points of arms.		

CHAPTER IV

COMPARATIVE MEASUREMENTS

FOR the comparative measurements I do not think that I can do better than quote those given by Colonel Duhousset which are mentioned in " The Artistic Anatomy of Animals," by E. Guyer. This excellent book has been translated into English by Mr. G. Heywood, Lecturer on Anatomy at the Royal College of Art, London. (Publishers: Baillière, Tindall and Cox.) Having had the advantage of being acquainted with Colonel Duhousset, and being aware that for years he gave particular attention to the study of the horse, and that he had a profound knowledge of the subject, moreover, knowing of no other authority more competent in the matter, I endorse without hesitation the comparative measurements which he gives, convinced, from experience, that they are the most trustworthy and that they give in all cases excellent results.

It will be seen that the basis of comparison in these measurements is the head.

Two heads and a half gives the following measurements.

1. The height of the withers, H, above the ground.

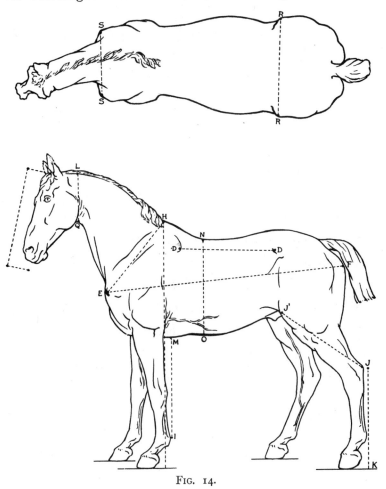

FIG. 14.

2. The length of the body from the point of the arm to that of the buttock. E. F.

The length of the head is nearly equal to the following measurements :—

1. The depth from the the back to the belly, N.O., the thickness of the body.

2. The distance from the summit of the withers to the point of the arm, H.E.

3. From the superior fold of the stifle to that of the ham, J.' J.

4. From the point of the ham to the ground, J. K.

5. From the dorsal angle of the scapula to the point of the haunch, D. D.

6. From the passage of the girth to the fetlock, M. I. or higher in large horses and racers ; to the middle of the fetlock or lower, for small ones and those of medium size.

7. The width of the haunches, R. R.

Two-thirds of the length of the head gives :—

The width of the chest from the tip of one arm to that of the other, from outside to outside, S. S.

Half the length of the head gives :

The outline of the neck of the level of the base of the head, Q. L.

Such are the comparative measurements generally recognised as the best; they will prove most useful in the making of a sketch, be it of an equestrian statue or of any other composition in which a horse figures. In keeping to them one will never

stray far from the possibilities of nature and one will avoid much that is ridiculous. However, if it is intended to make the portrait of a particular horse, or simply a study from nature, it must not be forgotten that, as in the case of the human figure, the proportions proper to the original will alone give its character and define its type.

It is thus important to take very exactly on the living model the measurements indicated (Fig. 13) and to fix them in the same way as is done in the study of the human figure. As it will be necessary often to refer to them during the progress of the work and to avoid having to retake them each time on the living subject, it is as well to write them right away on the scale of reduction, which is the same for the horse as for the human figure and which is described in the first volume of this work.

On the diagram (Fig. 14) will be seen a pointed line parallel with the profile of the head ; the measurement of this line is that which the head should have, in a horse measuring two heads and a half in length from the head of the humerus to the extremity of the croup and in height from the ground to the withers. It is the length of this line which has been used to establish the comparative measurements of this diagram and it is the length recognised as normal. It is the one that is to be used for fixing all other proportions in the horse. But it is admitted that, from the point of view of artistic effect, a head

slightly smaller gives a better appearance, gives more strength and more elegance to the animal, as will be noticed in several equestrian statues of the Renaissance, particularly in that of Coleoni, by Verocchio, which is one of the masterpieces of its kind, where the head being relatively smaller, all the other parts of the horse appear more powerful, without however being heavy. When the head is in the proportion and $2\frac{1}{2}$ with the length and height of the horse, the appearance of the animal is shorter, more knit together, and, notwithstanding this, the forms give the impression of being diminished in volume. I therefore think it preferable, the proportions once established on the basis of the normal size of the head, to reduce them afterwards, so that the horse's length and height be $2\frac{3}{4}$ heads.

I have found, from personal experience, that, in the case of a statue that is to be placed in the open air, especially if it is to form a silhouette against the sky, it is absolutely necessary that the thin parts of the horse, the four legs, should be strongly built up, that is to say that they should be bigger than they are in nature, for the strong light devours, so to speak, the outlines and diminishes the volume of the limbs. For an equestrian statue placed in these conditions, and a quarter larger than nature, I have made the leg, at the part where the cannon-bone is, $1\frac{1}{2}$ inches larger in circumference in proportion to what it is in nature, and the statue once in place, I have only regretted not having made it another half inch bigger.

It is so in sculpture for all works destined to stand out against the sky; all the parts which are detached from the principal mass, such as an arm, a leg, etc., must be strengthened in their volume, under penalty of appearing meagre when the work is once in place, and especially so if it is to be cast in bronze, for the sombre hue of the metal reduces still more the volume of the forms.

Indeed, the Coleoni statue is the most striking example of this principle, for if one has occasion to examine closely a reproduction, one is surprised at the heaviness of the legs and tempted to see in them a gross exaggeration, but if afterwards one chances to see this masterpiece in Venice, placed on its high pedestal and completely standing out against the sky, the proportions become admirable in their strength and their elegance—in thickening the legs the sculptor has avoided the appearance of thinness.

CHAPTER V

THIS done, work should be started by seeking the movement of the planes given by the direction of the great muscular masses and in defining their character. This must not be done by only looking at the work as one stands in front of it, but it must be viewed from all sides, from underneath and from above, so as to consider its various sections. If one neglects to work thus, the result will only be something flat, without movement and without suppleness.

Place carefully the heads of the bones, and strive to find the axial-curve of the larger ones, for this will give strength to the whole, since it is the bony frame which carries the muscular parts, and it is even advisable to exaggerate this principle to begin with.

The larger movements of the planes sufficiently established, it is well to indicate each muscle without however making a purely anatomical study (Fig. 15). But this research obliges us to analyse the reason of each prominence and of each depression ; thus we learn our lesson, and, when we know it, our work can only gain in straightforwardness, in strength, and in expression. Nothing is more disheartening than the state of doubt in which we find ourselves, when we do not understand the meaning of

FIG. 15.—MODELLING OF THE HORSE. SECOND STAGE.

what we have before our eyes. If we do not understand this, our work is uncertain, arduous and tedious, and however clever its execution may be it can never have the expression and strength necessary to a sculptural work. The study of anatomy in the case of the horse, is, perhaps, more necessary than in that of the human figure, for we know in our body what movements are possible, while if we have not made a study of animals, we may easily fall into grave errors; with a knowledge of anatomy we shall certainly avoid impossibilities, at all events, those appertaining to construction.

When our work has reached this stage, that is, that the movement is given, the proportions correct, that the indication of the large planes of the big muscular masses are true in bulk and in drawing, that we have thoroughly understood and indicated the heads of the bones, their curve, and that each muscle has been applied on the large planes, in a word, that at this point we have made an analysis of each of the parts which compose the horse, I will only repeat what I have said for the human figure : it is necessary to simplify, to enfold, to unite together all these anatomical details into large planes, remembering the value of the muscles that are brought into action, and in which there must be a state of contraction contrasting them with those that are in repose. In enfolding, so to speak, the preceding work in the skin, all the anatomical indications will be united in large masses, care being taken

to give to each of them, by the drawing, their characteristic forms. These large masses may be thus divided :— that of the shoulder, of the croup, of the body, of the neck, of the legs, etc.

The skin of the horse is particularly sensitive, especially over the neck and hind-quarters, and nature gives us these

Fig. 16.

Fig. 17.

details precisely, which are, in a thoroughbred, admirable for their distinction and elegance. While they give life to the execution, they also give a picturesque note which breaks the monotony of the work. The coat also has sweeping movements of the hairs which add a great charm to the surface ; these hairs meet at certain places forming what is known as "feathers," for instance, at the posterior part of the lateral sides of the body (Fig. 16), near the stifle-joints and again in front over the pectoral muscles (Fig 17).

CHAPTER VI

SOME SPECIAL POINTS

THERE are certain points to which I desire to draw atten-
tion, having seen them so often treated with neglect and
without taste. For example, the elegant composition of the
lines in the arrangement of the fetlock, the pastern and the
hoof. This part is often treated as a square heavy block,

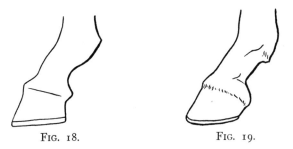

FIG. 18. FIG. 19.

(Fig. 18), while in nature, especially in a thoroughbred, it
is exceedingly elegant (Fig. 19).

It is the same with the root of the tail, which often gives
the idea of a broomstick fixed into the croup of the animal,
and from which the hairs hang down anyhow (Fig. 20).

It will be seen by Figures 21, 22 and 23 how one should proceed to avoid such an effect. First, the perfection of the lines of the tail at its point of attachment, second, how the

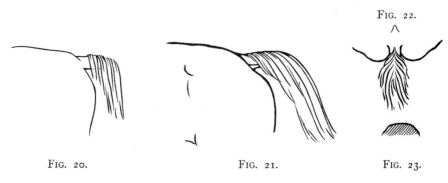

FIG. 22.

FIG. 20. FIG. 21. FIG. 23.

hairs are divided on the upper surface, third the section through the tail at its root.

Fig. 24 shows an advanced stage of the study.

I think it useful to give here the usual names of the different parts of the horse (Fig. 25).

I subjoin to this work a series of anatomical plates of the horse osteology and myology, which will be found sufficient as an introduction to the study of the subject. As we all know that when looking up some anatomical data in a book, the plate, nine times out of ten, represents the opposite side to that of which we are in need, I have, to remedy this annoyance, reversed each part and I feel sure that will avoid much loss of time.

Fig. 24.—Modelling of the Horse. Third Stage.

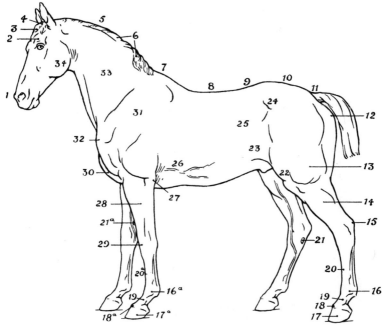

FIG. 25.—POINTS OF THE HORSE.

1.	Muzzle.	18, 18a.	Coronet
2.	Salt-cellar.	19, 19a.	Pastern.
3.	Forelock.	20, 20a.	Cannon bone.
4.	Nape.	21, 21a.	Chesnut.
5.	Crest.	22.	Stifle.
6.	Mane.	23.	Flank.
7.	Withers.	24.	Hip.
8.	Back.	25.	Back ribs.
9.	Loins.	26.	Girths.
10.	Croup.	27.	Point of elbow.
11.	Root of Dock or Crupper.	28.	Forearm.
12.	Point of Buttock.	29.	Knee.
13.	Quarters	30.	Breast.
14.	Second thigh or gaskin.	31.	Shoulder.
15.	Hock.	32.	Point of shoulder (point of arm).
16.	Fetlock.	33.	Neck.
17, 17a,	Hoof.	34.	Jaw, lower.

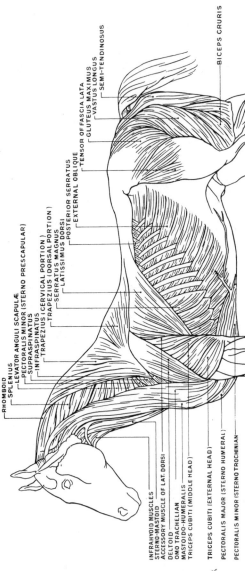

RHOMBOID
SPLENIUS
LEVATOR ANGULI SCAPULÆ
PECTORALIS MINOR (STERNO PRESCAPULAR)
SUPRASPINATUS
INFRASPINATUS
TRAPEZIUS (CERVICAL PORTION)
TRAPEZIUS (DORSAL PORTION)
SERRATUS MAGNUS
LATISSIMUS DORSI
POSTERIOR SERRATUS
EXTERNAL OBLIQUE
TENSOR OF FASCIA LATA
GLUTEUS MAXIMUS
VASTUS LONGUS
SEMI-TENDINOSUS

BICEPS CRURIS

INFRAHYOID MUSCLES
STERNO-MASTOID
ACCESSORY MUSCLE OF LAT. DORSI
DELTOID
OMO TRACHELIAN
MASTOIDO-HUMERALIS
TRICEPS CUBITI (MIDDLE HEAD)

TRICEPS CUBITI (EXTERNAL HEAD)

PECTORALIS MAJOR (STERNO HUMERAL)

PECTORALIS MINOR (STERNO TROCHNIAN)

FIG. 26.—TRUNK. LEFT LATERAL ASPECT. Myology—Superficial.

ATTACHMENTS OF MUSCLES.

INFRAHYOID MUSCLES (origin) sternum and scapula: (insertion) hyoid bone and thyroid cartilage. STERNO-MASTOID (o.) anterior extremity of sternum: (i.) by a tendon to angle of lower jaw, and by an aponeurosis to mastoido-humeral muscle and mastoid process. ACCESSORY MUSCLE OF LATISSIMUS DORSI (o.) external aspect of tendon of latissimus dorsi and posterior border of scapula: (i.) olecranon process and anti-brachial aponeurosis. DELTOID (o.) anterior portion from tuberosity of spine of scapula; posterior portion from superior part of posterior border of scapula: (i.) the two parts united into deltoid impression or crest of humerus. OMO-TRACHELIAN (o.) transverse processes of first four cervical vertebræ: (i.) anterior border of humerus. MASTOIDO-HUMERALIS (o.) posterior surface of skull and upper part of neck: (i.) anterior border of humerus. TRICEPS CUBITI (middle or long head) (o.) posterior border of scapula: (i.) olecranon process of ulna. TRICEPS CUBITI (external head) (o.) curved crest of humerus: (i.) olecranon process. PECTORALIS MAJOR (sterno-humeral) (o.) sternum: (i.) anterior margin of humerus. PECTORALIS MINOR (sterno-trochinian) (o.) abdominal aponeurosis and posterior part of sternum: (i.) lesser tuberosity of humerus.

RHOMBOID (o.) cervical ligament and spinous processes of foremost cervical vertebræ: (i.) spinal border of scapula. SPLENIUS (o.) superior cervical ligament and spinous processes of first four or five dorsal vertebræ: (i.) mastoid crest and transverse processes of atlas and three or four following vertebræ. LEVATOR ANGULI SCAPULÆ (o.) transverse processes of four lower cervical vertebræ: (i.) superior portion of spinal border of scapula. PECTORALIS MINOR (sterno-prescapular) (o.) sternum: (i.) by aponeurosis which covers the supraspinatus.

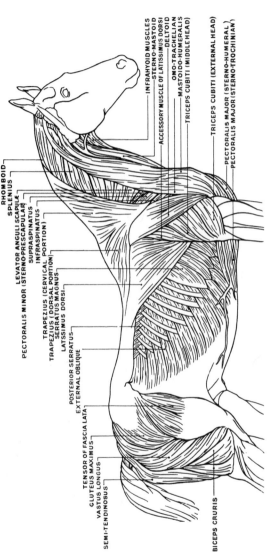

RHOMBOID
SPLENIUS
LEVATOR ANGULI SCAPULÆ
PECTORALIS MINOR (STERNO-PRESCAPULAR)
TRAPEZIUS (CERVICAL PORTION)
SUPRASPINATUS
INFRASPINATUS
TRAPEZIUS (DORSAL PORTION)
SERRATUS MAGNUS
LATISSIMUS DORSI
POSTERIOR SERRATUS
EXTERNAL OBLIQUE

TENSOR OF FASCIA LATA
GLUTEUS MAXIMUS
VASTUS LONGUS
SEMI-TENDINOSUS

BICEPS CRURIS

INFRAHYOID MUSCLES
STERNO-MASTOID
ACCESSORY MUSCLE OF LATISSIMUS DORSI
DELTOID
OMO-TRACHELIAN
MASTOIDO-HUMERALIS
TRICEPS CUBITI (EXTERNAL HEAD)

TRICEPS CUBITI (MIDDLE HEAD)

PECTORALIS MAJOR (STERNO-HUMERAL)
PECTORALIS MAJOR (STERNO-TROCHINIAN)

FIG. 26 A.—TRUNK. RIGHT LATERAL ASPECT. Myology—Superficial.

SUPRASPINATUS (o.) supraspinous fossa of scapula and cartilage of prolongation : (i.) great tuberosity or trochanter of humerus. INFRA-SPINATUS (o.) infraspinous fossa of scapula and cartilage of prolongation : (i.) great tuberosity of humerus below insertion of supraspinatus. TRAPE-ZIUS (cervical portion) (o.) superior cervical ligament and spinous processes of foremost dorsal vertebræ : (i.) spine of scapula. TRAPE-ZIUS (dorsal portion) (o.) spinous processes of dorsal vertebræ : (i.) tuberosity of spine of scapula. SERRATUS MAGNUS (o.) by digitations from the first eight ribs : (i.) subscapular fossa near the spinal border. LATISSIMUS DORSI (o.) by aponeurosis from the spinous processes of the last fourteen or fifteen dorsal vertebræ, from spinous processes of lumbar vertebræ, and from the last ribs : (i.) internal lip of bicipital groove of humerus and median portion of internal surface of same bone. (The fleshy fibres of this muscle are prolonged backwards as far as the twelfth rib.) POSTERIOR SERRATUS (o.) spinous processes of last three dorsal vertebræ and first three lumbar vertebræ : (i.) last six ribs. EXTERNAL OBLIQUE (o.) by digitations from the thirteen or fourteen posterior ribs and from the dorso-lumbar aponeurosis : (i.) by aponeurosis which covers the abdomen. TENSOR FASCIA LATA (o.) external iliac spine : (i.) by aponeurosis (fascia lata) into patella and blends with aponeurosis of biceps. GLUTEUS MAXIMUS (o.) internal iliac spine, external iliac spine, and from aponeurosis which covers the gluteus medius between these attachments : (i.) third trochanter of femur. VASTUS LONGUS (o.) sacral crest, aponeurosis which envelops the coccygeal muscles, sacrosciatic ligament and tuberosity of ischium : (i.) third trochanter of femur, fascia lata, and patella. SEMI-TENDINOSUS (o.) tuberosity of ischium, coccygeal aponeurosis, and sacral crest : (i.) blends with aponeurosis of leg, crosses internal surface of tibia, and is inserted into anterior border of same bone. BICEPS CRURIS (o.) tuberosity of ischium : (i.) by aponeurosis which blends with fascia lata and aponeurosis of leg, and anterior crest of tibia.

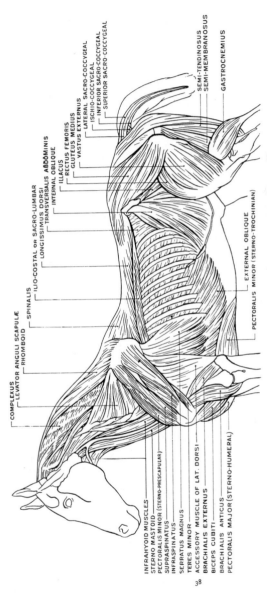

FIG. 27.—TRUNK. LEFT LATERAL ASPECT. Myology—Deep.

Labels (top, reading down the right side):
SEMI-TENDINOSUS
SEMI-MEMBRANOSUS
GASTROCNEMIUS
SUPERIOR SACRO-COCCYGEAL
INFERIOR SACRO-COCCYGEAL
ISCHIO-COCCYGEAL
LATERAL SACRO-COCCYGEAL
VASTUS EXTERNUS
GLUTEUS MEDIUS
RECTUS FEMORIS
ILIACUS
INTERNAL OBLIQUE
TRANSVERSAUS ABDOMINIS
LONGISSIMUS DORSI
ILIO-COSTAL or SACRO-LUMBAR
SPINALIS
RHOMBOID
LEVATOR ANGULI SCAPULÆ
COMPLEXUS

Labels (bottom/left):
INFRAHYOID MUSCLES
STERNO MASTOID
PECTORALIS MINOR (STERNO-PRESCAPULAR)
SUPRASPINATUS
INFRASPINATUS
SERRATUS MAGNUS
TERES MINOR
ACCESSORY MUSCLE OF LAT. DORSI
BRACHIALIS EXTERNUS
BICEPS CUBITI
BRACHIALIS ANTICUS
PECTORALIS MAJOR (STERNO-HUMERAL)
PECTORALIS MINOR (STERNO-TROCHINIAN)
EXTERNAL OBLIQUE

ATTACHMENTS OF MUSCLES.

INFRAHYOID MUSCLES (origin), sternum, and scapula : (insertion) hyoid bone and thyroid cartilage. STERNO-MASTOID (o.) anterior extremity of sternum : (i.) by tendon to angle of lower jaw, and aponeurosis to mastoido-humeral muscle and mastoid process. PECTORALIS MINOR (sterno-prescapular) (o.) sternum : (i.) by aponeurosis which covers the supraspinatus. SUPRASPINATUS (o.) supraspinous fossa of scapula and cartilage of prolongation : (i.) great tuberosity or trochanter of humerus. INFRASPINATUS (o.) infraspinous fossa of scapula and cartilage of prolongation : (i.) great tuberosity of humerus below insertion of supraspinatus. SERRATUS MAGNUS (o.) by digitations from the first eight ribs : (i.) subscapular fossa near the spinal border. TERES MINOR (o.) posterior border of scapula : (i.) great tuberosity of humerus. ACCESSORY MUSCLE OF LATISSIMUS DORSI (o.) external aspect of tendon of latissimus dorsi and posterior border of scapula : (i.) olecranon, and anti-brachial aponeurosis. BRACHIALIS EXTERNUS (o.) inferior extremity of scapula : (i.) olecranon. BICEPS CUBITI (o.) coracoid process of scapula : (i.) bicipital tuberosity on internal surface of radius. BRACHIALIS ANTICUS (o.) humerus : (i.) internal surface of radius and ulna. PECTORALIS MAJOR (sterno-humeral) (o.) sternum (i.), anterior margin of humerus. EXTERNAI OBLIQUE (o.) by digitations from the last thirteen or fourteen ribs, and from the dorso-lumbar aponeurosis : (i.) by aponeurosis which covers the abdomen. PECTORALIS MINOR (sterno-trochinian) (o.) abdominal aponeurosis and posterior part of sternum : (i.) lesser tuberosity of humerus. COMPLEXUS (o.) occiput : (i.) transverse processes of lower cervical vertebræ, and first three dorsal vertebræ. LEVATOR ANGULI SCAPULÆ

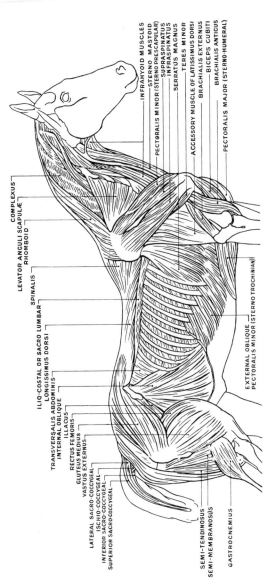

INFRAHYOID MUSCLES
STERNO MASTOID
PECTORALIS MINOR (STERNO PRESCAPULAR)
SUPRASPINATUS
INFRASPINATUS
SERRATUS MAGNUS
TERES MINOR
ACCESSORY MUSCLE OF LATISSIMUS DORSI
BRACHIALIS EXTERNUS
BICEPS CUBITI
BRACHIALIS ANTICUS
PECTORALIS MAJOR (STERNO-HUMERAL)

COMPLEXUS
LEVATOR ANGULI SCAPULÆ
RHOMBOID
SPINALIS
ILIO-COSTAL OR SACRO LUMBAR
LONGISSIMUS DORSI
TRANSVERSALIS ABDOMINIS
INTERNAL OBLIQUE
ILIACUS
RECTUS FEMORIS
GLUTEUS MEDIUS
VASTUS EXTERNUS

LATERAL SACRO-COCCYGEAL
ISCHIO-COCCYGEAL
INFERIOR SACRO-COCCYGEAL
SUPERIOR SACROCOCCYGEAL

SEMI-TENDINOSUS
SEMI-MEMBRANOSUS

GASTROCNEMIUS

EXTERNAL OBLIQUE
PECTORALIS MINOR (STERNO TROCHINIAN)

FIG. 27 A.—TRUNK. RIGHT LATERAL ASPECT. Myology—Deep.

(o.) transverse processes of four lower cervical vertebræ: (i.) superior portion of spinal border of scapula. RHOMBOID (o.) cervical ligament and spinous processes of foremost cervical vertebræ: (i.) spinal border of scapula. SPINALIS (o.) spine of seventh cervical vertebræ: (i.) spines of first few dorsal vertebræ, and muscles of back. ILIO-COSTAL or SACRO-LUMBAR (o.) seventh cervical vertebræ, and inferior edge of first fifteen ribs: (i.) superior edge of last fifteen ribs and ilium. LONGISSIMUS DORSI (o.) transverse processes of seventh cervical and all the dorsal and lumbar vertebræ, and ribs: (i.) spines of last lumbar vertebræ and of sacrum, and ilium. TRANSVERSALIS ABDOMINIS (o.) internal surface of last costal cartilages and transverse processes of lumbar vertebræ: (i.) linea alba. INTERNAL OBLIQUE (o.) external iliac spine: (i.) internal surface of last costal cartilages, and aponeurosis to linea alba. ILIACUS (o.) external iliac spine: (i.) femur. RECTUS FEMORIS (o.) ilium above articulation with femur: (i.) patella. GLUTEUS MEDIUS (o.) iliac fossa and sacro-lumbar aponeurosis: (i.) great trochanter of femur. VASTUS EXTERNUS (o.) external border of posterior surface of femur: (i.) tendon of rectus femoris, and patella. LATERAL SACRO-COCCYGEAL (o.) crest of sacrum: (i.) coccygeal vertebræ. ISCHIO-COCCYGEAL (o.) ilium: (i.) transverse processes of first two coccygeal vertebræ. INFERIOR SACRO-COCCYGEAL (o.) inferior surface of sacrum: (i.) coccygeal vertebræ. SUPERIOR SACRO-COCCYGEAL (o.) crest of sacrum: (i.) coccygeal vertebræ. SEMI-TENDINOSUS (o.) tuberosity of ischium, coccygeal aponeurosis, and sacral crest: (i.) blends with aponeurosis of leg, crosses internal surface of tibia, and is inserted into anterior border of same bone. SEMI-MEMBRANOSUS (o.) inferior surface and tuberosity of ischium, and aponeurosis covering coccygeal muscles: (i.) internal surface of internal condyle of femur. GASTROCNEMIUS (o.) shaft of femur: (i.) by tendo-Achillis in the calcaneum.

39

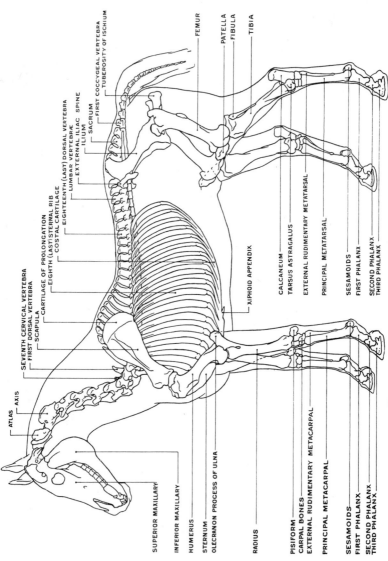

SUPERIOR MAXILLARY

INFERIOR MAXILLARY

HUMERUS

STERNUM

OLECRANON PROCESS OF ULNA

RADIUS

PISIFORM
CARPAL BONES
EXTERNAL RUDIMENTARY METACARPAL

PRINCIPAL METACARPAL

SESAMOIDS
FIRST PHALANX
SECOND PHALANX
THIRD PHALANX

ATLAS

AXIS

SEVENTH CERVICAL VERTEBRA
FIRST DORSAL VERTEBRA
SCAPULA
CARTILAGE OF PROLONGATION
EIGHTH (LAST) STERNAL RIB
COSTAL CARTILAGE
EIGHTEENTH (LAST) DORSAL VERTEBRA
LUMBAR VERTEBRÆ
EXTERNAL ILIAC SPINE
ILIUM
SACRUM
FIRST COCCYGEAL VERTEBRA
TUBEROSITY OF ISCHIUM

FEMUR

PATELLA

FIBULA

TIBIA

XIPHOID APPENDIX

CALCANEUM

TARSUS ASTRAGALUS

EXTERNAL RUDIMENTARY METATARSAL

PRINCIPAL METATARSAL

SESAMOIDS

FIRST PHALANX

SECOND PHALANX
THIRD PHALANX

FIG. 28.—LEFT LATERAL ASPECT. Osteology.

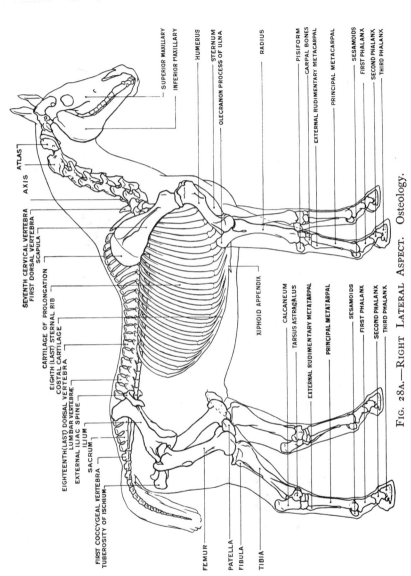

SUPERIOR MAXILLARY
INFERIOR MAXILLARY
HUMERUS
STERNUM
OLECRANON PROCESS OF ULNA
RADIUS
PISIFORM
CARPAL BONES
EXTERNAL RUDIMENTARY METACARPAL
PRINCIPAL METACARPAL
SESAMOIDS
FIRST PHALANX
SECOND PHALANX
THIRD PHALANX

ATLAS
AXIS

SEVENTH CERVICAL VERTEBRA
FIRST DORSAL VERTEBRA
SCAPULA
CARTILAGE OF PROLONGATION
EIGHTH (LAST) STERNAL RIB
COSTAL CARTILAGE
EIGHTEENTH (LAST) DORSAL VERTEBRA
LUMBAR VERTEBRÆ
EXTERNAL ILIAC SPINE
ILIUM
SACRUM
FIRST COCCYGEAL VERTEBRA
TUBEROSITY OF ISCHIUM

XIPHOID APPENDIX

CALCANEUM
TARSUS ASTRAGALUS
EXTERNAL RUDIMENTARY METATARSAL
PRINCIPAL METATARSAL
SESAMOIDS
FIRST PHALANX
SECOND PHALANX
THIRD PHALANX

FEMUR
PATELLA
FIBULA
TIBIA

FIG. 28A.—RIGHT LATERAL ASPECT. Osteology.

41

Modelling

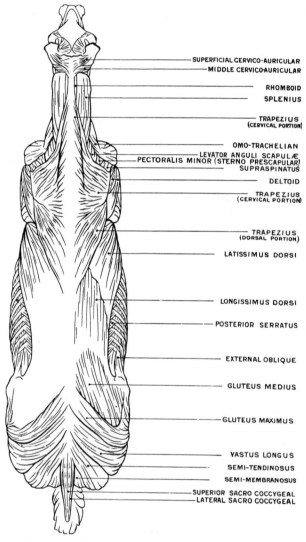

SUPERFICIAL CERVICO-AURICULAR
MIDDLE CERVICO-AURICULAR

RHOMBOID

SPLENIUS

TRAPEZIUS
(CERVICAL PORTION)

OMO-TRACHELIAN
LEVATOR ANGULI SCAPULÆ
PECTORALIS MINOR (STERNO PRESCAPULAR)
SUPRASPINATUS

DELTOID

TRAPEZIUS
(CERVICAL PORTION)

TRAPEZIUS
(DORSAL PORTION)

LATISSIMUS DORSI

LONGISSIMUS DORSI

POSTERIOR SERRATUS

EXTERNAL OBLIQUE

GLUTEUS MEDIUS

GLUTEUS MAXIMUS

VASTUS LONGUS

SEMI-TENDINOSUS

SEMI-MEMBRANOSUS

SUPERIOR SACRO COCCYGEAL
LATERAL SACRO COCCYGEAL

FIG. 29.—TRUNK. SUPERIOR ASPECT. Myology.

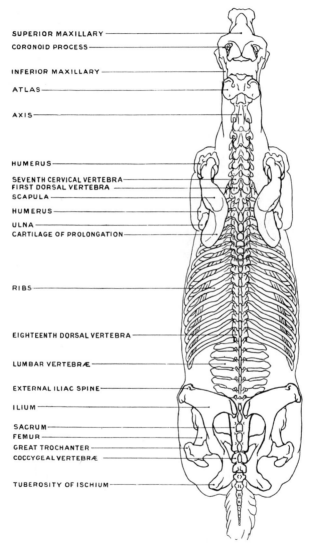

SUPERIOR MAXILLARY

CORONOID PROCESS

INFERIOR MAXILLARY

ATLAS

AXIS

HUMERUS

SEVENTH CERVICAL VERTEBRA
FIRST DORSAL VERTEBRA
SCAPULA

HUMERUS

ULNA
CARTILAGE OF PROLONGATION

RIBS

EIGHTEENTH DORSAL VERTEBRA

LUMBAR VERTEBRÆ

EXTERNAL ILIAC SPINE

ILIUM

SACRUM
FEMUR
GREAT TROCHANTER
COCCYGEAL VERTEBRÆ

TUBEROSITY OF ISCHIUM

FIG. 30.—TRUNK. SUPERIOR ASPECT. Osteology.

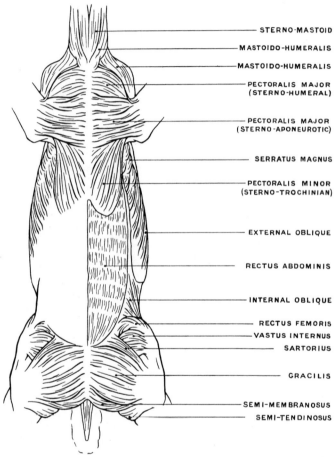

STERNO-MASTOID

MASTOIDO-HUMERALIS

MASTOIDO-HUMERALIS

PECTORALIS MAJOR
(STERNO-HUMERAL)

PECTORALIS MAJOR
(STERNO-APONEUROTIC)

SERRATUS MAGNUS

PECTORALIS MINOR
(STERNO-TROCHINIAN)

EXTERNAL OBLIQUE

RECTUS ABDOMINIS

INTERNAL OBLIQUE

RECTUS FEMORIS
VASTUS INTERNUS
SARTORIUS

GRACILIS

SEMI-MEMBRANOSUS
SEMI-TENDINOSUS

FIG. 31.—TRUNK. INFERIOR ASPECT. Myology.

ATTACHMENTS OF MUSCLES. (FIG. 31.)

STERNO-MASTOID (origin) anterior extremity of sternum ; (insertion) angle of lower jaw, and mastoid process. MASTOIDO-HUMERALIS (o.) posterior surface of skull and upper part of neck : (i.) anterior border of humerus, and anterior extremity of sternum. PECTORALIS MAJOR (sterno-humeral) (o.) sternum : (i.) anterior margin of humerus. PECTORALIS MAJOR (sterno-aponeurotic) (o.) sternum : (i.) aponeurosis of sterno-humeral portion and that of internal surface of leg. SERRATUS MAGNUS (o.) by digitations from the first eight ribs : (i.) subscapular fossa. PECTORALIS MINOR (sterno-trochinian) (o.) abdominal aponeurosis, and posterior part of sternum : (i.) lesser tuberosity of humerus. EXTERNAL OBLIQUE (o.) ribs : (i.) abdominal aponeurosis. RECTUS ABDOMINIS (o.) thorax : (i.) pubis. INTERNAL OBLIQUE (o.) external iliac spine : (i.) internal surface of last costal cartilages, and abdominal aponeurosis. RECTUS FEMORIS (triceps cruris) (o.) ilium : (i.) patella. VASTUS INTERNUS (triceps cruris) (o.) femur : (i.) patella. SARTORIUS (o.) fascia of pelvis : (i.) aponeurosis blends with that of gracilis on internal patellar ligament. GRACILIS o.) inferior aspect of pelvis : (i.) aponeurosis unites with those of sartorius and semi-tendinosus and is inserted into tibia. SEMI-MEMBRANOSUS (o.) inferior surface and tuberosity of ischium, and aponeurosis of coccygeal muscles : (i.) internal condyle of femur. SEMI-TENDINOSUS (o.) tuberosity of ischium coccygeal aponeurosis, and sacral crest : aponeurosis of internal surface of leg and anterior border of tibia.

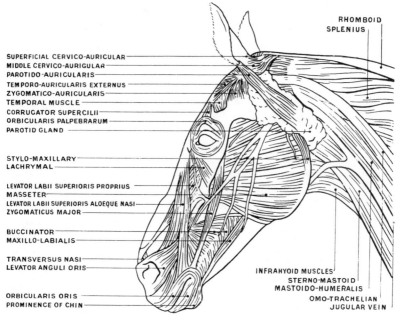

FIG. 32.—HEAD. LEFT LATERAL ASPECT. Myology.

Labels on the figure:

RHOMBOID
SPLENIUS

SUPERFICIAL CERVICO-AURICULAR
MIDDLE CERVICO-AURICULAR
PAROTIDO-AURICULARIS
TEMPORO-AURICULARIS EXTERNUS
ZYGOMATICO-AURICULARIS
TEMPORAL MUSCLE
CORRUGATOR SUPERCILII
ORBICULARIS PALPEBRARUM
PAROTID GLAND

STYLO-MAXILLARY
LACHRYMAL

LEVATOR LABII SUPERIORIS PROPRIUS
MASSETER
LEVATOR LABII SUPERIORIS ALOEQUE NASI
ZYGOMATICUS MAJOR

BUCCINATOR
MAXILLO-LABIALIS

TRANSVERSUS NASI
LEVATOR ANGULI ORIS

ORBICULARIS ORIS
PROMINENCE OF CHIN

INFRAHYOID MUSCLES
STERNO-MASTOID
MASTOIDO-HUMERALIS
OMO-TRACHELIAN
JUGULAR VEIN

ATTACHMENTS OF MUSCLES.

SUPERFICIAL CERVICO-AURICULAR (Cervico-auricularis-superioris) (origin)—superior cervical ligament : (insertion)—posterior surface of concha of ear. MIDDLE CERVICO-AURICULAR (Cervico-auricularis medius) (o.) superior cervical ligament : (i.) external part of base of concha. PAROTIDO-AURICULARIS (o.) external surface of parotid gland : (i.) base of concha. TEMPORO-AURICULARIS EXTERNUS (o.) parietal crest : (i.) internal border of scutiform cartilage and inner side of concha. ZYGOMATICO-AURICULARIS (o.) internal surface of great zygomatic : (i.) antitragus prominence at base of pinna. TEMPORAL MUSCLE (o.) temporal fossa : (i.) coronoid process of inferior maxilla. CORRUGATOR SUPERCILII (fronto-palpebral) (o.) frontal bone : (i.) blends with orbicularis palpebrarum. ORBICULARIS PALPEBRARUM (o.) by small tendon from a tubercle in external surface of lachrymal bone : (i.) surrounds palpebral orifice. STYLO-MAXILLARY (a fasciculus of the Digastric) : (o.) styloid process of occipital bone : (i.) inferior maxillary. LACHRYMAL (o.) malar bone below orbit : (i.) fibro-adipose layer which supports the moustache. LEVATOR LABII SUPERIORIS PROPRIUS (proper or deep elevator of upper lip and ala of nose) (o.) below orbital cavity : (i.) after a tendinous expansion between the nasal fossa it divides into fasciculi and ends in thickness of upper lip. MASSETER (o.) zygomatic arch and maxillary spine : (i.) external surface of the ramus of mandible and into its angle. LEVATOR LABII

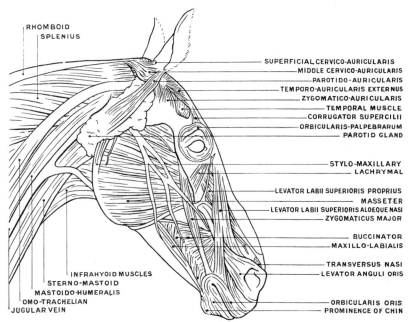

RHOMBOID
SPLENIUS

SUPERFICIAL CERVICO-AURICULARIS
MIDDLE CERVICO-AURICULARIS
PAROTIDO-AURICULARIS
TEMPORO-AURICULARIS EXTERNUS
ZYGOMATICO-AURICULARIS
TEMPORAL MUSCLE
CORRUGATOR SUPERCILII
ORBICULARIS-PALPEBRARUM
PAROTID GLAND

STYLO-MAXILLARY
LACHRYMAL

LEVATOR LABII SUPERIORIS PROPRIUS
MASSETER
LEVATOR LABII SUPERIORIS ALOEQUE NASI
ZYGOMATICUS MAJOR

BUCCINATOR
MAXILLO-LABIALIS

TRANSVERSUS NASI
LEVATOR ANGULI ORIS

INFRAHYOID MUSCLES
STERNO-MASTOID
MASTOIDO-HUMERALIS
OMO-TRACHELIAN
JUGULAR VEIN

ORBICULARIS ORIS
PROMINENCE OF CHIN

FIG. 32 A.—HEAD. RIGHT LATERAL ASPECT. Myology.

SUPERIORIS ALÆQUE NASI (internal or superficial elevator of upper lip and ala of nose) (o.) frontal and nasal bones: (i.) divides into two fasciculi, one passes over caninus and is inserted into upper lip, the other passes under caninus and is inserted into wing of nose. ZYGOMATICUS MAJOR (zygomatico-labial) (o.) on surface of masseter muscle close to maxillary spine: (i.) in deep surface of skin of labial commissure. BUCCINATOR (alveolo-labial) (superficial portion) (o.) alveolar border of superior maxillary: (i.) corresponding border of inferior maxillary. MAXILLO-LABIALIS (depressor of lower lip) (o.) deep layer of buccinator, and ramus of lower jaw: (i.) thickness of lower lip. TRANSVERSUS NASI situated on dorsum of nose and inserted into cartilaginous skeleton of nostrils. LEVATOR ANGULI ORIS or CANINUS (o.) external surface of maxilla in front of maxillary spine: (i.) expands and terminates in skin of nostril. ORBICULARIS ORIS is arranged as a ring round buccal orifice, in thickness of lips, and blends with surrounding muscles. PROMINENCE OF CHIN is a fibro-muscular pad which blends with the orbicularis oris. MUSCLES OF NECK. RHOMBOID arises from cervical ligament and spinous processes of foremost cervical vertebræ. SPLENIUS is attached to mastoid crest and transverse processes of atlas, axis, and three following vertebræ. INFRAHYOID MUSCLES are attached to the hyoid bone and thyroid cartilage. STERNO-MASTOID is attached to angle of lower jaw and by an aponeurosis to mastoido-humeral muscle and mastoid process. MASTOIDO-HUMERALIS is attached to posterior surface of skull and transverse process of atlas. OMO-TRACHELIAN is attached to transverse processes of first four cervical vertebræ.

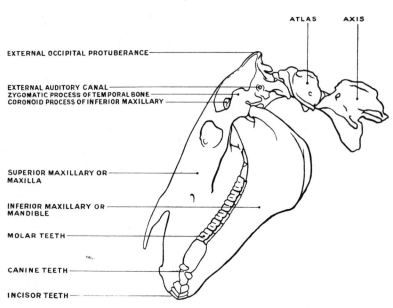

ATLAS AXIS

EXTERNAL OCCIPITAL PROTUBERANCE

EXTERNAL AUDITORY CANAL
ZYGOMATIC PROCESS OF TEMPORAL BONE
CORONOID PROCESS OF INFERIOR MAXILLARY

SUPERIOR MAXILLARY OR MAXILLA

INFERIOR MAXILLARY OR MANDIBLE

MOLAR TEETH

CANINE TEETH

INCISOR TEETH

FIG. 33.—HEAD. LEFT LATERAL ASPECT. Osteology.

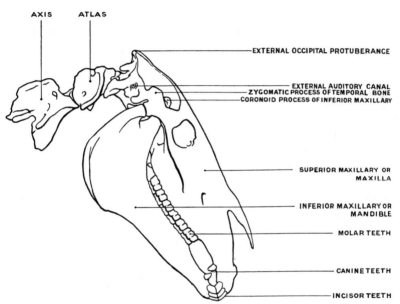

AXIS ATLAS

EXTERNAL OCCIPITAL PROTUBERANCE

EXTERNAL AUDITORY CANAL
ZYGOMATIC PROCESS OF TEMPORAL BONE
CORONOID PROCESS OF INFERIOR MAXILLARY

SUPERIOR MAXILLARY OR
MAXILLA

INFERIOR MAXILLARY OR
MANDIBLE

MOLAR TEETH

CANINE TEETH

INCISOR TEETH

FIG. 33 A.—HEAD. RIGHT LATERAL ASPECT. Osteology.

Myology. Osteology

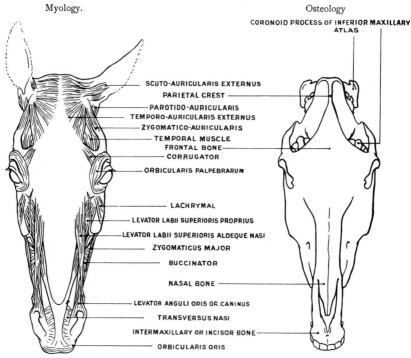

FIG. 34.—HEAD. ANTERIOR ASPECT.

ATTACHMENTS OF MUSCLES.

SCUTO-AURICULARIS EXTERNUS (origin) scutiform cartilage : (insertion) inner side of concha. PAROTIDO-AURICULARIS (o.) external surface of parotid gland : (i.) base of concha. TEMPORO-AURICULARIS EXTERNUS (o.) whole extent of parietal crest (i.) internal border of scutiform cartilage and inner side of concha. TEMPORAL MUSCLE (o.) temporal fossa : (i.) coronoid process of inferior maxilla. CORRUGATOR SUPERCILII (fronto-palpebral (o.) frontal bone : (i.) blends with orbicularis palpebrarum. ORBICULARIS PALPEBRARUM (o.) by small tendron from a tubercle on external surface of lachrymal bone : (i.) surrounds palpebral orifice. LACHRYMAL (o.) malar bone below orbit : (i.) fibro-adipose layer which supports the moustache. LEVATOR LABII SUPERIORIS PROPRIUS (proper or deep elevator of upper lip and ala of nose) (o.) below orbital cavity : (i.) after a tendinous expansion between the nasal fossa it divides into fasciculi and ends in thickness of upper lip. LEVATOR LABII SUPERIORIS ALÆQUE NASI (internal or superficial elevator of upper lip, and ala of nose) (o.) frontal and nasal bones : (i.) divides into two fasciculi, one passes over caninus and inserted into upper lip, the other passes under caninus and inserted into wing of nose. ZYGOMATICUS MAJOR (zygomatico-labial) (o.) on surface of masseter close to maxillary spine : (i.) in deep surface of skin of labial commissure. BUCCINATOR (alveolo-labial) (superficial portion) (o.) superior maxillary bone : (i.) inferior maxillary bone. LEVATOR ANGULI or CANINUS (o.) external surface of maxilla in front of maxillary spine : (i.) expands and terminates in skin of nostril. TRANSVERSUS NASI situated on dorsum of nose and inserted into cartilaginous skeleton of nostrils. ORBICULARIS ORIS is arranged in a ring round buccal orifice in thickness of lips, and blends with surrounding muscles

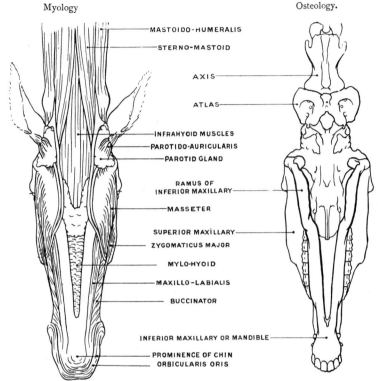

Myology Osteology.

MASTOIDO-HUMERALIS
STERNO-MASTOID
AXIS
ATLAS
INFRAHYOID MUSCLES
PAROTIDO-AURICULARIS
PAROTID GLAND
RAMUS OF
INFERIOR MAXILLARY
MASSETER
SUPERIOR MAXILLARY
ZYGOMATICUS MAJOR
MYLO-HYOID
MAXILLO-LABIALIS
BUCCINATOR
INFERIOR MAXILLARY OR MANDIBLE
PROMINENCE OF CHIN
ORBICULARIS ORIS

Fig. 35.—Head. Inferior Aspect.

ATTACHMENTS OF MUSCLES

MASTOIDO-HUMERALIS (origin) posterior surface of skull and transverse process of atlas : (insertion) humerus. STERNO-MASTOID (o.) sternum : (i.) by a tendon to angle of lower jaw, and by an aponeurosis to mastoido-humeral muscle and mastoid process. INFRAHYOID MUSCLES (sterno-thyroid) (o.) sternum : (i.) thyroid cartilage : (sterno-hyoid) (o.) sternum : (i.) hyoid bone : (omo-hyoid) (o.) scapula : (i.) hyoid bone. PAROTIDO-AURICULARIS (o.) external surface of parotid gland : (i.) base of concha. MASSETER (o.) zygomatic arch, and maxillary spine : (i.) external surface of ramus of mandible and into its angle. ZYGOMATICUS MAJOR (zygomatico-labial) (o.) on surface of masseter muscle close to maxillary spine : (i.) in deep surface of skin of labial commissure. MYLO-HYOID (o.) internal line of mandible : (i.) median raphe running between hyoid bone and anterior part of mandible. MAXILLO-LABIALIS (depressor of lower lip) (o.) deep layer of buccinator and ramus and lower jaw : (i.) thickness of lower lip. BUCCINATOR (alveolo-labial) (superficial portion) (o.) alveolar border of superior maxillary : (i.) corresponding border of inferior maxillary. PROMINENCE OF CHIN is a fibro-muscular pad which blends with the orbicularis oris. ORBICULARIS ORIS is arranged as a ring round buccal orifice in thickness of lips, and blends with surrounding muscles.

52

Modelling

LEFT RIGHT

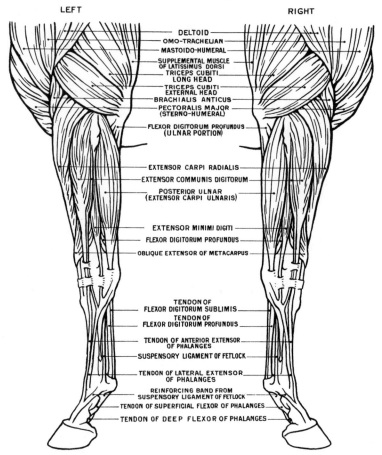

FIG. 36.—FORE-LEG. EXTERNAL ASPECT. Myology.

ATTACHMENTS OF MUSCLES.

DELTOID (origin) scapula : (insertion) deltoid impression or crest of humerus. OMO-TRACHELIAN (o.) cervical vertebræ : (i.) anterior border of humerus. MASTOIDO-HUMERAL (o.) skull and neck : (i.) anterior border of humerus. ACCESSORY MUSCLE OF LATISSIMUS DORSI (o.) tendon of latissimus dorsi, and scapula : (i.) olecranon process, and anti-brachial aponeurosis. TRICEPS CUBITI (long head) (o.) posterior border of scapula : (i.) olecranon process. TRICEPS CUBITI (external head) (o.) curved crest between deltoid impression and head of humerus : (i.) olecranon process. BRACHIALIS ANTICUS (o.) musculo-spiral groove below head of humerus : (i.) by two slips, one into the bicipital tuberosity on internal surface of radius, the other into the ulna. PECTORALIS MAJOR (sterno-humeral) (o.) sternum : (i.) anterior margin of humerus. FLEXOR DIGITORUM PROFUNDUS (ulnar portion) (o.) olecranon : (i.) third phalanx. (Deep

LEFT

RIGHT

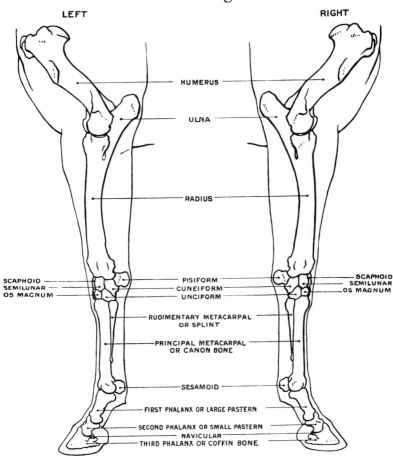

HUMERUS

ULNA

RADIUS

SCAPHOID
SEMILUNAR
OS MAGNUM

PISIFORM
CUNEIFORM
UNCIFORM

SCAPHOID
SEMILUNAR
OS MAGNUM

RUDIMENTARY METACARPAL
OR SPLINT

PRINCIPAL METACARPAL
OR CANON BONE

SESAMOID

FIRST PHALANX OR LARGE PASTERN

SECOND PHALANX OR SMALL PASTERN
NAVICULAR
THIRD PHALANX OR COFFIN BONE

FIG. 37.—FORE-LEG. EXTERNAL ASPECT. Osteology.

flexor of phalanges.) EXTENSOR CARPI RADIALIS (anterior extensor of metacarpus) (o.) external border of humerus above its epicondyle : (i.) tubercle on anterior surface of superior end of principal metacarpus. EXTENSOR COMMUNIS DIGITORUM (anterior extensor of phalanges) (o.) inferior part of external border of humerus, external and superior tuberosity of radius : (i.) tendon divides into two parts, the larger inserted into anterior surfaces of phalanges, the smaller unites with the tendon of extensor minimi digiti. POSTERIOR ULNAR (extensor carpi ulnaris) (o.) epicondyle : (i.) external part of superior extremity of metacarpus and fibrous band attached on pisiform. EXTENSOR MINIMI DIGITI (lateral extensor of phalanges) (o.) external surface of superior extremity of radius : (i.) after receiving fibrous band from carpus and tendon of extensor communis digitorum, into anterior surface of superior extremity of first phalanx. OBLIQUE EXTENSOR OF METACARPUS (o.) shaft of radius : (i.) superior extremity of internal rudimentary metacarpal. FLEXOR DIGITORUM SUBLIMIS (superficial flexor of phalanges) (o.) epitrochlea : (i.) second phalanx.

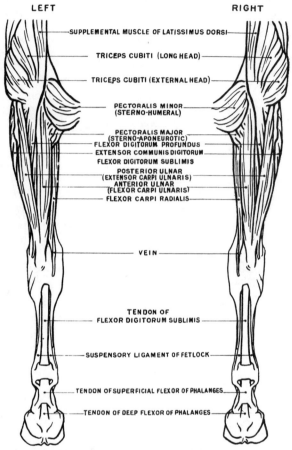

LEFT RIGHT

—SUPPLEMENTAL MUSCLE OF LATISSIMUS DORSI—

TRICEPS CUBITI (LONG HEAD)

TRICEPS CUBITI (EXTERNAL HEAD)

PECTORALIS MINOR
(STERNO-HUMERAL)

PECTORALIS MAJOR
(STERNO-APONEUROTIC)
FLEXOR DIGITORUM PROFUNDUS
EXTENSOR COMMUNIS DIGITORUM
FLEXOR DIGITORUM SUBLIMIS
POSTERIOR ULNAR
(EXTENSOR CARPI ULNARIS)
ANTERIOR ULNAR
(FLEXOR CARPI ULNARIS)
FLEXOR CARPI RADIALIS

VEIN

TENDON OF
FLEXOR DIGITORUM SUBLIMIS

SUSPENSORY LIGAMENT OF FETLOCK

TENDON OF SUPERFICIAL FLEXOR OF PHALANGES

TENDON OF DEEP FLEXOR OF PHALANGES

Fig. 38.—Fore-Leg. Posterior Aspect. Myology.

ATTACHMENTS OF MUSCLES.

ACCESSORY MUSCLE OF LATISSIMUS DORSI (origin) tendon of latissimus dorsi and scapula: (insertion) olecranon process and anti-brachial aponeurosis. TRICEPS CUBITI (long head) posterior border of scapula: (i.) olecranon process. TRICEPS CUBITI (external head) (o.) curved crest between deltoid impression and superior head of humerus: (i.) olecranon process. PECTORALIS MINOR (sterno-humeral) (o.) abdominal aponeurosis and posterior part of sternum: (i.) lesser tuberosity (trochin) of humerus. PECTORALIS MAJOR (sterno-aponeurotic) (o.) sternum: (i.) aponeurosis joined to those of sterno-humeral portion and of leg. FLEXOR DIGITORUM PROFUNDUS (ulnar portion) (o.) olecranon: (i.) third phalanx (deep flexor of

Modelling

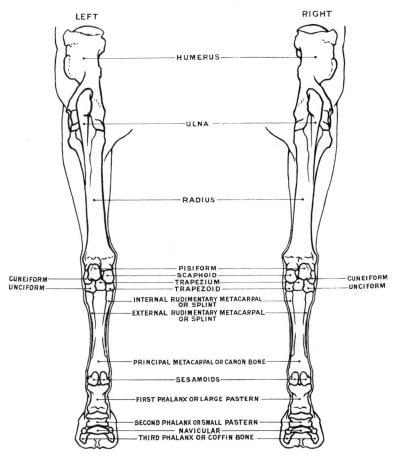

LEFT RIGHT

HUMERUS

ULNA

RADIUS

CUNEIFORM
UNCIFORM

PISIFORM
SCAPHOID
TRAPEZIUM
TRAPEZOID
INTERNAL RUDIMENTARY METACARPAL OR SPLINT
EXTERNAL RUDIMENTARY METACARPAL OR SPLINT

CUNEIFORM
UNCIFORM

PRINCIPAL METACARPAL OR CANON BONE

SESAMOIDS

FIRST PHALANX OR LARGE PASTERN

SECOND PHALANX OR SMALL PASTERN
NAVICULAR
THIRD PHALANX OR COFFIN BONE

FIG. 39.—FORE-LEG. POSTERIOR ASPECT. Osteology.

phalanges. EXTENSOR COMMUNIS DIGITORUM (anterior extensor of phalanges) (o.) inferior part of external border of humerus, external and superior tuberosity of radius: (i.) tendon divides into two parts, the larger inserted into anterior surfaces of phalanges, the smaller unites with tendon of extensor minimi digiti. FLEXOR DIGITORUM SUBLIMIS (superficial flexor of phalanges) (o.) epitrochlea: (i.) second phalanx. POSTERIOR ULNAR (extensor carpi ulnaris) (o.) epicondyle: (i.) external part of superior extremity of metacarpus and fibrous band attached on pisiform. ANTERIOR ULNAR (flexor carpi ulnaris) (o.) epitrochlea and olecranon: (i.) pisiform. FLEXOR CARPI RADIALIS (internal flexor of metacarpus) (o.) epitrochlea: (i.) superior extremity of external rudimentary metacarpal.

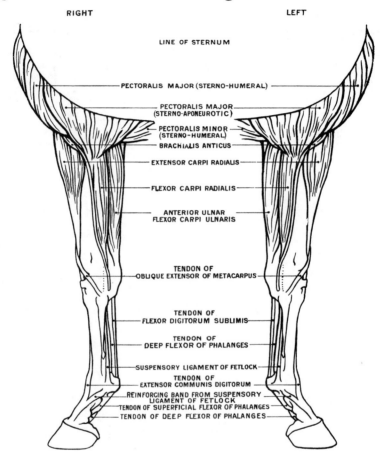

RIGHT LEFT

LINE OF STERNUM

PECTORALIS MAJOR (STERNO-HUMERAL)

PECTORALIS MAJOR (STERNO-APONEUROTIC)

PECTORALIS MINOR (STERNO-HUMERAL)

BRACHIALIS ANTICUS

EXTENSOR CARPI RADIALIS

FLEXOR CARPI RADIALIS

ANTERIOR ULNAR FLEXOR CARPI ULNARIS

TENDON OF OBLIQUE EXTENSOR OF METACARPUS

TENDON OF FLEXOR DIGITORUM SUBLIMIS

TENDON OF DEEP FLEXOR OF PHALANGES

SUSPENSORY LIGAMENT OF FETLOCK

TENDON OF EXTENSOR COMMUNIS DIGITORUM

REINFORCING BAND FROM SUSPENSORY LIGAMENT OF FETLOCK

TENDON OF SUPERFICIAL FLEXOR OF PHALANGES

TENDON OF DEEP FLEXOR OF PHALANGES

FIG. 40.—FORE-LEG. INTERNAL ASPECT. Myology.

ATTACHMENTS OF MUSCLES.

PECTORALIS MAJOR (sterno-humeral) (origin) sternum : (insertion) anterior margin of humerus. PECTORALIS MAJOR (sterno-aponeurotic) (o.) sternum : (i.) aponeurosis joined with those of sterno-humeral portion and of leg. PECTORALIS MINOR (sterno-humeral) (o.) abdominal aponeurosis and posterior part of sternum : (i.) lesser tuberosity (trochin) of humerus. BRACHIALIS ANTICUS (o.) musculo spiral groove below head of humerus : (i.) by two slips, one into bicipital tuberosity on internal surface of radius, the other into ulna. EXTENSOR CARPI RADIALIS (anterior extensor of metacarpus) (o.) external border of humerus above epicondyle : (i.) tubercle on anterior surface of superior end of principal metacarpal. FLEXOR CARPI RADIALIS (internal flexor of metacarpus) (o.) epitrochlea : (i.) superior

RIGHT

LEFT

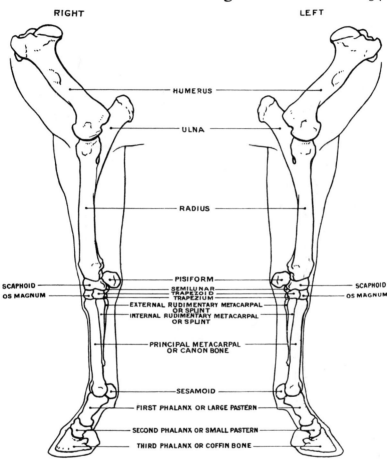

HUMERUS

ULNA

RADIUS

PISIFORM
SCAPHOID
OS MAGNUM
SEMILUNAR
TRAPEZOID
TRAPEZIUM
SCAPHOID
OS MAGNUM
EXTERNAL RUDIMENTARY METACARPAL
OR SPLINT
INTERNAL RUDIMENTARY METACARPAL
OR SPLINT

PRINCIPAL METACARPAL
OR CANON BONE

SESAMOID

FIRST PHALANX OR LARGE PASTERN

SECOND PHALANX OR SMALL PASTERN

THIRD PHALANX OR COFFIN BONE

FIG. 41.—FORE-LEG. INTERNAL ASPECT. Osteology.

extremity of internal rudimentary metacarpal. ANTERIOR ULNAR (flexor carpi ulnaris) (o.) epitrochlea and olecranon : (i.) pisiform. OBLIQUE EXTENSOR OF METACARPUS (o.) shaft of radius : (i.) superior extremity of internal rudimentary metacarpal. FLEXOR DIGITORUM SUBLIMIS (superficial flexor of phalanges) (o.) epitrochlea : (i.) second phalanx. DEEP FLEXOR OF PHALANGES (flexor digitorum profundus) (o.) epitrochlea, radius, and olecranon : (i.) third phalaux. EXTENSOR COMMUNIS DIGITORUM (anterior extensor of phalanges) (o.) inferior part of external border of humerus, external and superior tuberosity of radius : (i.) tendon divides into two parts, the larger inserted into anterior surfaces of phalanges, the smaller unites with tendon of extensor minimi digiti.

Modelling

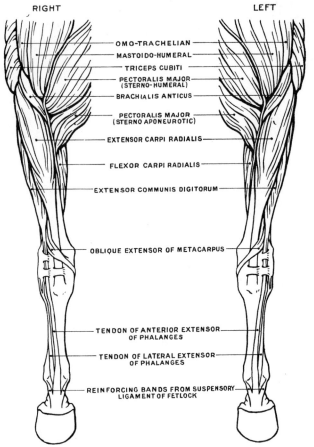

RIGHT LEFT

OMO-TRACHELIAN

MASTOIDO-HUMERAL

TRICEPS CUBITI

PECTORALIS MAJOR
(STERNO-HUMERAL)

BRACHIALIS ANTICUS

PECTORALIS MAJOR
(STERNO APONEUROTIC)

EXTENSOR CARPI RADIALIS

FLEXOR CARPI RADIALIS

EXTENSOR COMMUNIS DIGITORUM

OBLIQUE EXTENSOR OF METACARPUS

TENDON OF ANTERIOR EXTENSOR
OF PHALANGES

TENDON OF LATERAL EXTENSOR
OF PHALANGES

REINFORCING BANDS FROM SUSPENSORY
LIGAMENT OF FETLOCK

FIG. 42.—FORE-LEG. ANTERIOR ASPECT. Myology.

ATTACHMENTS OF MUSCLES.

OMO-TRACHELIAN (origin) cervical vertebræ : (insertion) anterior border of humerus. MASTOIDO-HUMERAL (o.) skull and neck : (i.) anterior border of humerus. TRICEPS CUBITI (external head) (o.) curved crest between deltoid impression and superior head of humerus : (i.) olecranon. PECTORALIS MAJOR (sterno-humeral) (o.) sternum : (i.) anterior margin of humerus. BRACHIALIS ANTICUS (o.) musculo-spiral groove below head of humerus : (i.) by two slips, one into bicipital tuberosity on internal surface of radius, the other into ulna. PECTORALIS MAJOR (sterno-aponeurotic) (o.) sternum : (i.) aponeurosis joined to those of sterno-humeral portion and of leg. EXTENSOR CARPI RADIALIS (anterior extensor of metacarpus) (o.)

RIGHT LEFT

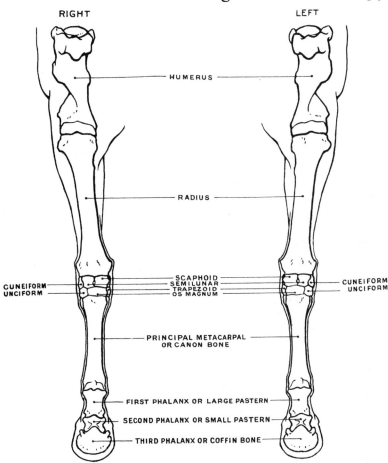

HUMERUS

RADIUS

SCAPHOID
SEMILUNAR
TRAPEZOID
OS MAGNUM

CUNEIFORM
UNCIFORM

CUNEIFORM
UNCIFORM

PRINCIPAL METACARPAL
OR CANON BONE

FIRST PHALANX OR LARGE PASTERN

SECOND PHALANX OR SMALL PASTERN

THIRD PHALANX OR COFFIN BONE

FIG. 43.—FORE-LEG. ANTERIOR ASPECT. Osteology.

external border of humerus above epicondyle : (i.) tubercle on anterior surface of superior end of principal metacarpal. FLEXOR CARPI RADIALIS (internal flexor of metacarpus) (o.) epitrochlea : (i.) superior extremity of internal rudimentary metacarpal. EXTENSOR COMMUNIS DIGITORUM (anterior extensor of phalanges) (o.) inferior part of external border of humerus, external and superior tuberosity of radius : (i.) tendon divides into two parts, the larger inserted into the anterior surfaces of phalanges, the smaller unites with tendon of extensor minimi digiti. OBLIQUE EXTENSOR OF METACARPUS (extensor ossis metacarpi pollicis and extensor primi internodii pollicis) (o.) shaft of radius : (i.) superior extremity of internal rudimental metacarpal.

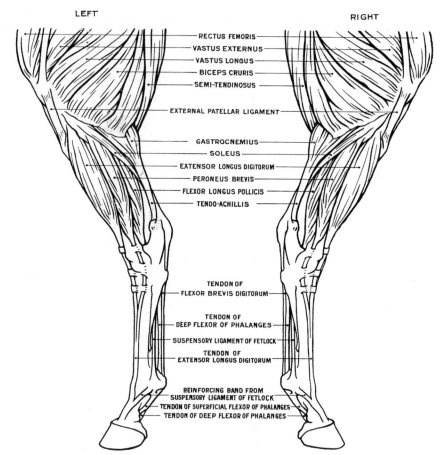

LEFT

RIGHT

RECTUS FEMORIS
VASTUS EXTERNUS
VASTUS LONGUS
BICEPS CRURIS
SEMI-TENDINOSUS

EXTERNAL PATELLAR LIGAMENT

GASTROCNEMIUS
SOLEUS
EXTENSOR LONGUS DIGITORUM
PERONEUS BREVIS
FLEXOR LONGUS POLLICIS
TENDO-ACHILLIS

TENDON OF
FLEXOR BREVIS DIGITORUM

TENDON OF
DEEP FLEXOR OF PHALANGES
SUSPENSORY LIGAMENT OF FETLOCK
TENDON OF
EXTENSOR LONGUS DIGITORUM

REINFORCING BAND FROM
SUSPENSORY LIGAMENT OF FETLOCK
TENDON OF SUPERFICIAL FLEXOR OF PHALANGES
TENDON OF DEEP FLEXOR OF PHALANGES

FIG. 44.—HIND-LEG. EXTERNAL ASPECT. Myology.

ATTACHMENTS OF MUSCLES.

RECTUS FEMORIS (origin) iliac bone : (insertion) patella. VASTUS EXTERNUS (o.) femur : (i.) tendon of rectus femoris, and patella. VASTUS LONGUS (o.) sacral crest, aponeurosis enveloping coccygeal muscles, and tuberosity of ischium : (i.) femur, fascia lata, and patella. BICEPS CRURIS (o.) tuberosity of ischium : (i.) aponeurosis blends with fascia lata and aponeurosis of leg. SEMI-TENDINOSUS (o.) tuberosity of ischium and crest of sacrum : (i.) aponeurosis covering internal surface of tibia, and anterior border of tibia. GASTROCNEMIUS (o.) shaft of femur : (i.) by tendo-Achillis into calcaneum. SOLEUS (o.) external tuberosity of

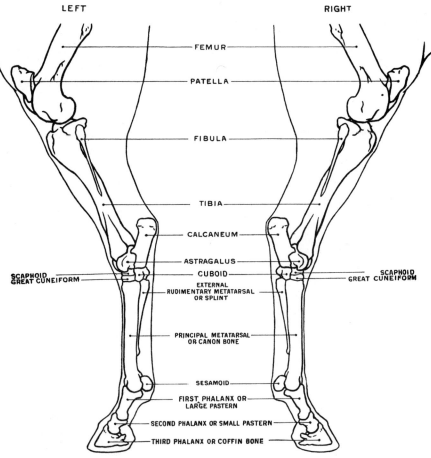

LEFT RIGHT

FEMUR

PATELLA

FIBULA

TIBIA

CALCANEUM

ASTRAGALUS

CUBOID

SCAPHOID
GREAT CUNEIFORM

EXTERNAL
RUDIMENTARY METATARSAL
OR SPLINT

PRINCIPAL METATARSAL
OR CANON BONE

SESAMOID

FIRST PHALANX OR
LARGE PASTERN

SECOND PHALANX OR SMALL PASTERN

THIRD PHALANX OR COFFIN BONE

SCAPHOID
GREAT CUNEIFORM

FIG. 45.—HIND-LEG. EXTERNAL ASPECT. Osteology.

tibia: (i.) tendon unites with tendon of gastrocnemius. EXTENSOR LONGUS DIGITORUM
(anterior extensor of phalanges) (o.) fossa below external condyle of femur: (i.) phalanges,
after receiving tendon of peroneus brevis and reinforcing bands from suspensory ligament.
PERONEUS BREVIS (o.) external lateral ligament of patella and whole length of fibula: (i.)
tendon blends with that of extensor longus digitorum towards middle of canon bone.
FLEXOR LONGUS POLLICIS (o.) fibula and tibia: (i.) united with tibialis posticus to form deep
flexor of phalanges. FLEXOR BREVIS DIGITORUM (superficial flexor of phalanges) (o.) fossa
above external condyle of femur: (i.) phalanges.

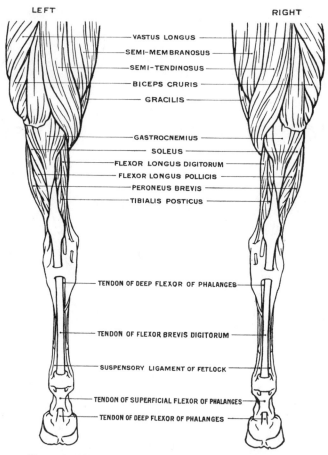

LEFT

RIGHT

VASTUS LONGUS

SEMI-MEMBRANOSUS

SEMI-TENDINOSUS

BICEPS CRURIS

GRACILIS

GASTROCNEMIUS

SOLEUS

FLEXOR LONGUS DIGITORUM

FLEXOR LONGUS POLLICIS

PERONEUS BREVIS

TIBIALIS POSTICUS

TENDON OF DEEP FLEXOR OF PHALANGES

TENDON OF FLEXOR BREVIS DIGITORUM

SUSPENSORY LIGAMENT OF FETLOCK

TENDON OF SUPERFICIAL FLEXOR OF PHALANGES

TENDON OF DEEP FLEXOR OF PHALANGES

FIG. 46.—HIND-LEG. POSTERIOR ASPECT. Myology.

ATTACHMENTS OF MUSCLES.

VASTUS LONGUS (origin) sacral crest, aponeurosis of coccygeal muscles, and tuberosity of ischium : (insertion) femur, fascia lata, and patella. SEMI-MEMBRANOSUS (o.) inferior surface of ischium, tuberosity of ischium, and aponeurosis of coccygeal muscles : (i.) internal condyle of femur. SEMI-TENDINOSUS (o.) tuberosity of ischium, and crest of sacrum : (i.) aponeurosis covering internal surface of tibia, and anterior border of tibia. BICEPS CRURIS (o.) tuberosity of ischium : (i.) aponeurosis blends with fascia lata and aponeurosis of leg. GRACILIS (o.) pubis and neighbouring regions : (i.) internal surface of tibia. GASTROCNEMIUS (o.) shaft of femur :

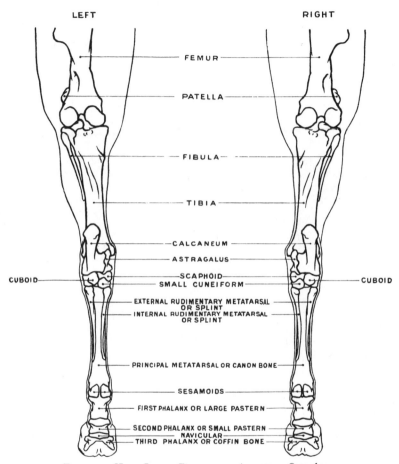

FIG. 47.—HIND-LEG. POSTERIOR ASPECT. Osteology.

(i.) by tendo-Achillis into calcaneum. SOLEUS (o.) external tuberosity of tibia : (i.) tendon unites with that of gastrocnemius. FLEXOR LONGUS DIGITORUM (o.) posterior surface of external tuberosity of tibia : (i.) tendon blends with those of deep flexors of phalanges. FLEXOR LONGUS POLLICIS (deep flexor of phalanges) (o.) fibula and tibia : (i.) phalanges, after uniting with tendon of flexor longus digitorum. PERONEUS BREVIS (o.) external patellar ligament, and whole length of fibula : (i.) tendon blends with that of extensor longus digitorum towards middle of canon bone. TIBIALIS POSTICUS (o.) external tuberosity of tibia, and head of fibula : (i.) unites with flexor longus pollicis to form deep flexor of phalanges. FLEXOR BREVIS DIGITORUM (superficial flexor of phalanges) (o.) fossa above external condyle of femur : (i.) phalanges.

Modelling

RIGHT LEFT

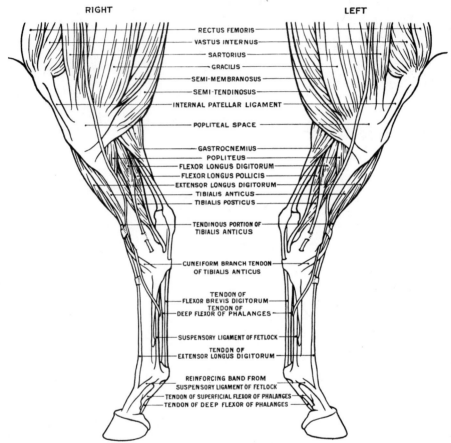

──── RECTUS FEMORIS ────
──── VASTUS INTERNUS ────
──── SARTORIUS ────
──── GRACILIS ────
──── SEMI-MEMBRANOSUS ────
──── SEMI-TENDINOSUS ────
──── INTERNAL PATELLAR LIGAMENT ────

──── POPLITEAL SPACE ────

──── GASTROCNEMIUS ────
──── POPLITEUS ────
──── FLEXOR LONGUS DIGITORUM ────
──── FLEXOR LONGUS POLLICIS ────
──── EXTENSOR LONGUS DIGITORUM ────
──── TIBIALIS ANTICUS ────
──── TIBIALIS POSTICUS ────

──── TENDINOUS PORTION OF ────
TIBIALIS ANTICUS

──── CUNEIFORM BRANCH TENDON ────
OF TIBIALIS ANTICUS

TENDON OF
──── FLEXOR BREVIS DIGITORUM ────
TENDON OF
──── DEEP FLEXOR OF PHALANGES ────

──── SUSPENSORY LIGAMENT OF FETLOCK ────

TENDON OF
──── EXTENSOR LONGUS DIGITORUM ────

REINFORCING BAND FROM
SUSPENSORY LIGAMENT OF FETLOCK
──── TENDON OF SUPERFICIAL FLEXOR OF PHALANGES ────
──── TENDON OF DEEP FLEXOR OF PHALANGES ────

FIG. 48.—HIND-LEG. INTERNAL ASPECT. Myology.

ATTACHMENTS OF MUSCLES.

RECTUS FEMORIS (origin) iliac bone : (insertion) patella. VASTUS INTERNUS (o.) femur : (i.) tendon of rectus femoris, and patella. SARTORIUS (o.) fascia covering iliac muscle : (i.) by an aponeurosis blending with that of gracilis. GRACILIS (o.) ischio-pubic symphysis and neighbouring regions : (i.) internal surface of tibia. SEMI-MEMBRANOSUS (o.) inferior surface of ischium, tuberosity of ischium, and aponeurosis of coccygeal muscles : (i.) internal condyle of femur. SEMI-TENDINOSUS (o.) tuberosity of ischium and crest of sacrum : (i.) aponeurosis covering internal surface of tibia, and anterior border of same bone. GASTROCNEMIUS (o.) shaft of femur : (i.) by tendo-Achillis into calcaneum. POPLITEUS (o.) external condyle of femur : (i.) posterior surface and internal border of tibia. FLEXOR LONGUS DIGITORUM (o.) posterior surface of external tuberosity of tibia : (i.) tendon blends with those of deep flexor of phalanges.

RIGHT LEFT

FEMUR

PATELLA

FIBULA

TIBIA

CALCANEUM

ASTRAGALUS

SCAPHOID
GREAT CUNEIFORM

CUBOID
SMALL CUNEIFORM
EXTERNAL
RUDIMENTARY METATARSAL
INTERNAL
RUDIMENTARY METATARSAL
OR SPLINT

SCAPHOID
GREAT CUNEIFORM

PRINCIPAL METATARSAL
OR CANON BONE

SESAMOID

FIRST PHALANX OR
LARGE PASTERN

SECOND PHALANX OR SMALL PASTERN

THIRD PHALANX OR COFFIN BONE

FIG. 49.—HIND-LEG. INTERNAL ASPECT. Osteology.

FLEXOR LONGUS POLLICIS (o.) fibula and tibia : (i.) united with tibialis posticus it forms the deep flexor of phalanges. EXTENSOR LONGUS DIGITORUM (o.) fossa below external condyle of femur : (i.) phalanges, after receiving reinforcing bands from the suspensory ligament of fetlock. TIBIALIS ANTICUS (o.) superior extremity of tibia : (i.) anterior surface of superior extremity of principal metatarsal, and branch tendon into small cunieform bone. TIBIALIS POSTICUS (o.) external tuberosity of tibia, and head of fibula : (i.) united with flexor longus pollicis it forms the deep flexor of phalanges. TENDINOUS PORTION OF TIBIALIS ANTICUS (o.) fossa above external condyle of femur : (i.) by two branches, one into superior extremity of principal metatarsus, the other into cuboid. FLEXOR BREVIS DIGITORUM (o.) above external condyle of femur : (i.) phalanges (superficial flexor of phalanges).

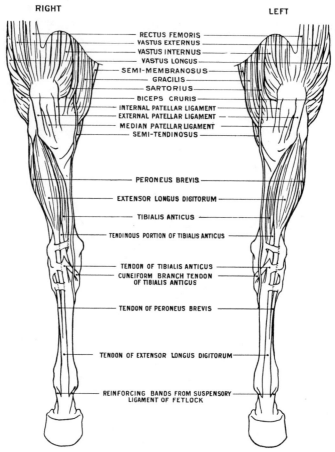

RIGHT

LEFT

RECTUS FEMORIS
VASTUS EXTERNUS
VASTUS INTERNUS
VASTUS LONGUS
SEMI-MEMBRANOSUS
GRACILIS
SARTORIUS
BICEPS CRURIS
INTERNAL PATELLAR LIGAMENT
EXTERNAL PATELLAR LIGAMENT
MEDIAN PATELLAR LIGAMENT
SEMI-TENDINOSUS

PERONEUS BREVIS

EXTENSOR LONGUS DIGITORUM

TIBIALIS ANTICUS

TENDINOUS PORTION OF TIBIALIS ANTICUS

TENDON OF TIBIALIS ANTICUS
CUNEIFORM BRANCH TENDON
OF TIBIALIS ANTICUS

TENDON OF PERONEUS BREVIS

TENDON OF EXTENSOR LONGUS DIGITORUM

REINFORCING BANDS FROM SUSPENSORY
LIGAMENT OF FETLOCK

FIG. 50.—HIND-LEG. ANTERIOR ASPECT. Myology.

ATTACHMENTS OF MUSCLES.

RECTUS FEMORIS (origin) iliac bone : (insertion) patella. VASTUS EXTERNUS (o.) femur : (i.) tendon of rectus femoris, and patella. VASTUS INTERNUS (o.) femur : (i.) tendon of rectus femoris, and patella. VASTUS LONGUS (o.) sacral crust, aponeurosis enveloping coccygeal muscles, and tuberosity of ischium : (i.) femur, fascia lata, and patella. SEMI-MEMBRANOSUS (o.) inferior surface of ischium, tuberosity of ischium, and aponeurosis of coccygeal muscles : (i.) internal condyle of femur. GRACILIS (o.) pubis and neighbouring regions: (i.) internal surface of tibia. SARTORIUS (o.) fascia covering iliac muscles : (i.) by aponeurosis blending with that of gracilis. BICEPS CRURIS (o.) tuberosity of ischium : (i.) aponeurosis blends with fascia lata and

RIGHT LEFT

FEMUR

PATELLA

FIBULA

TIBIA

CALCANEUM

ASTRAGALUS
SCAPHOID
GREAT CUNIEFORM

CUBOID CUBOID

EXTERNAL RUDIMENTARY METATARSAL

PRINCIPAL METATARSAL OR CANON BONE

FIRST PHALANX OR LARGE PASTERN

SECOND PHALANX OR SMALL PASTERN

THIRD PHALANX OR COFFIN BONE

FIG. 51.—HIND-LEG. ANTERIOR ASPECT. Osteology.

aponeurosis of leg. SEMI-TENDINOSUS (o.) tuberosity of ischium, and crest of sacrum : (i.) aponeurosis covering internal surface of tibia, and anterior border of tibia. PERONEUS BREVIS (o.) external patellar ligament and whole length of fibula : (i.) tendon blends with that of extensor longus digitorum towards middle of canon bone. EXTENSOR LONGUS DIGITORUM (anterior extensor of phalanges) (o.) fossa below external condyle of femur : (i.) phalanges, after receiving tendon of peroneus brevis and reinforcing bands from suspensory ligament. TIBIALIS ANTICUS (o.) superior extremity of tibia : (i.) anterior superior extremity of canon bone, and branch tendon into small cuneiform. TENDINOUS PORTION OF TIBIALIS ANTICUS (o.) fossa above external condyle of femur : (i.) by two tendons, one into superior extremity of canon bone, the other into cuboid.

CHAPTER VII

HAVING so often heard certain amateurs say that science is useless in art, that taste alone suffices to the creation of artistic work, I cannot but think that such an absurdity is not only due to their absolute ignorance, but is, moreover, a means of dissimulating their idleness and disinclination for all study. It is not then necessary to discuss their views, alas ; their works suffice to justify my opinion of them. Let us leave them to their fate.

I will content myself with giving the opinion of men of great artistic value, who have sought, studied, and worked ceaselessly all their life, and who, with the greatest modesty, are unanimous in recognising the importance of science in art and particularly in sculpture.

Here, for example, is a passage from a monograph of Dr. Richer—Professor of Anatomy at the *École des Beaux-Arts*, Paris, and who is also a sculptor, in which he admirably defines the necessary part which science plays in the progress of art.

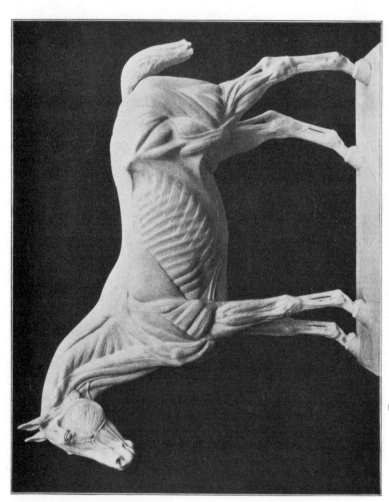

Fig. 52.—Modelled Anatomical Study of the Horse.

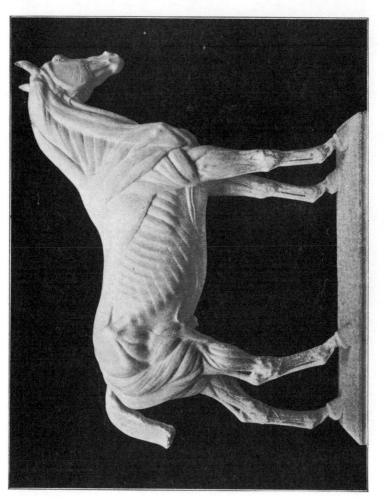

FIG. 53.— MODELLED ANATOMICAL STUDY OF THE HORSE.

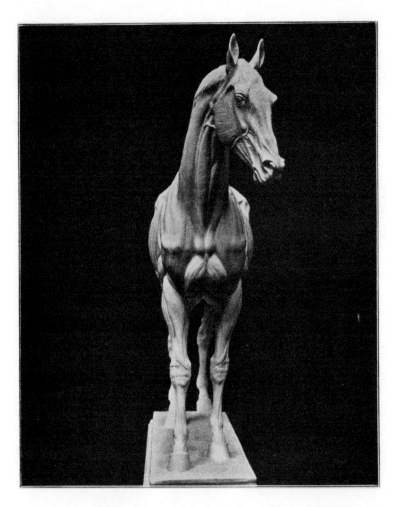

FIG. 54.—MODELLED ANATOMICAL STUDY OF THE HORSE.

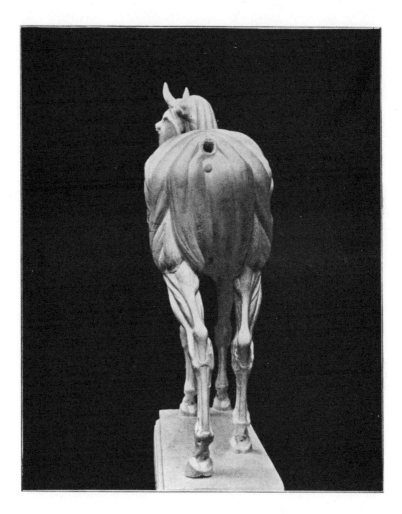

FIG. 55.—MODELLED ANATOMICAL STUDY OF THE HORSE.

I should like to recommend the lecture of this monograph to all who are interested in the subject, for they can only profit largely thereby. He says :

" But whatever part genius may owe to unconsciousness, it can only fully realise its work by building it on the unshakable basis of reason and of reasoning."

And further on he quotes a passage from the works of Leonardo da Vinci :

" In a general way, science has for mission to distinguish that which is impossible from that which is possible. Imagination abandoned to itself will only follow unrealisable dreams. Science restrains it by teaching us to understand that which cannot be. It does not follow from this that science contains the principles of art, but that it is necessary to study science either before one studies art or at the same time, to learn within what limits art is obliged to remain."

Again from Dr. Richer, this passage :

" Science always helps to introduce order in the work, which is one of the conditions of beauty. Science in art must never predominate, must never be obtrusive, it must, on the contrary, serve ; its attitude must be one of modesty and effacement. To science belong the foundations and the heavy work of the monument, which afterwards art will adorn. But though hidden the action of science is none the less of importance, for it is science that gives life to the work and makes it lasting."

And these lines taken from Jules Breton's book, *Nos peintres du siècle* :

" Fancy alone is incapable of producing anything lasting.

Nature has essential laws which it is absolutely necessary to know and to assimilate. The observance of these laws, far from hindering individual originality, only develops its intensity and allows it to be bold without danger."

Further on he adds :

" The thumb sketch promises everything and realises nothing."

This from the great painter Gérome :

" When a sculptor starts a figure, if he has carefully taken the principal measurements, and accurately indicated the prominences of the bones, he is astonished to see that, though there is as yet only uncouth masses, there is already a resemblance to the model, that the work is already well advanced and that its completion is only a question of hours and of work."

Here is another passage from *Étude sur le sculpteur Barye*, by his confrère E. Guillaume :

" There are among the greatest artists some who make of science a powerful auxiliary and seek in it the preciseness of their inspiration. It would seem that they borrow its methods and its means ; they create nothing without having deliberately observed, and it is only after having acquired a sure knowledge that they seek to represent forms. To know is for them the first rule, a rigorous duty and, so to speak, a point of honour. However brilliantly gifted they may be, they never apply their talent without referring to precise facts, and without appealing to their artistic conscience. Their life is a perpetual tribute to Truth. But this voluntary subordination on their part does not lessen them. Thanks to the artistic understanding which animates them, they remove reality to a higher sphere and nature such as they reveal it to us is endowed with their own

ideality. At the same time the sincerity and logic which have guided them remain as an acquistion to their followers. And if the personality of their genius proves unattainable, they leave a salutary example and make a clearance through which others may follow without losing their way. It is thus, whatever the ability, that, thanks to a positive knowledge, reliableness in art is attained without which personal gifts would be as nothing."

I will close these quotations with this saying of Peiss :

" The eye only sees in things that which it looks for, and it only looks for that of which the mind has already framed the idea."

The outcome of this is that the student must study, but study does not mean merely that he must try and imitate what he has before him, but that he must seek its reason and its laws. Otherwise this imitation will never be but an exercise which will only develop the cleverness of his handiwork, and he will never make progress in any other direction. In a short time, seeing nothing in his model but its superficial form, he will find that the work he does has no contrasts of qualities and is monotonous and insipid, as is all work which only possesses, what is known in studio parlance abroad as, *the value of the paw*, which in the matter of art is less than very little. His progress will be arrested, and instead of feeling each day an ever-growing interest in his studies, if he be an artist, he will only experience a sense of lassitude and be profoundly disheartened, the varied forms of his model remaining for him an insolvable mystery. Before translating

a poem it is necessary to become familiar with the spirit and the impulse which lurk in the mere words ; so must the student who wishes to represent nature thoroughly understand it.

In time study renders the student capable of discovering the beauties of nature ; he sees in his model characteristic traits and accessory parts ; he distinguishes the *ensemble* through the details ; he exercises, then, according to his soul, sincerely and almost unconsciously, a choice in his imitation, and that without any violent struggle to prove himself original, a struggle which generally gives the results which we too often see in certain so-called art exhibitions and which rather seem to be the outcome of a prolonged stay in a lunatic asylum.

True personality is only developed and revealed at the price of being sincere in the face of nature and to oneself ; it is then only that we put into our work our own sentiments and emotions and that, so to speak, we create to our own image. Then our work becomes the reflection of our soul, of our feelings, and it is alone under such conditions of sincerity and knowledge that our creations become personal.

To conclude the subject of the importance which science has in the execution of a sculptural work, it is necessary to distinguish two things in it, as it were two distinct parts, though indissolubly united. First, the movement, construction, and measurements ; secondly, the accent, the spirit,

the sentiment, and the style. The first part is obtained by means of the compass, the plumb-line, the horizontal and oblique lines, and a knowledge of anatomy. The second part is entirely one of feeling and of personal taste; it is the artistic part, and this cannot be measured. The first part is acquired and can be taught without fear, it necessitates effort, will, a great conscience, it is the part of science; the second is the part of art, which demands natural gifts that nothing can replace; and if the first is the positive part, the second is its soul.

CHAPTER VIII.

THE CONSTRUCTION OF THE TWO CHASSIS.

IT is understood that the sketch which it is proposed to enlarge is a model $\frac{1}{4}$ the size of the finished work, in which everything has been established, so that it shall not be necessary, as I have said before, to make any other changes in the enlargement than those called for, by the drawing, character, etc., for, as it will be seen from the diagrams of the large armature, which follow, everything in it must be firmly fixed, and this must be so to guard against accidents during the work. This thoroughly grasped, and having a good sketch, proceed in the following way.

Take the greatest length of the sketch, from the head to the buttock, also the greatest width, which is generally at the thighs a little below the anterior iliac crests.

Allow for the small chassis, about $1\frac{3}{4}$ inches beyond these measurements, that is to say that if the sketch measures $20\frac{1}{4}$ inches in length and $5\frac{1}{4}$ inches in width, the length of the chassis will be 22 inches, and its width 7 inches.

Take slips of wood well planed about $\frac{3}{4}$ inch wide and $\frac{1}{8}$ inch thick and of the lengths indicated above, that is, two of 22 inches and two of $6\frac{3}{4}$ inches. The smaller slips being nailed inside the extremities of the long ones, the $\frac{1}{8}$ inch thickness of the latter on either side will make the total of 7 inches for the width of the chassis. The pieces are to be joined by means of a nail at each angle and the angles further strengthened by pieces of wood $3\frac{1}{2}$ inches in length,

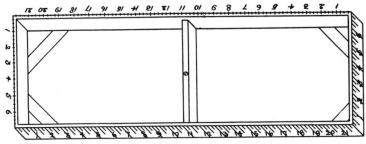

FIG. 56.

the extremities of which are nailed at about 2 inches from each angle ; further add across the centre of the chassis a transverse piece of wood $\frac{3}{4}$ inch square. It is of the greatest importance that the various parts of the chassis should be at right angles. (Fig. 56.)

Divide each of the sides into inches, and their subdivisions, halves, quarters and eighths, beginning at the left hand end of each side, marking each side from 1 to 22, and each extremity from 1 to 7. (Fig. 56.)

Mark each of the inch divisions by a line taking the whole width of the wood, the half by a line, and the fourths and eighths by lines decreasing proportionally.

The large chassis is made in the same way as the small one, but four times the size of the latter. So that if the small chassis is 22 inches long and 7 inches wide, the large one must be 7 feet 4 inches long, and 2 feet 4 inches

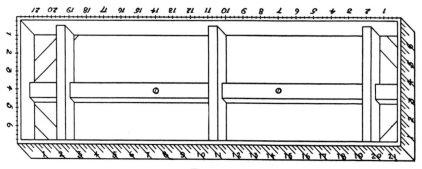

FIG. 57.

wide. The large chassis will be divided into twenty-two divisions like the small one, but each of the divisions will be four times the size of that of the small one. It must also be made much stronger ; not only will the pieces of the chassis be four times the length of the smaller one, but they will also be four times as wide and four times as thick. Moreover, it will be necessary to add a central piece of wood in the sense of the length. (Fig. 57.)

As in the case of the small chassis, it is necessary that

all the parts of the large one be perfectly at right angles, otherwise the pointing cannot be exact.

Next make what is known as the height-measure for the small model, in the following way. Take a well-planed lath, which must be as long as the distance from the plinth of the model to the point at which the chassis is placed above the horse. If the measurement from the base of the plinth to the top of the head of the horse is $19\frac{1}{2}$ inches, the chassis will have been placed at about 21 inches, so the lath must have this length, plus the width of the wood of the chassis ($\frac{3}{4}$ of an inch) or $21\frac{3}{4}$ inches. This lath must be fixed on a transverse piece of wood as indicated in Fig. 58.

This measure made, divide it into inches, etc., on either side.

The height-measure for the enlargement will be made in exactly the same way, always having the proportions and divisions four times larger.

We next turn our attention to the making of what are known as the measuring-sticks, one for the model and one for the enlargement.

Fig. 58.

These are small laths of wood, which enable us to establish the measurements of depth and are cut as indicated in Fig. 59.

FIG. 59.

The large one will be, of course, four times the length of the small one, and the latter will be about 14 inches long and $\frac{1}{8}$ of an inch thick and will be also divided on both sides into inches and their subdivisions, the divisions and subdivisions on the other being four times larger. These are all the implements necessary.

In a word, everything that is used in working on the enlargement must be four times the size of what is used for the small model.

CHAPTER IX

FIXING THE TWO CHASSIS

AFTER having placed the sketch on a stand about 4 feet high, and assured oneself, by means of the level, that the surface is perfectly horizontal, fix the model in the centre by means of four nails, placed near the corners, binding the nails, surface of the stand, and base of the model together with plaster in such a way that, during the progress of the work, the model cannot be moved, otherwise all the measurements would be disturbed.

Next nail to the four angles of the chassis four pieces of wood, 21¾ inches long and ¾ of an inch square. (Fig. 60.)

FIG. 60.

The four uprights fixed to the chassis, place the whole on the top of the stand so that the chassis frames the horse evenly (Fig. 61), that is to say, so that the central line of the horse's back shall be in the centre of the chassis (Fig. 62).

Fig. 61.

Fig. 62.

Having found the place of the chassis, nail the uprights to the stand and strengthen their lower parts with plaster that should extend to the plinth of the model. The uprights must be in the vertical line and the chassis perfectly horizontal.

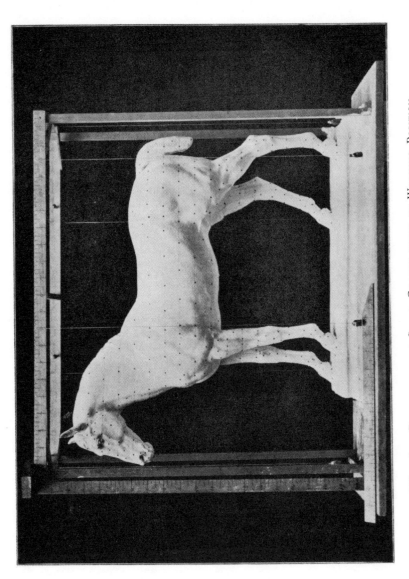

Fig. 63.—Photo. showing Small Chassis fixed in Working Position.

There must be no possible movement either in the model or the chassis during the pointing, so that it is imperative in some way or another that the whole shall be solidly established, otherwise all the measurements taken subsequent to any disturbance will not be true. This is a point of the greatest importance, and must be the subject of the most minute attention.

There are two ways of putting the large chassis in place; first, by fixing four uprights at the angles, as in the case of the small chassis; second, by suspending it from the ceiling of the studio. The latter way is by far the best, as thus the danger of knocking against the uprights during work and disturbing the measurements is avoided.

For this second method, much depends on the studio; but some means must be found of fixing to the ceiling four descending branches reaching down to the height at which

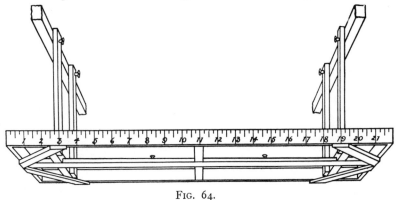

FIG. 64.

it is proposed to have the chassis, and so placed that the lower extremities arrive to near the four angles of the chassis, to which they must be firmly fixed with screws, bearing in mind that the chassis must be perfectly horizontal. (Fig. 64.)

In this way it will be absolutely rigid, and nothing will be in the way during the construction of the armature and the pointing, which will then be the easier and the more rapid.

The height of the uprights when used must be four times that of the distance from the stand to the chassis of the model.

CHAPTER X

THE iron support of the large armature is indicated in Figure 65 and its construction and measurements will be seen there in detail and also the description of the branch which forms its base.

The board on which the armature stands is made of five planks about 9 inches wide and 6 feet 6 inches long, held together by transverse planks of the same width as the others and as long as the width of the entire board, as shown in Figure 66.

The sketch being surrounded by its chassis, and that of the enlargement fixed, the iron of the large armature is also fixed in its place, as indicated in the diagram (Fig. 66). To do this, use the plumb-lines, which should be attached to nails in the longitudinal central piece of the chassis. The side ones should each be placed at Number 11, and the end ones at $3\frac{1}{2}$, which are the centres of these aspects. It will then be easy to find exactly the middle position for the iron. But

FIG. 65.

FIG. 65 A.—PHOTO. OF AN IRON SUPPORT FOR A LIFE-SIZE HORSE.

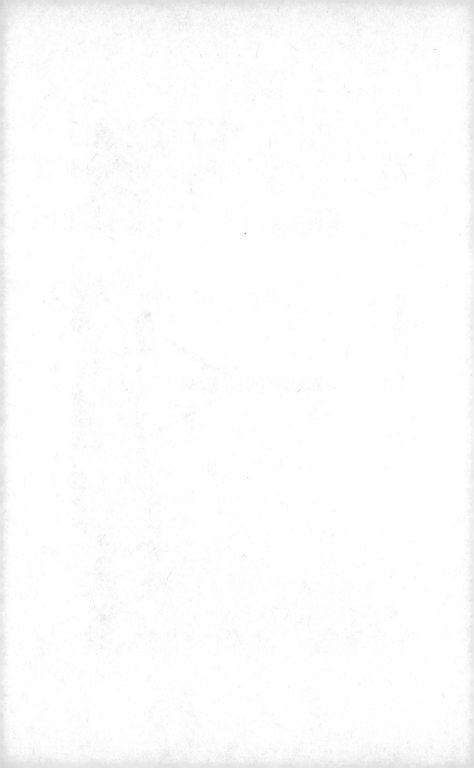

FIG. 66.

it must here be said that the vertical part of the iron should not be placed exactly in the centre ; it is necessary to calculate roughly from the model the proportional weight of the clay fore and aft, so as to find the best place at which the vertical branch should enter the body of the horse, so that as far as possible more weight should not be at the fore part than at the hind part. Generally, taking the centre of the chassis, it is better to place the vertical branch a little towards the head.

Use the chassis and the different implements as follows :

Both the great chassis and the small one must be furnished on each of the four sides with a slender black string, plumb-line, placed so that it hangs truly.

With a pencil, mark a point in the sketch on the middle of the body of the horse. Take the elevation of this point by means of the small height-measure, placed on the chassis in front of the point ; with this, placed well at a right angle, use the measuring-stick and read off the number of divisions on it. Do the same now for the enlargement. Then fix a fair sized lump of clay on the iron and stick a small piece of wood horizontally into it, so that the free end of the piece of wood meets the end of the measuring-stick. The height of the point is thus obtained.

It now remains to find the distance and the depth; to do this, place the plumb-line of the model at number 1 or 2

on the posterior side of the small chassis, and with the measuring-stick measure the distance from the string to this piece of wood. We will suppose that in the sketch this distance is 7 inches. Then place the plumb-line of the large chassis in the same way as that of the small one, at number 1 or 2, and with the large measuring-stick measure this distance. Place the measuring-stick against the string at number 7 and the extremity of this measuring stick gives the distance of the point corresponding with that marked on the sketch. Move the piece of wood placed in the clay, of which we have already the height until it meets the extremity of the measuring-stick, without altering the height, which should again be verified.

We have thus the height and the distance ; the depth has now to be found.

Place on the chassis of the sketch the side string, in a line with the point marked on the plaster, and with the measuring-stick find the distance separating this point from the string. We will suppose that it is $3\frac{1}{2}$. Do the same for the enlargement and place the string on the same number as that of the sketch. With the measuring-stick find the depth which is $3\frac{1}{2}$ and push the piece of wood in the clay or draw it out, until its extremity is at that distance. The space then between the iron and this point is that which may be filled by the wooden armature, being careful to

allow for three or four inches of clay, so that the armature shall not be too near the surface and in the way during the progress of the work.

The same must be done at different points around the iron, that is at the centre and the two ends on either side. In this way six points will have been established, determin-

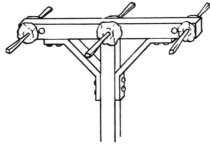

FIG. 67.

ing the space in which the armature is to be constructed. (Fig. 67.)

The space left between the iron and the extremity of these points is to be filled by a wooden armature; which is to be made as follows. Take two planks 3 feet 6 inches long, 9 inches wide and 2 inches thick; make two holes in them corresponding exactly with those in the horizontal branch of the iron. To do this correctly place the plank against the iron, and from the other side of the iron pass a pencil through the holes, making a mark on the wood. This gives the exact places where the two holes are to

be made in the plank. The same is then done for the other plank. After this, pass bolts first through the holes of the plank which is going to be placed on the more important side of the composition, then through the holes in the iron, then through the holes of the plank on the other side, and screw the whole firmly together, being careful that the nuts are on the latter side of the horse, so that during the casting, when the clay and the armature are removed from the mould, it shall be easy to unscrew the nuts, the reason of this being that in casting a horse, one side of the horse is done in a single piece, while the other side is done in several pieces, which allows of the clay being removed more easily than would be the case if each shell were cast in a single piece, as this would render their separation almost impossible. It is also necessary to have one side moulded in several pieces to facilitate the final casting. On the more important side the shell remains upright, while on the other it is removed in pieces.

These two planks in place, calculate what space remains before reaching the maximum thickness of the armature ; add then on either side, to the first plank two other planks, or even three, if necessary, so that this armature shall reach to within three or four inches of the ultimate surface of the clay. These additional planks may be nailed (Fig. 68).

Neck.—Next place the wood that is to support the neck. Proceed in the same way as you have done for establishing

the points of the body. Having made a pencil mark on the model at the middle of the side of the neck, place one of the strings on the anterior aspect of the chassis at the division facing the centre of the neck ; then on the left side place a string on the number opposite the mark which has been made on the side of the neck. With the height-measure placed on the chassis, take the measuring-stick, place its point on the mark, and, keeping it perfectly horizontal, read at what number it meets the height-measure.

Then place the plumb-line of the enlargement chassis on the same number as the small chassis and measure the height as you have done for the model. Place a lath on the planks of the fore part of the body with a single nail or a piece of clay so that it can be easily moved. On this lath mark the height. This found, measure the distance on the model, that is to say, from the string on the anterior aspect, and apply this measurement on the enlargement by proceeding in the same way. Cross the horizontal line on the lath by a vertical line at the distance given by the measuring-stick. Then from the string on the left side of the model take the measurement for the depth ; which will be transferred to the enlargement. It will then be seen where the wood of the neck should be placed to be well in its centre.

In the same way indicate another point at the extremity of the neck near the head, which will give the length of

the wood for the neck. Then cut this piece of wood as indicated in the diagram (Fig. 68) and fix it by means of nails or bolts, the nuts being on the less important side of the animal. Measure also the thickness of the neck on the model, so as to find what thickness is to be given to the wood, and so that there shall remain space for enough clay for modelling; that is to say, so as to be able to remove some of the clay if necessary without the wood being exposed.

Head.—For the head employ the same method as for the neck, nailing, or fixing with a lump of clay, a lath on this wood of the neck, directed according to the centre of the head. Mark a point in the centre of the cheek; take its height, distance and depth. This point fixed, place the piece of wood in such a way that it shall be well in the centre of the mass of the head, allowing on either side of the wood enough space for the clay. The armature for the head may be lengthened with piping, 1 inch thick, fixed on the top of the head and descending all along the wood, to be attached to the wood of the neck, as is indicated in the figure (Fig. 68). The wood of the head is bound to that of the neck by means of flat bands of iron screwed in front and at the back, as in the diagram (Fig. 68).

Legs.—Having fixed a point on the sketch at the place indicated in the diagram (Fig. 68) by the letter H, take its

FIG. 68.

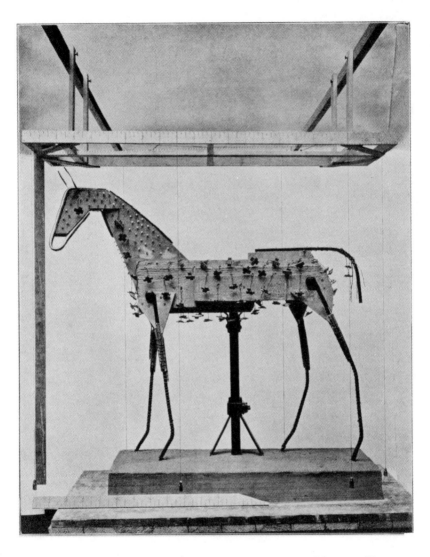

FIG. 69.—PHOTO FROM COMPLETE ARMATURE FOR A LIFE-SIZE HORSE.

three measurements. See then what space remains from this wood in connection with these three measurements, and fix a coach-screw, which is to be screwed into the wood, until its head is at about two or three inches from what will be the ultimate surface of the clay. On this screw hook a piece of iron three-quarters of an inch square, of which the extremity is to be bent as indicated in the diagram (Fig. 68). This iron must be as straight as possible and descend to about the middle of the plinth and be bent at the lower part, at the place corresponding to the fetlock and hoof; see diagram (Fig. 68). Take the three measurements to find the position of the knee. For this, surround the iron, at this part, with clay, being careful to place it equally all around and fix the point on this lump of clay. It is extremely important that the iron should be perfectly in the centre. Great attention must be given to this, otherwise much trouble will ensue later. The place of the hoof will be determined in the same way ; the iron being hooked is easily moved so as to find its proper position. Proceed in the same way for the other legs.

Tail.—For the tail introduce a piece of wood in the empty space above the horizontal branch of the iron, between the planks and nail from the sides (Fig. 68, Letter B). On the top of this piece of wood attach a piece of iron, having the necessary length and curve. To this iron fix " butterflies " in sufficient number to support the mass of the tail.

Be careful before finally fixing the tail to make sure of its centre and length by taking the three measurements.

This first stage of the armature represents, so to speak, the carcass; there remains now to add to it "butterflies," small pieces of wood, etc., so as to give good support to the clay. The legs, after the direction of the irons has been found, are fixed as is indicated in the diagram (Fig. 68) by pieces of wood (Letter I), and the iron must be surrounded at the thickest part of the legs by other pieces of wood. These latter are kept in position by wire wound around the whole, which can be also twisted around the leg-irons to prevent the clay from slipping. Nail numbers of "butterflies" and pieces of lath wherever it is deemed necessary for the better keeping up of the mass of the clay (Fig. 69).

CHAPTER XI

COVERING THE ARMATURE WITH CLAY

THE next thing is to surround the armature with clay, beginning with the centre of the body and taking care to see that the clay penetrates well into the interstices of the armature and is thoroughly adherent. The thickness of the clay should be about two inches all over the body, neck, and head. The legs should be left free, until a few points have already been fixed on the other parts of the body, which will allow of better seeing the position to be given to the irons of the legs. It is necessary, as a certain quantity of clay is placed on the front part of the horse, to place an equal quantity on the hind part. For if all the front part is covered first, leaving the hind part uncovered, all the weight being in front may bend the armature forwards, notwithstanding its strength. Thus, beginning in the centre of the body, place alternately about six inches of clay on either side of this centre, until the limits of the armature are reached. The weight of the hindquarters generally balances fairly that of the head and neck.

When the armature is thus covered with clay begin to fix the principal points, such as those of the iliac crests, of the knees, shoulders, of the back and front of the neck, two or three for the head, and on all the salient parts of the model. These first points need not be absolutely correct, as it will be necessary to take them again later on. They are but a guide for the moment, enabling one to judge the quantity of clay to be added.

This done surround the legs with clay, placing the same quantity on each side of the iron. If it is noticed that the irons, in respect to the measurements, are not well in the centre of the clay, it is easy at this point to move them until they are in place. These irons, once fixed in their places, put in some of the points of the hind legs : the patellæ, the hocks, and the extremity of the hoofs. Do the same for the front legs.

The *ensemble* thus arrived at, one can at a glance add, between the points already placed, the necessary clay to obtain a bulk corresponding in proportion to that of the model.

CHAPTER XII

I NEXT use the following method.

Trace horizontal lines on the plaster model at about one inch distance one from the other; to do this the spirit-level must be used so as to be sure that these lines are perfectly horizontal. On these lines mark dots with a pencil at about every one and a half inches (Fig. 60)

These lines will be established on the enlargement in the following manner. Take on the small model the height of the first line, by means of the height-measure. Let us suppose that it is six inches from the chassis. Place the height-measure on the large chassis and the measuring-stick on number six of that measure at a perfect right angle, and mark by a small horizontal line on the clay the point touched by the extremity of the measuring-stick. On this line place a straight-edge of the length of the horse, using the level to establish its perfect horizontality. Trace a long line on the clay (Fig. 74), like that already traced on the model. Do the same for the other lines.

97

These horizontal lines give the height of all the points marked on the model, which will thus obviate having to take the measurements for each point. It only remains to take the measurements of the distance and of the depth.

I should say that it is better that two persons should work together at the pointing, one taking the measurements on the model while the other transposes them on the enlargement. The first one calls out the distance, which the second one establishes on the enlargement, and the same is done for the depth. This is naturally quicker and less monotonous.

When one person is working alone, the best way is to write on paper the distances, and below each the depths, of all the points marked on one of the lines traced on the model.

Distance	9		$8\frac{1}{4}$		7		6
Depth	$3\frac{7}{8}$		3		$2\frac{1}{2}$		2

This does away with the necessity of getting down from the scaffolding to measure each point.

All the horizontal lines being traced on the clay as they are on the model, proceed as follows :

Supposing that the first point of the first line has been fixed, which will be somewhere near the upper part of the shoulder, place a string on the anterior aspect of the small chassis in such a way that the string is in a line with the point to be determined.

Transpose this distance on the clay at the first line, then place another string in front of this point on the model and likewise on the enlargement, and take the depth and fix it on the clay (Fig. 70).

FIG. 70.

Be careful that the two strings are placed so as always to make a right angle with the point. Fix a peg in the clay, which should be pushed in until its free extremity corresponds exactly with the measurements of distance and depth.

Coming now to beyond the centre of the body, place the string which gives the distance on the posterior aspect of the chassis, in the same way as has been done for the first point, in a straight line with the point required. The string for the depth must naturally be changed at each point, so that it shall be truly facing the point.

When the point to be fixed is on an oblique plane with the chassis, the two strings may be placed on the same branch of the chassis, but always in such a way that the two strings and the point form a right angle (Fig. 71).

For the legs horizontal lines may also be traced, but it will happen that there are certain points to be determined, on the

FIG. 71.

heads of the bones, or in deep places, which important points are not situated on one of the horizonal lines; in this case it will be necessary to take the three measurements, height, distance and depth.

For such points as are under the belly, one can take two distances, from a string on the anterior or posterior aspects

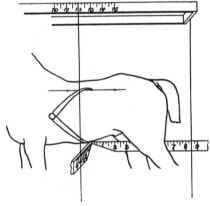

FIG. 72.

of the chassis and from the left or right side aspect, so as to make a cross, then take the thickness with a compass, from one of the points already fixed on the first line or on the back, and which is truly in the vertical line, with the point to be fixed on the abdomen (Fig. 72).

It will be well when all the clay is put on, to fix a plumb-line to the extremity of the nostrils of the horse and to place a nail on the plinth just where the point of the weight reaches.

Fig. 73.

In this way it will be easy to gather if the armature has moved at any time during the work, that is to say, whether it has inclined forwards or backwards, for as soon as the

point of the weight is no longer right over the nail, there has been some movement.

Too much care cannot be taken in making the armature as strong as possible. In giving the necessary time to this, many difficulties and worries will be saved during the progress of the work.

When the pointing is finished, the two chassis may be removed and the model brought near. It is only necessary to fill with clay the empty spaces between each of the points to the extremity of the pegs, and to indicate the different forms of the model. In a very short time an exact and agreeable preparation will be obtained. There will necessarily be modifications to be made in the treatment and in the drawing, for the character of the work required by each scale is different.

If one were obliged to make this enlargement by simply trusting to the eye, which evidently could be done, it would require much more time, and it is doubtful if it could be done as exactly, to say nothing of the greater labour it would require. This method can be applied as well to a figure as to any other subject. It is possible for two persons to do the pointing of a life-size horse in about ten days, and I have done it often myself. At the end of this time a preparation is obtained, which by any other method would require months.

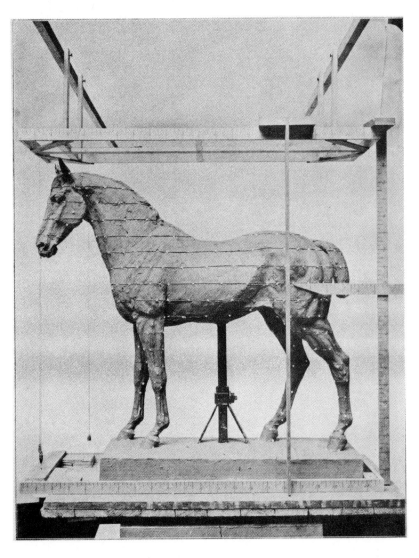

Fig. 74.—Example of the Pointing Completed on the Enlargement.

There is another method of pointing which is perhaps quicker, and of which the principle remains virtually the same. Instead of a single chassis placed above the work, a second identical in size and divisions is added to the base and this reposes on the board to which the iron of the armature is fixed. When the iron is fixed to the board and the top chassis is in place, the other is passed over the iron on to the board, and the plumb-lines are then placed over the four centres of the top chassis, that is, on the number 11 for both sides and on 3½ for the ends. The lines fall to the base and the lower chassis is moved until the lines fall over the same numbers on it. The two frames are then absolutely superposed, one above the other, which must be done with the greatest care, paying attention at the same time that the lower one is placed absolutely horizontally. The latter is then nailed to the board (Fig. 76). With this method it is necessary to have a second height-measure exactly similar to the first.

Proceed then in this way:—

Let us suppose that we wish to fix a point in the middle of the body of the horse on the model; place one of the height-measures opposite the point; with the measuring-stick applied at right angles, the height of the point is obtained; the distance which separates the point from the inner edge of the height-measure given on the measuring-stick is its depth; then the distance is obtained by placing the measuring-stick on the

point and applying it against the other height-measure which is on the posterior aspect of the chassis.

The two height-measures of the enlargement are then placed on the upper frame of the large chassis, at the corresponding numbers to those of the small chassis of the model, and to fix the point one proceeds in the same way as one has just done for the model. This does not prevent establishing the horizontal lines, as in the other method; once these horizontal lines are traced on the clay, there will only remain two measurements to take, the distance and the depth.

In the case of the lower frame of the chassis of the small model, it will be nailed to the extremity of the four uprights, before fixing them to the stand, proceeding in the same way with the plumb-lines as for the enlargement, so as to be sure that it is perfectly in line beneath the upper part (Fig. 75).

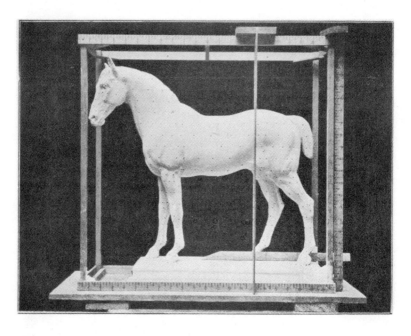

Fig. 75.—To Exemplify the Alternate Method of Pointing.

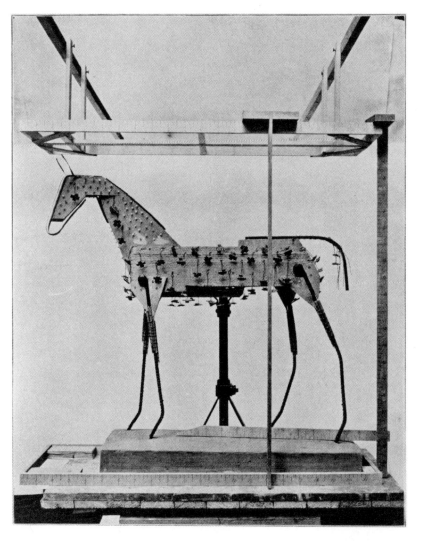

FIG. 76.—TO EXEMPLIFY ALTERNATE METHOD OF POINTING.

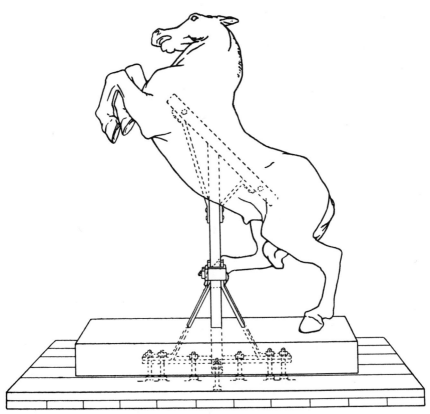

FIG. 77.—MODEL OF THE IRON FOR AN ARMATURE OF A REARING HORSE.

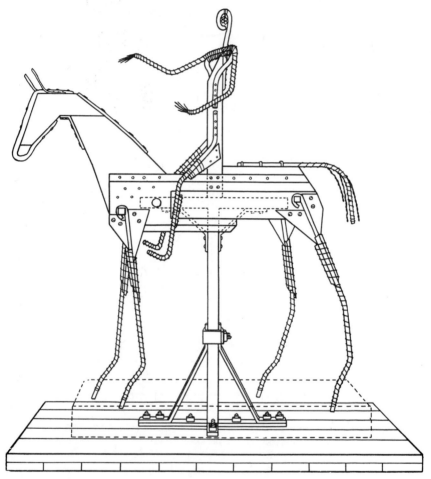

Fig. 78.—Model for Armature of Equestrian Statue.

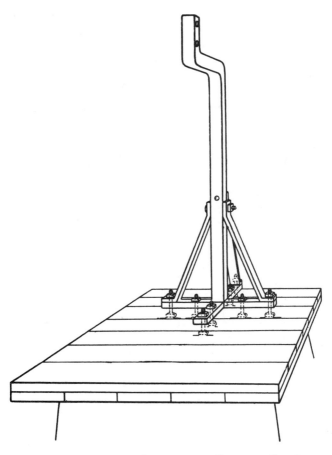

Fig. 79.—Model for Armature of Standing Statue.

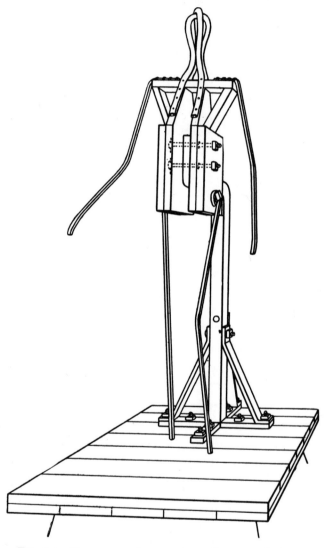

FIG. 80.—MODEL FOR ARMATURE OF STANDING STATUE.

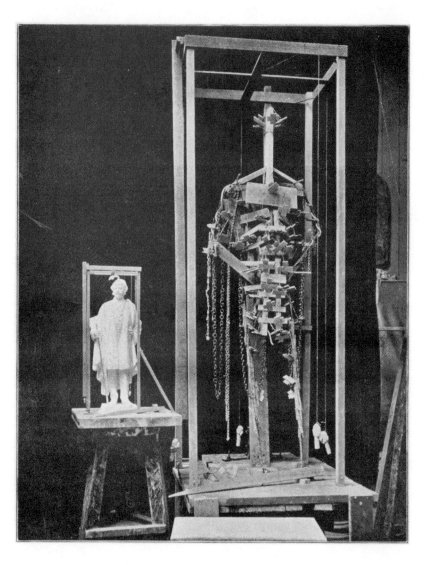

FIG. 81.—PHOTO. FROM A **COMPLETE ARMATURE** FOR A **LARGE STATUE**.

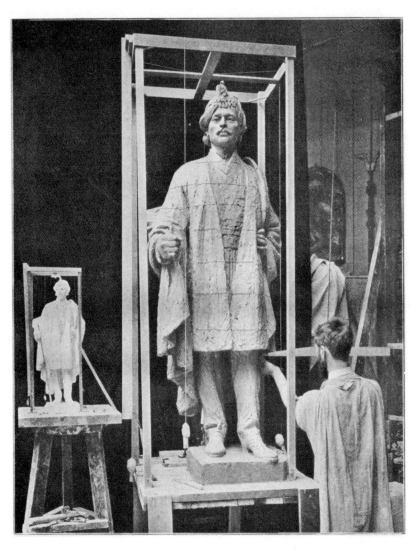

Fig. 82.—Photo showing a Large Statue being Pointed.

CHAPTER XIII

POINTING A RELIEF

THE pointing of a relief can be done in absolutely the same way as that of a figure in the round. If a sketch is made one-quarter of the proposed figure, as in the case of the horse, this sketch must be carried very forward and, once moulded in plaster, should be fixed on a stand, care being taken to see from the side that it is placed quite vertically.

Fix on the top of this sketch a piece of board of the same length, but with a width of 1 inch over the highest projection of the relief. Divide the front border of this piece of board into inches, half-inches, etc., as done for the implements used in the enlargement of the horse. Fix two or three nails in the upper surface of this piece of board, one in the centre and one at each extremity to fit the plumb-lines to, which will fall over the front of the relief. Do the same for the enlargement on a scale four times larger, if the sketch is quarter-size; five times larger if the sketch is $\frac{1}{5}$, etc. Use similar implements and in the same way as used for the horse, that is height-measures and measuring-sticks.

Take first the height of a point, secondly the distance to

the plumb-line placed at one of the extremities of the plank, and thirdly the depth from the plumb-line placed opposite the point (Fig. 83). Transpose these measurements on the enlargement. It is thus easy to trace horizontal lines across the relief, on which dots will be marked at the necessary places, so as to avoid taking the height at each point (Fig. 83).

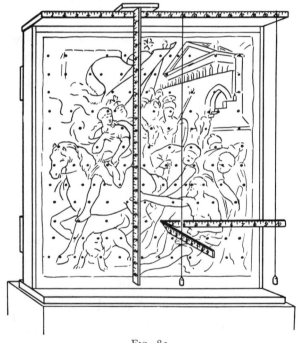

Fig. 83.

As in the case of the horse one may proceed by a second method in which the plumb-lines need not be used and the

height-measure is all that is required. This is done by adding a board to the base of the relief, similar to the one above it. This second board must be divided into inches, etc., like the first, so that the numbers on each correspond exactly ; that is to say, that if the string is placed on the central number of the top board, $10\frac{1}{2}$, it must fall just on the $10\frac{1}{2}$ on the lower board. It is also necessary to assure oneself by a side view that both boards have exactly the same projection ; for this to be so, the string must touch the lower board while remaining vertical.

This done, place the height measure on the board of the sketch at a given number, let us say 4 ; this measure keeping

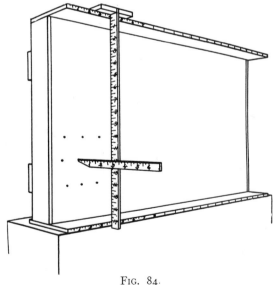

the vertical must touch the corresponding number 4 on the lower board. Take next with a measuring-stick the height of the point to be fixed, and, keeping the measuring-stick at a right angle with the height-measure, not only

Fig. 84.

will the height be obtained, but also the distance, and by observing on the measuring-stick at what number the inner edge of the height-measure passes, the depth will be determined. Proceeding thus, much time is gained, and by doing it with great care, a correct pointing is obtained (Fig. 84).

CHAPTER XIV

ON THE SCULPTURAL PRESENTMENT OF ANIMALS IN GENERAL

NOWADAYS, contrary to the practice of the old Egyptians, animals in sculpture are treated more after the manner of portraits, and details occupy a place of great importance. Instead of the grandiose, laconic and solemn art, which passing with ease from the great masses to the great planes, modelled the forms in a summary manner, giving only their essence, we frequently see sculptures in which the execution presents more research, more colour, and which seek to express the asperities of the hide, the details of the manes, the roughness of the hairs, the markings of the coat, etc.

It must be admitted that this determination to seek external reality, carried out with discernment and tact, may add to the force of the image and enhance its expression, but only when the artist subjects detail to the essential and strongly graven lines of the figure, and knows how to make one feel, under the living details, the construction of the animal, the free play of the muscles. That great master in the rendering of

animals, Barye, did this admirably. There the interest of the practical work allows the triumph of the sculptural silhouette and of the muscular suppleness ; the surface remains large, because it remains simple notwithstanding all the shades of the execution.

But, if this system be exaggerated, it becomes unsuitable to monumental art, because it is contrary to the part which sculpture should play in the decoration of buildings. To fit in with the stability of architecture, statuary in general must, first of all, choose lasting attitudes, have firmly established lines, so as not to clash with the majestic immobility of a great building by a too literal imitation of life, which suscitates the idea of movement and can only lessen monumental dignity. How poor would be the effect, in a decorative motive representing the horses of the Sun or those of Neptune, if the sculptor kept to a servile imitation of the details of nature, instead of giving to his work a still greater character than that which he finds in the living individuals, instead of adding some supernatural touches.

However, this does not mean that even here the sincere study of nature may be neglected, on the contrary it is only by a thorough knowledge of the composition of the individual that we shall be able to amplify the personality, and it is almost by an unconscious process that we shall make those modifications which will differentiate the work of art from

the work of nature. I cannot insist too much on the great sincerity which we must have when we seek to understand nature, whatever it may be, and on the necessity of utilising every possible means in our possession to help us to make our copy a faithful one.

The compass is of the greatest help, but it is necessary to learn how to use it. It is not everyone who knows how to measure and sometimes, with the best of intentions, one makes mistakes through inexperience and often also, as I have observed in the case of students, through a certain self-complacency.

Osteology will help us to understand the construction and myology the movement of the forms; however, it is certain that if this knowledge were to beget mannerisms, if under pretence that these things exist in reality, one were to show them such as dissection reveals them, and not with that variety of character which is infinite, it would be necessary to mistrust it. But understood as a means of accounting for the organism, this knowledge is indispensable to whoever seeks to represent living beings. It can never be useless to understand thoroughly what one sees and what one does; this is not contrary to that "naïveté," which must not be confounded with ignorance.

Albert Dürer gives the following advice to one of his students :—

"Apply thyself to observe Nature, allow thyself to be guided by it and be not led away from it to follow thine own good will, imagining that thou wilt find better thyself. For then thou wilt go astray. In truth, art has its roots in nature, he who seeks them there, there will he find them."

And he has said further :—

"Thou wilt guard thyself from thinking to make something more perfect than the work which God hath made."

For all work done with such an aim will be without strength and without vigour, and we may assert that none can express beauty through his own sense and through his thoughts alone, and it is necessary that this beauty, which he will think he draws from within himself, shall have been beforehand put there by the study and a diligent and careful imitation of nature.

Sir Joshua Reynolds says :—

"The study of nature is the beginning and the end of the theory of art; it is in nature alone that it is possible to find that beauty which is the great object of the painter, and which cannot be looked for elsewhere. It is as impossible to conceive the idea of beauty superior to that which is presented by nature, as it is to conceive that of a sixth sense, or of any other perfection beyond the bearing of the human mind."

"Nature is and always will be," he says again in one of his lectures on painting, "the inexhaustible spring to which all perfections must owe their origin."

Ingres, the great painter, tells us :—

"It is by truth that the great secret of beauty is to be attained."

Carpeaux, one of the greatest French sculptors, whose personality in art is so characteristic, said to one of his pupils :—

"Let Nature be your constant guide, live with it, study it unremittingly ; make not a stroke with the pencil, give not a touch with the modelling tool without having it before your eyes ; it alone gives life."

Among all animals, the lion by the firmness of its outlines, its decided and strong planes, is certainly one which the best lends itself to decorative art, and it is employed thus more often than otherwise. Its forms are so typical and accentuated, that they leave to the sculptor a certain latitude for exaggeration, without disfiguring, but on the contrary accentuating the character. Animals are all the more susceptible to be idealised by style that they are the more savage. I repeat it, those that we have at all times under our eyes, which are associated with our everyday life, demand a more intimate observation and more charm in the execution. But this exaggeration or amplification can never be but an insistence on typical points, which, seen from a certain distance, convey the grand effect of nature.

CHAPTER XV

THE lion has an imposing presence and a bold gaze, a proud bearing and a terrible voice. Its size is not excessive, as that of the hippopotamus, nor too thick-set, as that of the bear ; but is on the contrary so well-proportioned that the body of the lion appears to be the model of strength joined to agility, as firm as it is nervous, being neither overweighted with flesh, nor blurred with fat, and there is nothing super-abundant about it—it is all nerve and muscle. This great muscular strength finds outward expression in prodigious bounds and jumps, which the animal makes with the greatest ease ; in the rapid sweeping movements of its tail, a blow of which is strong enough to throw a man to the ground ; in the ease with which it moves the skin of its face, which adds greatly to its particular physiognomy or rather to the expression of its fury, and lastly in the faculty it has of causing its mane to move, which not only stands up, but which is agitated in all senses when the animal's anger is roused.

The lion's mane covers all the anterior part of the body; the hairs of its mane are fairly soft and smooth like those of the rest of the body and grow in length as the animal advances in age. These long hairs are always absent in the lioness.

The lion walks with great dignity—his step is well stretched out and his feet glide on the surface of the ground. In walking the claws are retracted and the animal bears only on the pads under its feet which gives that effect of silent softness to its progress. Cumming, in his *Hunter's Life*, says :—

" There is something so noble and imposing in the presence of the lion, when seen walking free and undaunted on his native soil, that no description can convey an adequate idea of his striking appearance."

When he has approached his prey he crouches on his belly and then springs on it with such force that he nearly always seizes it at the first bound. The movement is almost exactly that of the cat, and I have often used the latter to find a particular movement, or to prepare myself to see it, in the lion.

A large lion measures about twelve feet from the nose to the end of the tail and is generally considerably under four feet in height. Denham mentions the skin of a lion sent to him by a Sheikh " measuring from the tail to the nose fourteen feet

two inches." The lion being of nocturnal habits, its vision is keener at night than in the daylight and "their eyes, in a dark night, glow like two balls of fire" (Cumming). The tail of the lion is fairly long and terminated by a tuft of hair, which, like the mane, is only fully developed when the animal reaches the age of seven. Lions may live to a considerable age and have been known, in captivity, to reach the full three score years and ten.

There are two principal varieties of lion, the African and the Asiatic; the former being the larger and more ferocious.

The study of the lion is in no way so easy as that of domestic animals; the best way is to make a number of sketches from nature until one is familiar with the forms and then with the movements, studying afterwards the proportions and the anatomy. It is necessary to proceed in this study as in that of young children, who cannot be expected to sit, that is, to make frequent drawings of them, observing the different attitudes which are familiar to them, in a word, to penetrate oneself with all that is characteristic of them, and thus become enabled gradually to complete by intuition that which has escaped observation. Nowadays we can make instantaneous photographs which are of the greatest help, as they show exactly what is natural in the movement, and we are free to accentuate it. As I say at the beginning of this volume, in

making a lion, it is not generally our aim to represent such or such an individual, but to strike the eye with the essence of the characteristic points of the animal.

It is also well, before beginning to work from nature, to copy some of these animals made by the eminent sculptor Barye, who better than anyone in this branch of art has known how to be great and true. Casts of his works can be easily obtained, and from these plaster models it will be easy to study the construction and proportions, which in them are always perfect, and at the same time the firm treatment of the great flat surfaces and of the drawing which is so strong and yet so true.

The treatment of the representation of the lion from the decorative point of view was well understood by our great sculptor Stevens. We all know that lion of small proportions, but so great in character, which he made for the British Museum; in it he has put all the characteristic points in a very simplified form, and this lion alive would be even more imposing than nature itself.

CHAPTER XVI

THE principle of the armature for a lion is absolutely the same as that set forth for the horse, but, however, in a different proportion as the height and length of the animal are smaller. The iron support for a life-size lion should measure from the base to the horizontal branch three feet, and the length of the horizontal branch may be two feet. This iron will be fixed to the plinth by four branches, screwed firmly as previously described.

If the fore paws are to repose on a higher plane than the hind ones, the horizontal branch must be necessarily inclined according to the position of the body. The remainder of the armature is in every way similar to that of the horse, and this principle is applicable to all the quadrupeds. (Fig. 85. Completed armature for a life-size lion.)

What I have to say as to the beginning of the work on a lion can only be a repetition of what I have said already for

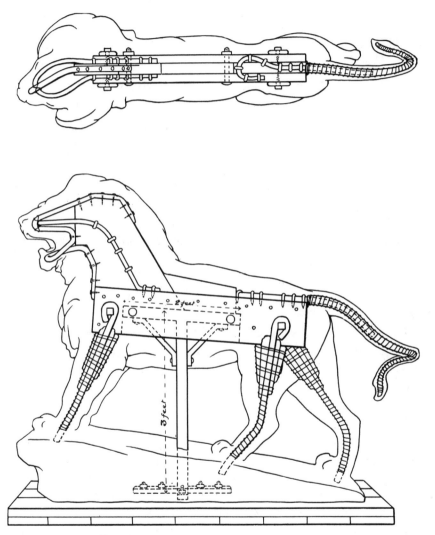

Fig. 85.—Armature for a Life-size Lion.

the human figure and for the horse; I shall therefore make these remarks as brief as possible.

For the sketch, first of all place the armature *exactly* according to the attitude desired, using as principal guide the line of the vertebral column seen from above; afterwards by a side view the lead-tubing for the legs will be placed in position.

The armature having been given the proper movement, surround it with a certain quantity of clay and indicate boldly the large planes, which allow of a better judgment of their relations.

This done fix the proportions and the points for the construction (Fig. 86).

As it is impossible to take measurements on a lion (this being only possible on a dead animal), the comparative measurements which I give further on may be used and will be found reliable; they are those employed by an artist, such as Barye, for whom this subject had no secrets. As in the case of the horse take the head as a guide for the other proportions.

If we propose to make a lion measuring 6 feet 3 inches from the tip of the nose to the root of the tail, in an attitude of stillness, when the two front legs are close together and also the two hind legs, when the head and neck are almost on a horizontal plane with the line of the back, the length of the

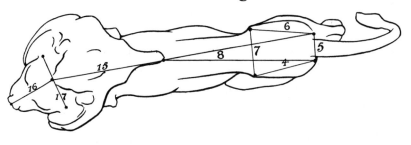

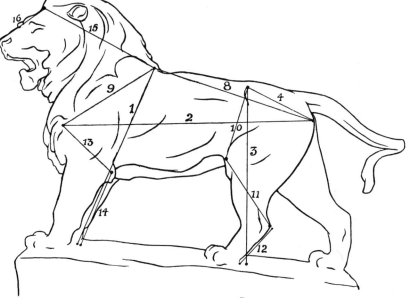

FIG. 86.—MEASUREMENTS OF CONSTRUCTION.

1. Plinth to top of shoulders.
2. Point of arm to point of buttock.
3. Plinth to anterior iliac.
4. Anterior iliac to point of buttock.
5. Between points of buttocks.
6. Point of buttock to anterior iliac.
7. Between anterior iliacs.
8. Point of buttock to top of shoulder.
9. Point of shoulder to point of arm.
10. Anterior iliac and patella.
11. Patella to calcaneum.
12. Calcaneum to plinth.
13. Point of arm to elbow.
14. Elbow to plinth.
15. Point of shoulders to root of mane.
16. Length of face.
17. Width of cheek bones.

body from the head of the humerus to the extreme point of the buttock should be 4 feet 4 inches ; this length being equal to three heads. Divide 4 feet 4 inches by 3, which gives 17 inches for the length of the head from the point of the nose to the top of the skull ; this measurement, 17 inches, will be used to find all the other measurements for the different parts of the lion.

This measurement of 17 inches found, establish a scale in the following manner ; trace an horizontal line 4 feet 4 inches

HEAD 1 ¾ ½ ¼ O 1 HEAD 2

FIG. 87.

in length (length from the head of the humerus to the root of the tail) and divide this line into three parts of 17 inches each, then in halves, quarters and eighths (Fig. 87).

If we allow for the body 4 feet 4 inches, in allowing 6 inches for the neck and 17 inches for the head, this makes a total of 6 feet 3 inches.

The photograph of the first stage (Figs. 88 and 88a) and the diagram (Fig. 86) show the first measurements to be taken, which are indicated on the photograph by white dots and in the diagram (Fig. 86) in the order in which they should be taken.

If a first sketch is to be made of, let us say, a quarter

FIG. 88.—PHOTO OF FIRST STAGE.

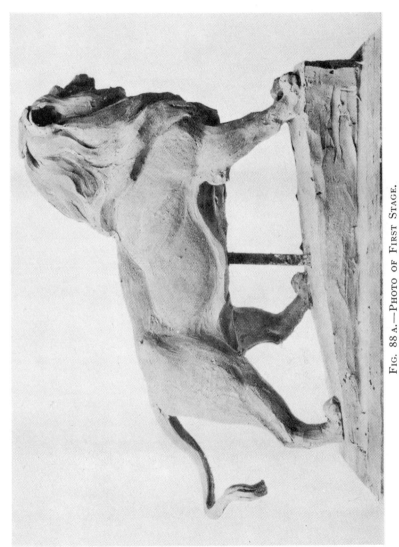

FIG. 88 A.—PHOTO OF FIRST STAGE.

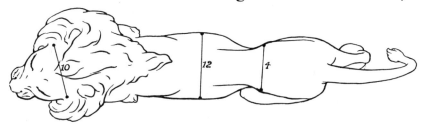

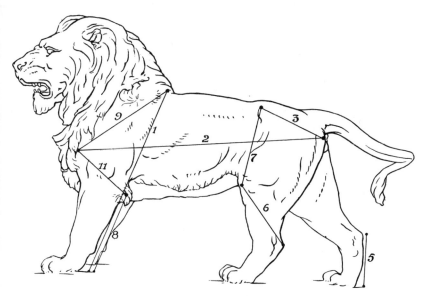

FIG. 89.—COMPARATIVE MEASUREMENTS.

1. From the plinth to the top of the shoulder, $2\frac{1}{2}$ heads.
2. From the head of the humerus to the root of the tail (point of buttock), 3 heads.
3. From the point of the buttock to the external spine of the iliac, $\frac{7}{8}$ of a head.
4. Between the two external spines of iliacs, $\frac{1}{2}$ a head.
5. From the plinth to the calcaneum, $\frac{3}{4}$ of a head.
6. From the calcaneum to beneath the patella, 1 head.
7. From the patella to the point of the external spine of the iliac, 1 head. (This measurement depends on the movement of the leg, and may be much longer if the leg is stretched backwards.)
8. Fore legs: from the plinth to the olecranon process, 1 head.
9. From the point of the shoulder to the head of the humerus, 1 head. (Here, again if the leg is carried backwards the distance may be a little longer.)
10. Width of the head at the level of the eyes, $\frac{2}{3}$ of a head.
11. From the head of the humerus to the olecranon process, nearly 1 head.
12. The greatest thickness of the thorax, about $\frac{2}{3}$ of a head.
13. The length of the tail is about 2 feet 9 inches.

nature, divide the 4 feet 4 inches (length of the body, natural size) by 4, which gives 1 foot 1 inch, from the head of the humerus to the root of the tail. Divide this line as has been done for the larger scale into 3 ; this third will give the size of the head reduced to a quarter, that is 5 inches $\frac{5}{8}$, a little full. Having divided the horizontal line into three, then these in half, quarters and eighths, use this scale in the same way as for the full size animal.

The measurements should be fixed by means of pegs as in the preceding studies.

When all these measurements have been taken and fixed with care, work by bold outlines on the large planes, avoiding the details, as indicated in Figs. 88, 88a.

The second stage shows the rendering of the anatomy ; the drawing being the guide to find the form, and at the same time the character and volume. It nearly always happens that the indication of the muscular forms and their movements renders the great planes more uncertain ; so that as the work is pushed forwards it is necessary to apply oneself to group all the details into large masses, being careful to observe their relative proportions (Fig. 90, second stage).

In the making of a large lion for decorative purpose, I think it is preferable to make the proportions of width larger

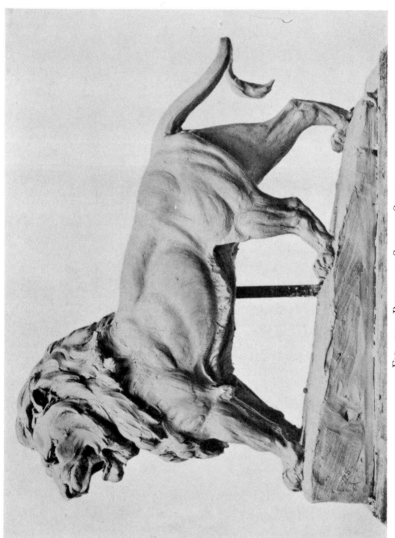

FIG. 90.—PHOTO OF SECOND STAGE.

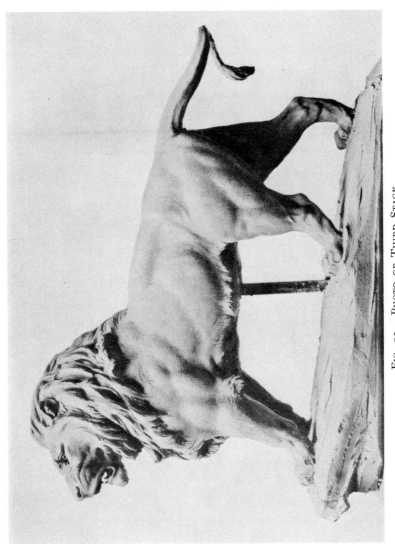

Fig. 91.—Photo of Third Stage.

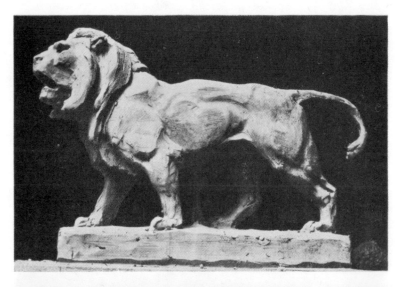

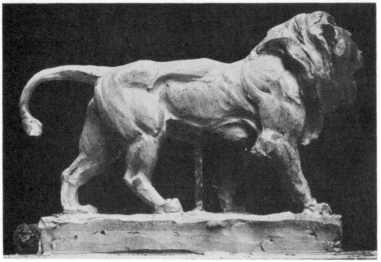

Fig. 92.—A Different Attitude in the First Stage.

than those given by nature ; one may allow instead of half a head between the two iliacs, nearly $\frac{3}{4}$ of a head, and for the width of the thorax in proportion. This will only add to the strength of the sculptural effect without losing in truthfulness. The proportions of length must remain the same (Fig. 91, third stage).

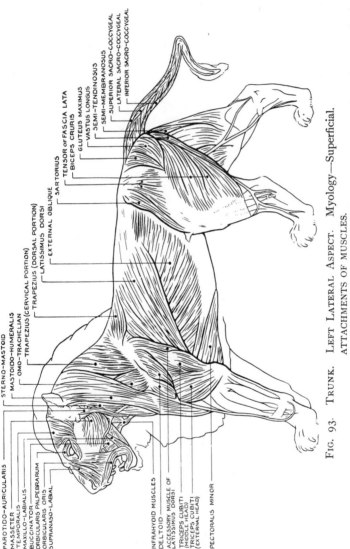

FIG. 93. TRUNK. LEFT LATERAL ASPECT. Myology—Superficial.

ATTACHMENTS OF MUSCLES.

INFRAHYOID MUSCLES (origin) sternum : (insertion) thyroid cartilage and hyoid bone. DELTOID (o.) one part from spine of scapula, the other from the acromion process : (i.) humerus. ACCESSORY MUSCLE OF LATISSIMUS DORSI (o.) from tendon of latissimus dorsi : (i.) olecranon process, and aponeurosis of leg. TRICEPS CUBITI (middle or long head) (o.) posterior border of scapula : (i.) olecranon process. TRICEPS CUBITI (external head) (o.) humerus : (i.) olecranon process. PECTORALIS MINOR (o.) abdominal aponeurosis and posterior part of sternum : (i.) humerus. STERNO-MASTOID (o.) anterior extremity of sternum : (i.) mastoid process of skull. MASTOIDO-HUMERALIS (o.) posterior part of skull, and superior cervical ligament : (i.) humerus. OMO-TRACHELIAN (o.) atlas, and skull : (i.) spine of scapula. TRAPEZIUS (cervical portion) (o.) superior cervical ligament : (i.) spine of scapula. TRAPEZIUS (dorsal portion) (o.) spines of foremost dorsal vertebræ : (i.) spine of scapula. LATISSIMUS DORSI

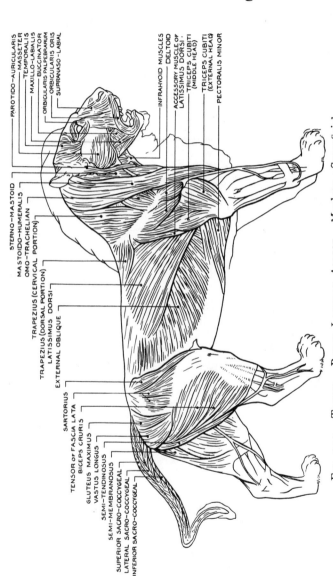

FIG. 93 A.—TRUNK. RIGHT LATERAL ASPECT. Myology—Superficial.

(o.) by aponeurosis from spinous processes of last dorsal vertebræ and lumbar vertebræ, and from ribs : (i.) humerus. EXTERNAL OBLIQUE (o.) by digitations from the eight or nine posterior ribs, and from the aponeurosis of back : (i.) abdominal aponeurosis. SARTORIUS (patellar portion) (o.) anterior iliac spine : (i.) patella. TENSOR of FASCIA LATA (o.) anterior iliac spine : (i.) by aponeurosis into patella and blends with aponeurosis of leg. BICEPS CRURIS (o.) tuberosity of ischium and ligament of sacrum : (i.) by aponeurosis covering leg, and attached to crest of tibia. GLUTEUS MAXIMUS (o.) sacrum and aponeurosis covering the gluteus medius : (i.) great trochanter of femur. VASTUS LONGUS (o.) first few occygeal vertebræ : (i.) femur, and by tendon into patella. SEMI-TENDINOSUS (o.) tuberosity of ischium : (i.) blends with aponeurosis of leg—crosses internal surface of tibia and inserted into its anterior border. SEMI-MEMBRANOSUS (posterior part) (o.) inferior surface of ischium : (i.) internal tuberosity of tibia. The SACRO-COCCYGEAL muscles arise from the sacrum and iliac bone, and are inserted into the coccygeal vertebræ.

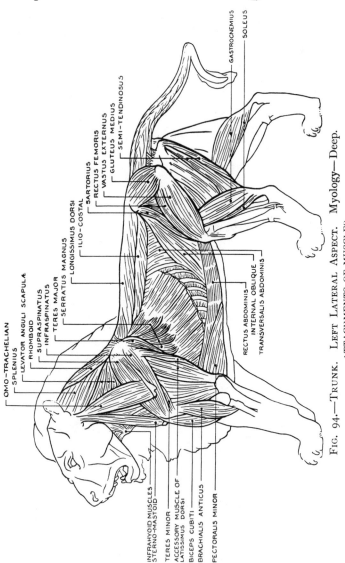

FIG. 94.—TRUNK. LEFT LATERAL ASPECT. Myology—Deep.
ATTACHMENTS OF MUSCLES.

INFRAHYOID MUSCLES (origin) sternum : (insertion) thyroid cartilage and hyoid bone. STERNO-MASTOID (o.) anterior extremity of sternum : (i.) mastoid process of skull. TERES MINOR (o.) scapula : (i.) humerus. ACCESSORY MUSCLE OF LATISSIMUS DORSI (o.) from tendon of latissimus dorsi : (i.) olecranon process and aponeurosis of leg. BICEPS CUBITI (o.) inferior extremity of scapula : (i.) radius. BRACHIALIS ANTICUS (o.) humerus : (i.) radius, and ulna. PECTORALIS MINOR (o.) abdominal aponeurosis and posterior part of sternum : (i.) humerus. OMO-TRACHELIAN (o.) atlas, and skull : (i.) spine of scapula. SPLENIUS (o.) superior cervical ligament and foremost dorsal vertebræ: (i.) atlas, axis, and mastoid crest. LEVATOR ANGULI SCAPULÆ (o.) lower cervical vertebræ : (i.) spinal border of scapula. RHOMBOID (o.) superior cervical ligament and foremost dorsal vertebræ: (i.) scapula. SUPRASPINATUS (o.) scapula : (i.) humerus.

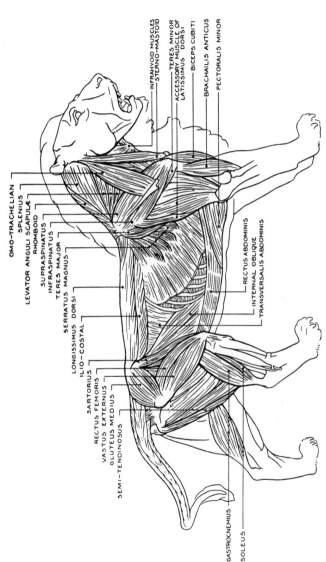

OMO-TRACHELIAN
SPLENIUS
LEVATOR ANGULI SCAPULÆ
RHOMBOID
SUPRASPINATUS
INFRASPINATUS
TERES MAJOR
SERRATUS MAGNUS
LONGISSIMUS DORSI
ILIO-COSTAL
SARTORIUS
RECTUS FEMORIS
VASTUS EXTERNUS
GLUTEUS MEDIUS
SEMI-TENDINOSUS

GASTROCNEMIUS
SOLEUS

INFRAHYOID MUSCLES
STERNO-MASTOID
TERES MINOR
ACCESSORY MUSCLE OF LATISSIMUS DORSI
BICEPS CUBITI
BRACHIALIS ANTICUS
PECTORALIS MINOR

RECTUS ABDOMINIS
INTERNAL OBLIQUE
TRANSVERSALIS ABDOMINIS

FIG. 94 A.—TRUNK. RIGHT LATERAL ASPECT. Myology.—Deep.

INFRASPINATUS (o.) scapula : (i.) humerus. TERES MAJOR (o.) scapula : (i.) humerus. SERRATUS MAGNUS (o.) first eight ribs (i.) scapula. LONGISSIMUS DORSI (o.) spinous processes of lumbar vertebræ and sacrum : (i.) transverse processes of lumbar vertebræ, ribs, and cervical vertebræ. ILIO-COSTAL (o.) sacrum, and lumbar vertebræ : (i.) ribs. SARTORIUS (o.) anterior iliac spine, and inferior border of ilium : (i.) patella, and tibia. RECTUS FEMORIS (triceps cruris) (o.) iliac bone : (i.) patella. VASTUS EXTERNUS (triceps cruris) (o.) femur : (i.) tendon of rectus femoris, and patella. GLUTEUS MEDIUS (o.) iliac crest (i.) great trochanter of femur. SEMI-TENDINOSUS (o.) tuberosity of ischium : (i.) aponeurosis of leg, and tibia. GASTROCNEMIUS (o.) shaft of femur : (i.) by tendo-Achillis into calcaneum. SOLEUS (o.) external tuberosity of tibia : (i.) tendon of gastrocnemius. RECTUS ABDOMINIS stretches from the ilium to the thorax. INTERNAL OBLIQUE (o.) anterior iliac spine and crest : (i.) costal cartilages and abdominal aponeurosis. TRANSVERSALIS ABDOMINIS (o.) transverse processes of lumbar vertebræ, and last costal cartilages : (i.) abdominal aponeurosis.

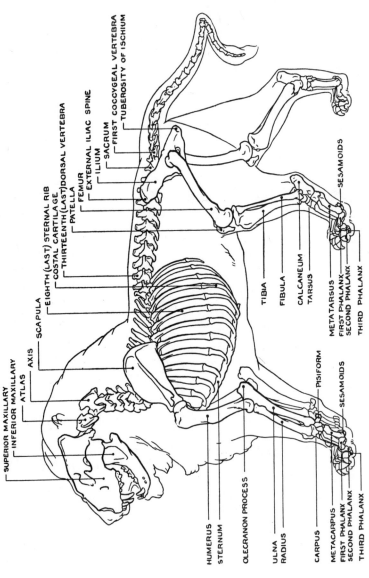

FIG. 95.—LEFT LATERAL ASPECT. Osteology.

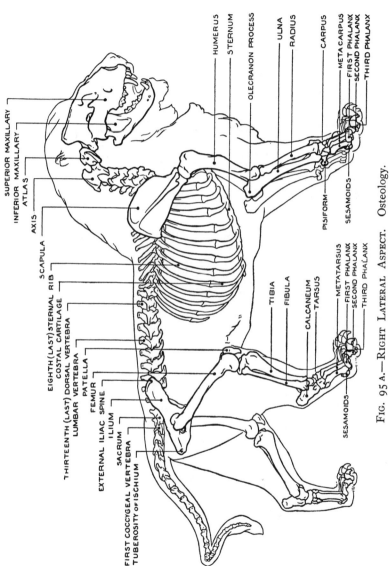

FIG. 95 A.—RIGHT LATERAL ASPECT. Osteology.

SUPERIOR MAXILLARY
INFERIOR MAXILLARY
ATLAS
AXIS
SCAPULA
EIGHTH (LAST) STERNAL RIB
COSTAL CARTILAGE
THIRTEENTH (LAST) DORSAL VERTEBRA
LUMBAR VERTEBRA
PATELLA
FEMUR
EXTERNAL ILIAC SPINE
ILIUM
SACRUM
FIRST COCCYGEAL VERTEBRA
TUBEROSITY of ISCHIUM

HUMERUS
STERNUM
OLECRANON PROCESS
ULNA
RADIUS
CARPUS
METACARPUS
FIRST PHALANX
SECOND PHALANX
THIRD PHALANX
PISIFORM
SESAMOIDS

TIBIA
FIBULA
CALCANEUM
TARSUS
METATARSUS
FIRST PHALANX
SECOND PHALANX
THIRD PHALANX
SESAMOIDS

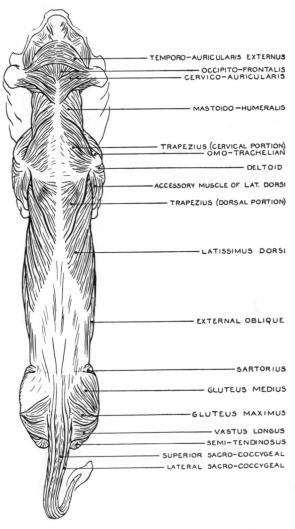

FIG. 96.—TRUNK. SUPERIOR ASPECT. Myology.

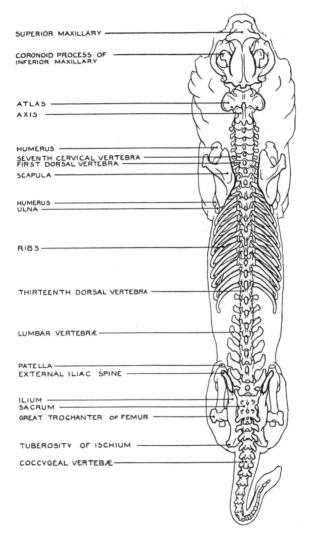

SUPERIOR MAXILLARY

CORONOID PROCESS OF
INFERIOR MAXILLARY

ATLAS
AXIS

HUMERUS
SEVENTH CERVICAL VERTEBRA
FIRST DORSAL VERTEBRA
SCAPULA

HUMERUS
ULNA

RIBS

THIRTEENTH DORSAL VERTEBRA

LUMBAR VERTEBRÆ

PATELLA
EXTERNAL ILIAC SPINE

ILIUM
SACRUM
GREAT TROCHANTER OF FEMUR

TUBEROSITY OF ISCHIUM

COCCYGEAL VERTEBÆ

FIG. 97.—TRUNK. SUPERIOR ASPECT. Osteology.

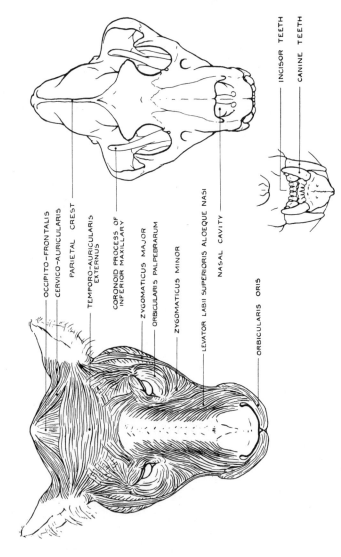

INCISOR TEETH

CANINE TEETH

OCCIPITO-FRONTALIS

CERVICO-AURICULARIS

PARIETAL CREST

TEMPORO-AURICULARIS EXTERNUS

CORONOID PROCESS OF INFERIOR MAXILLARY

ZYGOMATICUS MAJOR

ORBICULARIS PALPEBRARUM

ZYGOMATICUS MINOR

LEVATOR LABII SUPERIORIS ALOEQUE NASI

NASAL CAVITY

ORBICULARIS ORIS

FIG. 98.—HEAD. ANTERIOR ASPECT.

ATTACHMENTS OF MUSCLES (Fig. 98. Head).

OCCIPITO-FRONTALIS (origin) occipital protuberance : (insertion) blends with muscles above orbits. CERVICO-AURICULARIS (o.) superior cervical ligament : (i.) ears. TEMPORO-AURICULARIS EXTERNUS (o.) parietal crest : (i.) scutiform cartilage and inner side of ear. ZYGOMATICUS MAJOR (o.) scutiform cartilage at base of ear : (i.) commissure of lips. ORBICULARIS PALPEBRARUM surrounds orifice of eyes. ZYGOMATICUS MINOR (o.) malar bone : (i.) muscles surrounding lips. LEVATOR LABII SUPERIORIS ALOEQUE NASI (supranaso-labial) frontal and nasal bones : (i.) upper lip, and wing of nose. ORBICULARIS ORIS surrounds mouth and blends with muscles of that region.

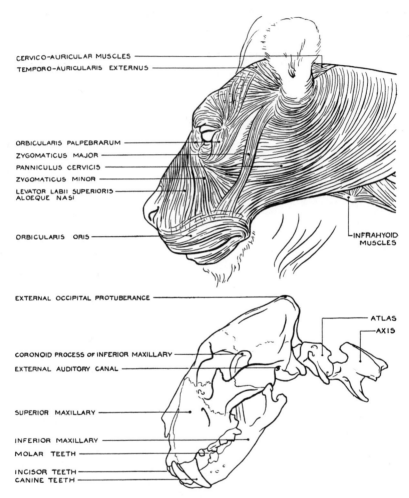

CERVICO-AURICULAR MUSCLES

TEMPORO-AURICULARIS EXTERNUS

ORBICULARIS PALPEBRARUM

ZYGOMATICUS MAJOR

PANNICULUS CERVICIS

ZYGOMATICUS MINOR

LEVATOR LABII SUPERIORIS
ALOEQUE NASI

ORBICULARIS ORIS

INFRAHYOID
MUSCLES

EXTERNAL OCCIPITAL PROTUBERANCE

ATLAS

AXIS

CORONOID PROCESS OF INFERIOR MAXILLARY

EXTERNAL AUDITORY CANAL

SUPERIOR MAXILLARY

INFERIOR MAXILLARY

MOLAR TEETH

INCISOR TEETH

CANINE TEETH

FIG. 99.—HEAD. LEFT LATERAL ASPECT

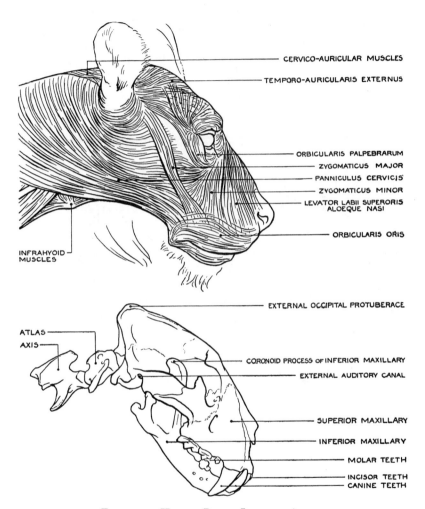

CERVICO-AURICULAR MUSCLES

TEMPORO-AURICULARIS EXTERNUS

ORBICULARIS PALPEBRARUM
ZYGOMATICUS MAJOR
PANNICULUS CERVICIS
ZYGOMATICUS MINOR
LEVATOR LABII SUPERORIS
ALOEQUE NASI

ORBICULARIS ORIS

INFRAHYOID
MUSCLES

EXTERNAL OCCIPITAL PROTUBERACE

ATLAS
AXIS

CORONOID PROCESS OF INFERIOR MAXILLARY
EXTERNAL AUDITORY CANAL

SUPERIOR MAXILLARY

INFERIOR MAXILLARY

MOLAR TEETH

INCISOR TEETH
CANINE TEETH

FIG. 99 A.—HEAD. RIGHT LATERAL ASPECT.

LEFT RIGHT

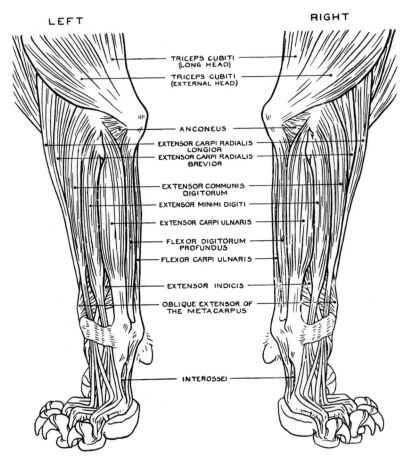

TRICEPS CUBITI
(LONG HEAD)

TRICEPS CUBITI
(EXTERNAL HEAD)

ANCONEUS

EXTENSOR CARPI RADIALIS
LONGIOR

EXTENSOR CARPI RADIALIS
BREVIOR

EXTENSOR COMMUNIS
DIGITORUM

EXTENSOR MINIMI DIGITI

EXTENSOR CARPI ULNARIS

FLEXOR DIGITORUM
PROFUNDUS

FLEXOR CARPI ULNARIS

EXTENSOR INDICIS

OBLIQUE EXTENSOR OF
THE METACARPUS

INTEROSSEI

FIG. 100.—FORE-LEG. EXTERNAL ASPECT. Myology.

ATTACHMENTS OF MUSCLES.

TRICEPS CUBITI (long head) (origin) scapula : (insertion) olecranon process. TRICEPS CUBITI (external head) (o.) humerus : (i.) olecranon process. ANCONEUS (o.) humerus : (i.) olecranon process. EXTENSOR CARPI RADIALIS LONGIOR and BREVIOR (o.) humerus : (i.) metacarpus. EXTENSOR COMMUNIS DIGITORUM (o.) external condyle of humerus : (i.) by four tendons into the second and third phalanges of the four external digits. EXTENSOR MINIMI DIGITI (o.) external condyle of humerus : (i.) by four tendons (passing under those of ext. com.

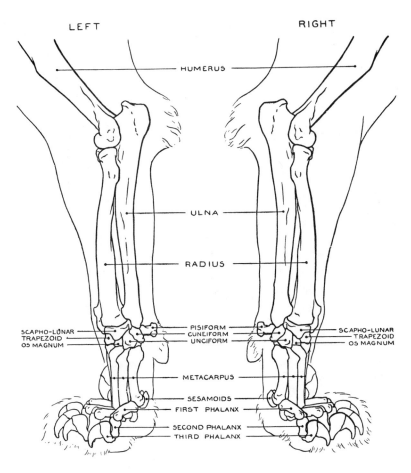

FIG. 101.—FORE-LEG. EXTERNAL ASPECT. Osteology.

dig.) into the four external digits. EXTENSOR CARPI ULNARIS (posterior ulnar) (o.) external condyle of humerus : (i.) external metacarpal. FLEXOR DIGITORUM PROFUNDUS (o.) shaft of ulna : (i.) by five tendons into the posterior surfaces of the five digits. FLEXOR CARPI ULNARIS (anterior ulnar) (o.) olecranon process, and internal condyle of humerus : (i.) pisiform bone. EXTENSOR INDICIS (o.) radius and ulna : (i.) by two tendons into the two internal digits. OBLIQUE EXTENSOR OF THE METACARPUS (o.) radius and ulna : (i.) metacarpal of internal digit (thumb). INTEROSSEI (o.) metacarpal bones : (i.) phalanges.

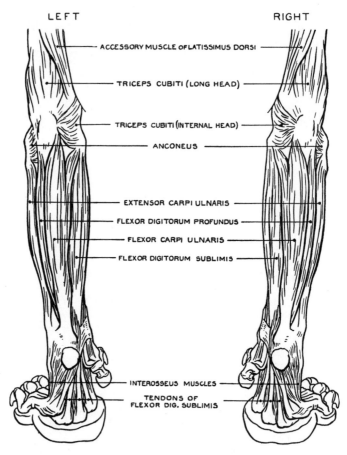

LEFT RIGHT

ACCESSORY MUSCLE OF LATISSIMUS DORSI

TRICEPS CUBITI (LONG HEAD)

TRICEPS CUBITI (INTERNAL HEAD)

ANCONEUS

EXTENSOR CARPI ULNARIS

FLEXOR DIGITORUM PROFUNDUS

FLEXOR CARPI ULNARIS

FLEXOR DIGITORUM SUBLIMIS

INTEROSSEUS MUSCLES

TENDONS OF
FLEXOR DIG. SUBLIMIS

FIG. 102.—FORE-LEG. POSTERIOR ASPECT. Myology.

ATTACHMENTS OF MUSCLES.

ACCESSORY MUSCLE OF LATISSIMUS DORSI (origin) from tendon of latissimus dorsi : (insertion) olecranon process, and aponeurosis of leg. TRICEPS CUBITI (long head) (o.) scapula : (i.) olecranon process. TRICEPS CUBITI (internal head) (o.) humerus : (i.) olecranon process. ANCONEUS (o.) humerus: (i.) olecranon process. EXTENSOR CARPI ULNARIS (posterior ulnar) (o.) external condyle of humerus : (i.) external metacarpal. FLEXOR DIGITORUM PROFUNDUS (o.) internal

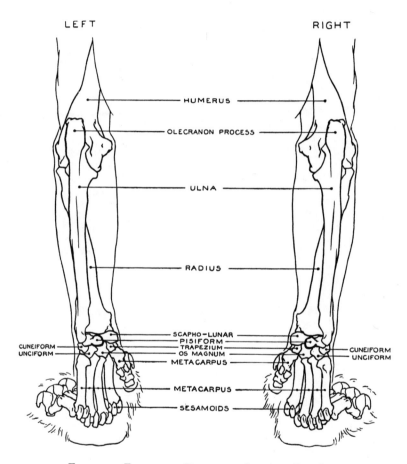

LEFT RIGHT

HUMERUS

OLECRANON PROCESS

ULNA

RADIUS

SCAPHO-LUNAR
PISIFORM
CUNEIFORM TRAPEZIUM CUNEIFORM
UNCIFORM OS MAGNUM UNCIFORM
METACARPUS

METACARPUS

SESAMOIDS

FIG. 103.—FORE-LEG. POSTERIOR ASPECT. Osteology.

condyle of humerus, and shaft of ulna : (i.) by five tendons into the posterior surfaces of the
five digits. FLEXOR CARPI ULNARIS (anterior ulnar) (o.) olecranon process, and internal
condyle of humerus : (i.) pisiform bone. FLEXOR DIGITORUM SUBLIMIS (o.) internal condyle of
humerus : (i.) by four tendons into the four external digits. INTEROSSEUS MUSCLES (o.) meta-
carpal bones : (i.) phalanges.

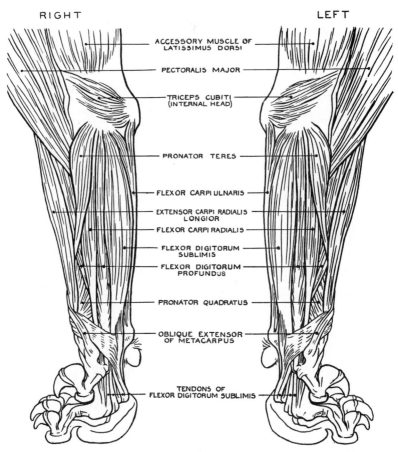

RIGHT LEFT

ACCESSORY MUSCLE OF
LATISSIMUS DORSI

PECTORALIS MAJOR

TRICEPS CUBITI
(INTERNAL HEAD)

PRONATOR TERES

FLEXOR CARPI ULNARIS

EXTENSOR CARPI RADIALIS
LONGIOR

FLEXOR CARPI RADIALIS

FLEXOR DIGITORUM
SUBLIMIS

FLEXOR DIGITORUM
PROFUNDUS

PRONATOR QUADRATUS

OBLIQUE EXTENSOR
OF METACARPUS

TENDONS OF
FLEXOR DIGITORUM SUBLIMIS

Fig. 104. —Fore-leg. Internal Aspect. Myology.

ATTACHMENTS OF MUSCLES.

Accessory muscle of latissimus dorsi (origin) from tendon of latissimus dorsi : (insertion) olecranon process and aponeurosis of leg. Pectoralis major (o.) sternum : aponeurosis of leg and humerus. Triceps cubiti (internal head) (o.) humerus : (i.) olecranon process. Pronator teres (o.) internal condyle of humerus : (i.) shaft of radius. Flexor carpi ulnaris (anterior ulnar) (o.) olecranon process, and internal condyle of humerus : (i.)

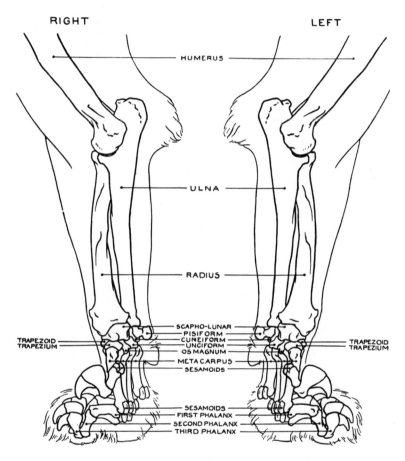

RIGHT

LEFT

HUMERUS

ULNA

RADIUS

SCAPHO-LUNAR
PISIFORM
CUNEIFORM
UNCIFORM
OS MAGNUM
METACARPUS
SESAMOIDS

TRAPEZOID
TRAPEZIUM

TRAPEZOID
TRAPEZIUM

SESAMOIDS
FIRST PHALANX
SECOND PHALANX
THIRD PHALANX

FIG. 105.—FORE-LEG. INTERNAL ASPECT. Osteology.

pisiform bone. EXTENSOR CARPI RADIALIS LONGIOR (o.) humerus : (i.) metacarpus. FLEXOR CARPI RADIALIS (o.) internal condyle of humerus : (i.) second and third metacarpals. FLEXOR DIGITORUM SUBLIMIS (o.) internal condyle of humerus : (i.) by four tendons into the four external digits. FLEXOR DIGITORUM PROFUNDUS (o.) internal condyle of humerus, and shaft of ulna : (i.) by five tendons into the posterior surfaces of the five digits. PRONATOR QUADRATUS stretches between radius and ulna. OBLIQUE EXTENSOR OF METACARPUS (o.) radius and ulna : (i.) metacarpal of thumb.

RIGHT LEFT

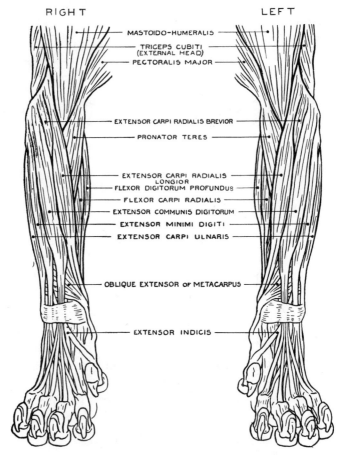

MASTOIDO-HUMERALIS
TRICEPS CUBITI (EXTERNAL HEAD)
PECTORALIS MAJOR

EXTENSOR CARPI RADIALIS BREVIOR
PRONATOR TERES

EXTENSOR CARPI RADIALIS LONGIOR
FLEXOR DIGITORUM PROFUNDUS
FLEXOR CARPI RADIALIS
EXTENSOR COMMUNIS DIGITORUM
EXTENSOR MINIMI DIGITI
EXTENSOR CARPI ULNARIS

OBLIQUE EXTENSOR OF METACARPUS

EXTENSOR INDICIS

FIG. 106.—FORE-LEG. ANTERIOR ASPECT. Myology.

ATTACHMENTS OF MUSCLES.

MASTOIDO-HUMERALIS (origin) posterior part of skull, and superior cervical ligament : (insertion) humerus. TRICEPS CUBITI (external head) (o.) humerus : (i.) olecranon process. PECTORALIS MAJOR (o.) sternum : (i.) aponeurosis of leg. EXTENSOR CARPI RADIALIS LONGIOR and BREVIOR (o.) humerus : (i.) metacarpus. PRONATOR TERES (o.) internal condyle of humerus : (i.) shaft of radius. FLEXOR DIGITORUM PROFUNDUS (o.) internal condyle of humerus, and shaft of ulna : (i.) by five tendons into digits. FLEXOR CARPI RADIALIS (o.)

Modelling 149

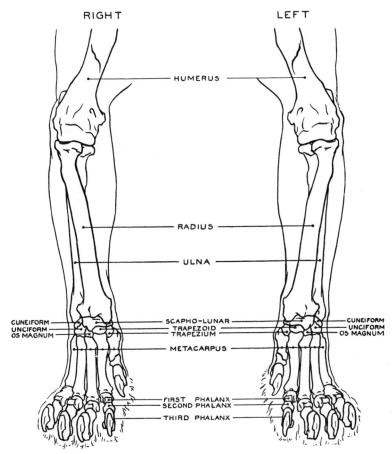

RIGHT LEFT

HUMERUS

RADIUS

ULNA

CUNEIFORM SCAPHO-LUNAR CUNEIFORM
UNCIFORM TRAPEZOID UNCIFORM
OS MAGNUM TRAPEZIUM OS MAGNUM

METACARPUS

FIRST PHALANX
SECOND PHALANX
THIRD PHALANX

FIG. 107.—FORE-LEG. ANTERIOR ASPECT. Osteology.

internal condyle of humerus: (i.) second and third metacarpals. EXTENSOR COMMUNIS DIGITORUM (o.) external condyle of humerus: (i.) by four tendons into the second and third phalanges of the four external digits. EXTENSOR MINIMI DIGITI (o.) external condyle of humerus: (i.) by four tendons (passing under those of ext. comm. dig.) into the four external digits. EXTENSOR CARPI ULNARIS (posterior ulnar) (o.) external condyle of humerus: (i.) external metacarpal. OBLIQUE EXTENSOR OF METACARPUS (o.) radius and ulna: (i.) metacarpal of thumb. EXTENSOR INDICIS (o.) radius and ulna: (i.) by two tendons into the two internal digits.

LEFT

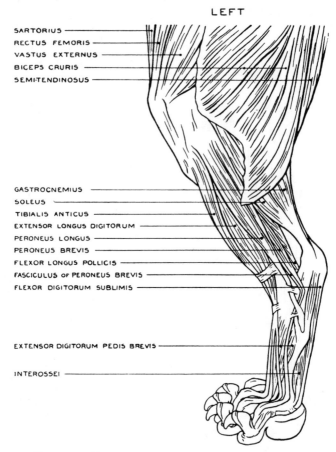

SARTORIUS

RECTUS FEMORIS

VASTUS EXTERNUS

BICEPS CRURIS

SEMI-TENDINOSUS

GASTROCNEMIUS

SOLEUS

TIBIALIS ANTICUS

EXTENSOR LONGUS DIGITORUM

PERONEUS LONGUS

PERONEUS BREVIS

FLEXOR LONGUS POLLICIS

FASCICULUS OF PERONEUS BREVIS

FLEXOR DIGITORUM SUBLIMIS

EXTENSOR DIGITORUM PEDIS BREVIS

INTEROSSEI

FIG. 108.— HIND-LEG. EXTERNAL ASPECT. Myology.

ATTACHMENTS OF MUSCLES.

SARTORIUS (patellar portion) (origin) anterior iliac spine : (insertion) patella. RECTUS
FEMORIS (triceps cruris) (o.) iliac bone : (i.) patella. VASTUS EXTERNUS (triceps cruris) (o.)
femur : (i.) tendon of rectus femoris, and patella. BICEPS CRURIS (o.) tuberosity of ischium,
and ligament of sacrum : (i.) by aponeurosis covering external aspect of leg. SEMI-TENDINOSUS
(o.) tuberosity of ischium : (i.) aponeurosis of leg, and tibia. GASTROCNEMIUS (o.) femur :
(i.) by tendo-Achillis into calcaneum. SOLEUS (o.) external tuberosity of tibia : (i.) tendon of

Modelling

RIGH T

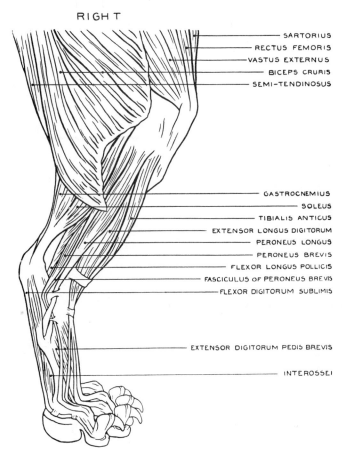

SARTORIUS
RECTUS FEMORIS
VASTUS EXTERNUS
BICEPS CRURIS
SEMI-TENDINOSUS

GASTROCNEMIUS
SOLEUS
TIBIALIS ANTICUS
EXTENSOR LONGUS DIGITORUM
PERONEUS LONGUS
PERONEUS BREVIS
FLEXOR LONGUS POLLICIS
FASCICULUS OF PERONEUS BREVIS
FLEXOR DIGITORUM SUBLIMIS

EXTENSOR DIGITORUM PEDIS BREVIS

INTEROSSEI

FIG. 108A.—HIND-LEG. EXTERNAL ASPECT. Myology.

gastrocnemius. TIBIALIS ANTICUS (o.) external tuberosity and crest ot tibia : (i.) bones o
rudimentary great toe. EXTENSOR LONGUS DIGITORUM (o.) femur : (i.) by four tendons into
the second and third phalanges of digits. PERONEUS LONGUS (o.) external tuberosity of tibia :
(i.) metatarsus. PERONEUS BREVIS (o.) tibia and fibula : (i.) external metatarsal (an annexed
fasciculus of this muscle arises from the head of fibula and its tendon unites with that of
extensor of external digit). FLEXOR LONGUS POLLICIS (o.) tibia and fibula : (i.) by four
tendons into digits. FLEXOR DIGITORUM SUBLIMIS (o.) femur : (i.) by four tendons into digits.
EXTENSOR DIGITORUM PEDIS BREVIS (o.) calcaneum : (i.) three internal digits. INTEROSSEI
(o.) metacarpal bones : (i.) phalanges.

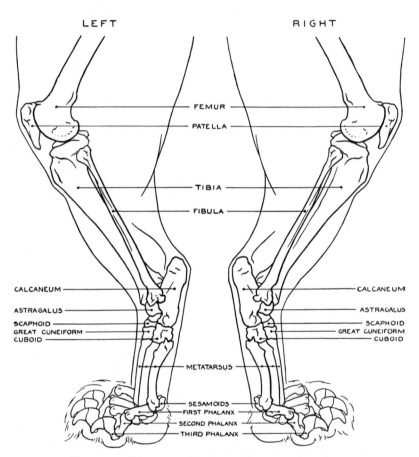

FIG. 109.—HIND-LEG. EXTERNAL ASPECT. Osteology.

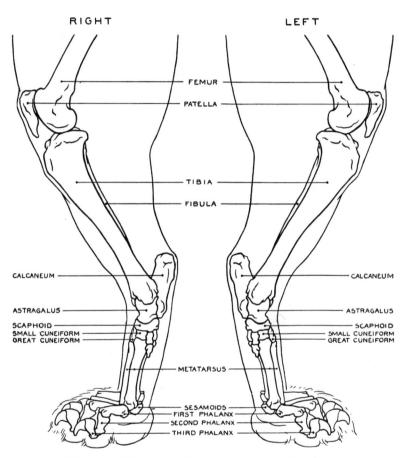

RIGHT LEFT

FEMUR

PATELLA

TIBIA

FIBULA

CALCANEUM CALCANEUM

ASTRAGALUS ASTRAGALUS

SCAPHOID SCAPHOID
SMALL CUNEIFORM SMALL CUNEIFORM
GREAT CUNEIFORM GREAT CUNEIFORM

METATARSUS

SESAMOIDS
FIRST PHALANX
SECOND PHALANX
THIRD PHALANX

FIG. 110.—HIND-LEG. INTERNAL ASPECT. Osteology

RIGHT

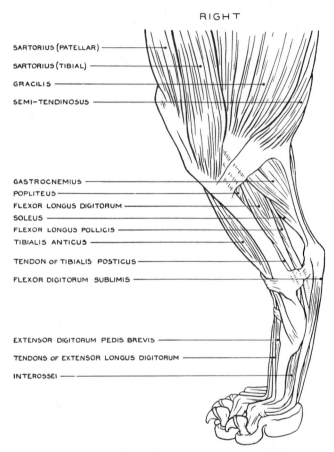

SARTORIUS (PATELLAR)
SARTORIUS (TIBIAL)
GRACILIS
SEMI-TENDINOSUS

GASTROCNEMIUS
POPLITEUS
FLEXOR LONGUS DIGITORUM
SOLEUS
FLEXOR LONGUS POLLICIS
TIBIALIS ANTICUS
TENDON OF TIBIALIS POSTICUS
FLEXOR DIGITORUM SUBLIMIS

EXTENSOR DIGITORUM PEDIS BREVIS
TENDONS OF EXTENSOR LONGUS DIGITORUM
INTEROSSEI

FIG. 111.—HIND-LEG. INTERNAL ASPECT. Myology.

ATTACHMENTS OF MUSCLES.

SARTORIUS (patellar) (origin) anterior iliac spine : (insertion) patella. SARTORIUS (tibial) (o.) inferior border of ilium : (i.) tibia. GRACILIS (o.) pubis and nferior surface of ilium : (i.) tibia and aponeurosis. SEMI-TENDINOSUS (o.) tuberosity of ischium : (i.) aponeurosis of leg, and tibia. GASTROCNEMIUS (o.) femur : (i.) by tendo-Achillis into calcaneum. POPLITEUS (o.) external condyle of femur : (i.) tibia. FLEXOR LONGUS DIGITORUM (o.) external tuberosity

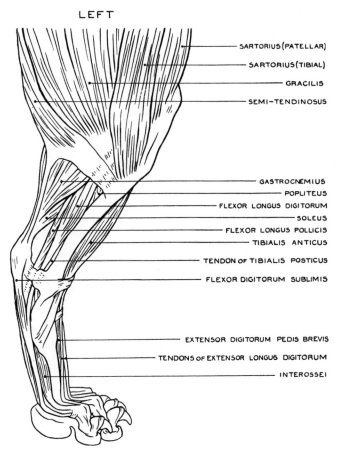

LEFT

SARTORIUS (PATELLAR)

SARTORIUS (TIBIAL)

GRACILIS

SEMI-TENDINOSUS

GASTROCNEMIUS

POPLITEUS

FLEXOR LONGUS DIGITORUM

SOLEUS

FLEXOR LONGUS POLLICIS

TIBIALIS ANTICUS

TENDON OF TIBIALIS POSTICUS

FLEXOR DIGITORUM SUBLIMIS

EXTENSOR DIGITORUM PEDIS BREVIS

TENDONS OF EXTENSOR LONGUS DIGITORUM

INTEROSSEI

FIG. 111A.—HIND-LEG. INTERNAL ASPECT. Myology.

of tibia : (i.) internal digit. SOLEUS (o.) external tuberosity of tibia : (i.) tendon of gastrocnemius. FLEXOR LONGUS POLLICIS (o.) tibia and fibula : (i.) by four tendons into digits. TIBIALIS ANTICUS (o.) external tuberosity and crest of tibia : (i.) bones of rudimentary great toe. TIBIALIS POSTICUS (o.) external tuberosity of tibia, and head of fibula : (i.) tarsus. FLEXOR DIGITORUM SUBLIMIS (o.) femur : (i.) by four tendons into digits. EXTENSOR DIGITORUM PEDIS BREVIS (o.) calcaneum : (i.) three internal digits. INTEROSSEI (o.) metatarsal bones : (i.) phalanges.

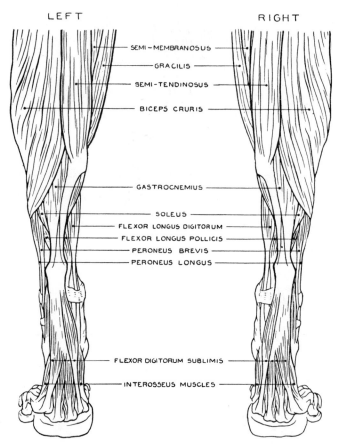

LEFT RIGHT

SEMI—MEMBRANOSUS

GRACILIS

SEMI-TENDINOSUS

BICEPS CRURIS

GASTROCNEMIUS

SOLEUS

FLEXOR LONGUS DIGITORUM

FLEXOR LONGUS POLLICIS

PERONEUS BREVIS

PERONEUS LONGUS

FLEXOR DIGITORUM SUBLIMIS

INTEROSSEUS MUSCLES

FIG. 112.—HIND-LEG. POSTERIOR ASPECT. Myology.

ATTACHMENTS OF MUSCLES.

SEMI-MEMBRANOSUS (posterior portion) (origin) inferior surface of ischium : (insertion) internal tuberosity of tibia. GRACILIS (o.) pubis and inferior surface of ilium : (i.) tibia, and aponeurosis. SEMI-TENDINOSUS (o.) tuberosity of ischium : (i.) aponeurosis of leg, and tibia. BICEPS CRURIS (o.) tuberosity of ischium, and ligament of sacrum : (i.) by aponeurosis covering external aspect of leg. GASTROCNEMIUS (o.) femur : (i.) by tendo-Achillis into calcaneum.

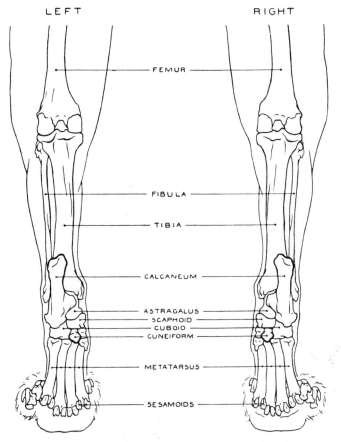

FIG. 113.—HIND-LEG. POSTERIOR ASPECT. Osteology.

SOLEUS (o.) external tuberosity of tibia : (i.) tendon of gastrocnemius. FLEXOR LONGUS DIGITORUM (o.) external tuberosity of tibia : (i.) internal digit. FLEXOR LONGUS POLLICIS (o.) tibia and fibula : (i.) by four tendons into digits. PERONEUS BREVIS (o.) tibia and fibula : (i.) external metatarsal. PERONEUS LONGUS (o.) external tuberosity of tibia : (i.) metatarsus. FLEXOR DIGITORUM SUBLIMIS (o.) femur : (i.) by four tendons into digits. INTEROSSEUS MUSCLES (o.) metatarsal bones : (i.) phalanges.

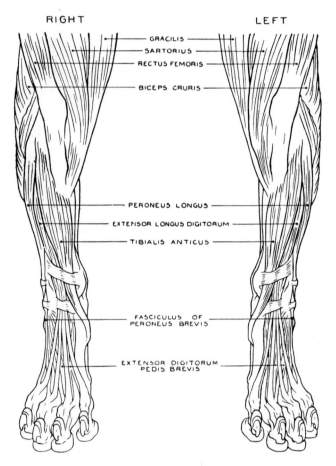

RIGHT LEFT

GRACILIS
SARTORIUS
RECTUS FEMORIS
BICEPS CRURIS
PERONEUS LONGUS
EXTENSOR LONGUS DIGITORUM
TIBIALIS ANTICUS
FASCICULUS OF PERONEUS BREVIS
EXTENSOR DIGITORUM PEDIS BREVIS

Fɪɢ. 114.—Hɪɴᴅ-ʟᴇɢ. Aɴᴛᴇʀɪᴏʀ Aꜱᴘᴇᴄᴛ. Myology.

ATTACHMENTS OF MUSCLES.

Gʀᴀᴄɪʟɪꜱ (origin) pubis and inferior surface of ilium : (insertion) tibia and aponeurosis ot leg. Sᴀʀᴛᴏʀɪᴜꜱ (o.) anterior iliac spine, and inferior border of ilium : (i.) patella, and tibia. Rᴇᴄᴛᴜꜱ ꜰᴇᴍᴏʀɪꜱ (triceps cruris) (o.) iliac bone : (i.) patella. Bɪᴄᴇᴘꜱ ᴄʀᴜʀɪꜱ (o.) tuberosity

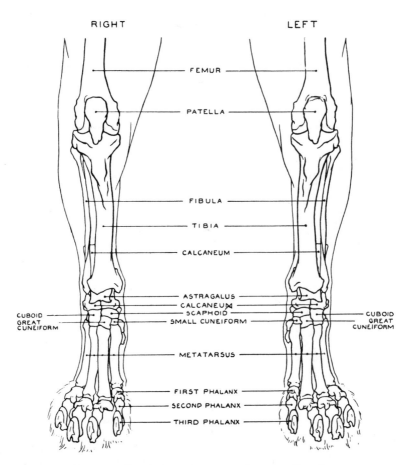

FIG. 115.—HIND-LEG. ANTERIOR ASPECT. Osteology.

of ischium, and ligament o. sacrum : (i.) by aponeurosis covering external aspect o leg. PERONEUS LONGUS (o.) external tuberosity of tibia : (i.) metatarsus. EXTENSOR LONGUS DIGITORUM (o.) femur : (i.) by four tendons into the second and third phalanges of digits. TIBIALIS ANTICUS (o.) external tuberosity and crest of tibia : (i.) bones of rudimentary great toe. PERONEUS BREVIS (o.) tibia and fibula : (i.) external metatarsal. EXTENSOR DIGITORUM PEDIS BREVIS (o.) calcaneum : (i.) three internal digits.

CHAPTER XVII

THE BULL

These animals of the genus quadrupeds belong to the ruminant order and are characterised by horns jutting outwards and then bending straight upwards, or curved forwards or downwards, in the shape of a crescent. They are remarkable for their size, the strength of their limbs, their large muzzle, and the dewlap or heavy folds of skin which hang from the neck. Far from being timid and prone to run away as stags and antelopes, they defend themselves against the largest wild animals, resist man, or even attack him, throwing him with their horns or trampling him under their hoofs.

The bull has twelve molar teeth in each jaw, six on either side, no canines, and only in the inferior jaw eight incisors, the middle ones being thin and with a cutting edge. The tongue bristles with small, more or less firm, hooklets, which are pointed and directed backwards, making it very rough. The bellowing of the bull, which is extremely powerful, becomes much attenuated in the ox.

The bull is the stallion of the bovine race; he should be fat without excess, have a dark eye, a proud gaze, a large forehead, a short head, fine horns, long and hairy ears, a strong muzzle, a short and straight nose, a thick and fleshy neck, a wide chest and strong shoulders, a straight back, full and powerful legs and a firm and sure bearing. Nature has made this animal proud and untractable, but by castration the source of its impetuosity is destroyed, without depriving it of any of its natural strength. It then only gains in size and becomes more massive and at the same time more tractable, more patient, more docile, and is thus in many countries made use of for agricultural work.

The first front teeth fall out at ten months and are replaced by others which are not so white nor so wide; at sixteen months the neighbouring teeth fall out and are also replaced by others, and at three years all the incisors have been renewed. They are then equal, long and fairly white, but as the animal advances in years, they become unequal and dark.

The horns grow during the entire life of the bull, and it is easy to make out the thickenings, or annular nodes, which indicate the years of growth, counting three years for the distance from the point of the horn to the first node, and one year for each succeeding interval. These horns are formidable arms of defence: when the animal wishes to use

them, he lowers his head and presents the points at his adversary, transfixes him, gores him, and throws him a distance through the air. A peculiarity of the bovine race is that the horns are present both in the male and in the female.

It would be impossible to enumerate all the different breeds, but many of these exhibit some marked characteristic of their own which makes them easily recognisable to those conversant with the matter. In the United Kingdom alone there are at least twelve breeds ; among these may be cited the Scottish Shorthorn ; the Dexter or the Northumberland breed with short legs and wide horns ; the Longhorn of the Isle of Man, with the horns slanting downwards ; the Holderness Shorthorn ; the Highland Bull, with a rough, curly, red coat and wide curved horns ; the Leicester, with long horns curved downwards and forwards ; the Chillingham, a descendant of a breed known in Britain at the time of the Roman conquest ; the Hereford, the Norfolk, the Devon, the Welsh and the Jersey Bull with short, stubby horns. Among foreign breeds the more notable are the Spanish fighting bulls, of which the short black bull bred around Sevilla is perhaps the most striking type ; a noble bull native of the sandy plains of Hungary with its splendidly erect horns ; the Simmenthal Bull of Switzerland, massive, thick-legged and stupid-looking ; the many fine varieties in the United States ; the French breeds

—notably the Picardy, the Brittany, the Limousin, the "Vendéenne," the "Auvergne," the "Charolais" and the Cantal; the superb Roman Bull so splendidly portrayed by Clesinger in his "Taureau Vainqueur," one of the many offshoots of the old Iberian race, the descendants of which are, in varied types, spread over a large area extending from Naples, through Sicily, Corsica, Algeria, Morocco, and Portugal to Béarn; the Cape breed and, not less typical of all, the Hissar Humped Bull of India.

In the monuments of Assyria the Bull figures largely. Layard says: "The wild bull, from its frequent representation in the bas-reliefs, appears to have been considered scarcely less formidable and noble game than the lion. The king is frequently seen contending with it, and warriors pursue it both on horseback and on foot." Here we find the bull represented with a human head. These symbolical figures were of colossal proportions; the Louvre possesses two admirable specimens which once adorned the entrance of the palace of Khorsabad and which are about eleven feet high, and the British Museum two other perfect specimens twelve feet high and twelve feet long. It is probable that these human-headed bulls impart racial or dynastic symbolism.

The Farnese Bull of Apollonius of Tralles in the Museum at Naples, without being one of the masterpieces of antiquity,

is a work of considerable interest. It shows Zethus and Amphion binding Dirce to the horns of a bull, to revenge the fate of their mother Antiope.

There exists among the ancient engraved gems a number of cameos, representing not only bulls, but also lions, elephants, boars, etc., and the artists have in all carefully followed in their execution the construction, the attachments, and the outline of the muscles brought into play by the particular action portrayed. It is here apparent how truth was familiar to the ancient engraver; a truth which the Egyptians and the Greeks knew how to express so tersely. For in these small proportions they only accentuated the expressive and characteristic parts, and all the stones are of excellent workmanship. They are indeed the more often remarkable for that higher interpretation of Nature, which only seeks essential traits—that is, those traits which convey the idea of habit and express character.

There is nothing better in this way than the cameo of the "Dyonisius" Bull, by the Greek engraver Hyllos, who lived in the age of Augustus. The sentiment of strength in anger and energy in movement is admirable. Here, as not only in the graven gems, but also in all sculptural works of the great epochs, Grecian art gives us its secret, which is to strike just and to strike hard.

The bull by its large lines which join the generally

salient heads of the bones, its large flat surfaces, the thickness of the base of the neck, the powerfulness of its bony frame, its short and strong legs, is one of the animals which possesses the greatest personal character, and this renders it comparatively easy to imitate. The human figure is much more difficult to represent, and more especially the female figure where everything is gracefulness, elegance, and of which the charm, the expressive points of the outline, the delicate modelling of the planes are almost imperceptible even to a highly trained eye. The same difference exists in the difficulty that there is between the making of the bust of a young girl and that of an old man. In the bull everything is frankly indicated, it seems to be shapened with a hatchet, and it lends itself more than all other animals to a laconic treatment or simplification in its representation, without fear of the type being distorted. The decided proportions allow its character to be easily caught.

The sculptor who has conscientiously studied the human figure, whose observing mind has been awakened by the fine shades, the perfect harmony of the proportions in man, can, the horse excluded, with a small anatomical knowledge and a study of their habits, make excellent representations of animals. It goes without saying, however, that to arrive at the perfect style of a Barye, a Fremiet, or of others, it necessitates an artistic sentiment of the highest order.

CHAPTER XVIII

THE principle of the armature for the bull, both for the sketch and life size, is the same as that for the horse and the lion. (Fig. 116 shows that of the life size.)

To give the attitude, proceed in the sketch exactly in the same way as for the others, using the vertebral column to find the movement.

The armature surrounded with clay, begin to establish the large planes as indicated in figures 117 and 117a (First Stage of modelling).

This done, make a scale, using the length of the head as a comparative measurement for the other parts of the body. Make the scale thus : if the sketch is to be 16 inches in length from the head of the humerus to the extreme point of the buttock, trace a horizontal line this length on a plank or a piece of cardboard : knowing that in this length there are three heads, divide into three parts, each of which will

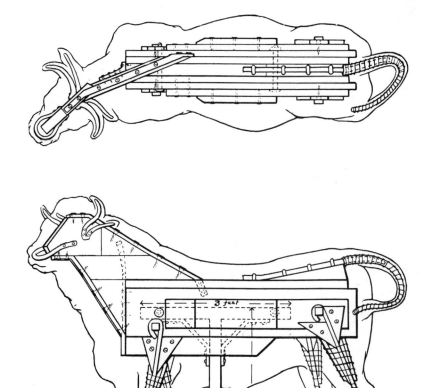

FIG. 116.—ARMATURE FOR A LIFE-SIZE BULL.

represent the length of the head, and divide each part again into halves, quarters, and eighths. (Fig. 118.)

FIG. 118.

By consulting the list of comparative measurements of the head in respect to the other parts, it will be easy to establish the first measurements necessary for the construction. In the list of comparative measurements will be found some which are only of secondary importance. The measurements of construction will be fixed, as in the case of the previous studies.

These measurements differ naturally according to breeds, but they may be used as a guide in a purely decorative work. If it is a question of portraiture, it will be necessary to follow exactly those given by the model, for we must never forget that it is the proportions proper to the individual which alone give its character and its type.

I will add nothing as regards the execution to that which I have said for the other studies. And to sum up: begin always with the attitude, establish very firmly the great planes with a little clay, keeping well within the volume of the model, fix on this preparation the proportions which enable one to find the construction, apply over the large

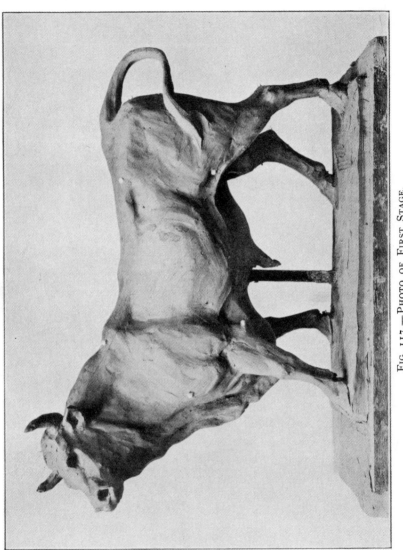

FIG. 117.—PHOTO OF FIRST STAGE.

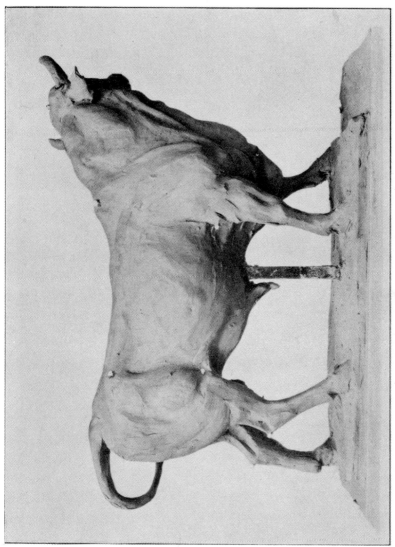

FIG. 117A.—PHOTO OF FIRST STAGE.

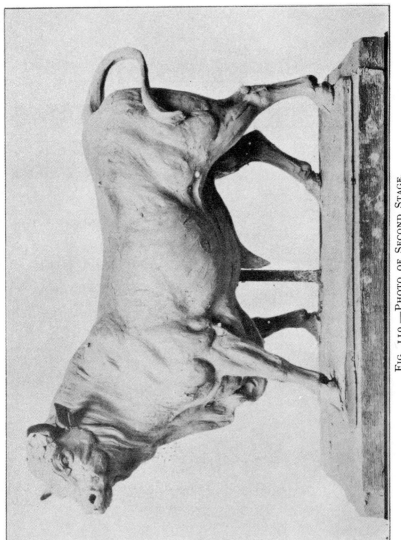

Fig. 119.—Photo of Second Stage.

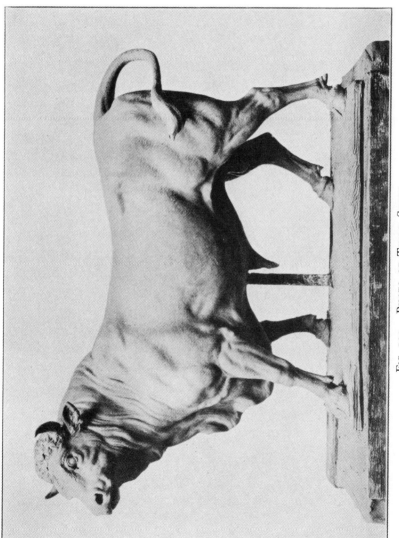

FIG. 120.—PHOTO OF THIRD STAGE.

planes the movement of the forms, having for guide an anatomical knowledge which will be controlled by the drawing in obtaining both form and volume, and by drawing also seek the sections of all the parts of the body, then the relation of the importance of the lights, shades and half-tones ; doing this by continually changing the light. Thus will be obtained first the envelope and its simplification, and at last the style which is the result of the observation of the typical points of the individual subject. By accentuating these points with understanding, tact and delicacy, the essence of the character will be given, and it is drawing alone which will allow of these qualities being obtained, qualities which are of the utmost importance in a work of art ; all the others are but a necessary preparation for the realisation of these.

I say, then, to the students of sculpture : you cannot have too great a knowledge of drawing, for it is the principal foundation, even more so than it is in the case of painting.

Figure 119 shows the indication of the movement of the forms and figure, 120 gives an example of the work further elaborated (Third Stage).

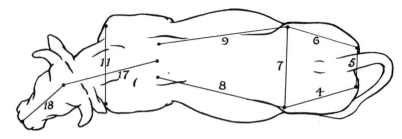

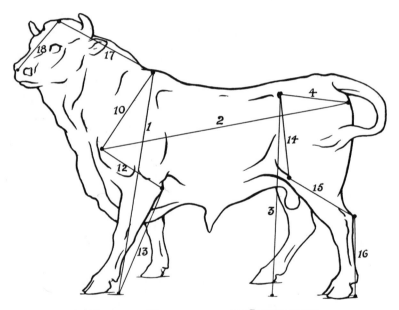

Fig. 121.—Measurements of Construction.

1.	Plinth to top of shoulder blade.	10.	Top of shoulder blade to point of arm.
2.	Point of arm to point of buttock.	11.	Between points of arms.
3.	Plinth to external iliac.	12.	Point of arm to elbow.
4.	External iliac to point of buttock.	13.	Elbow to plinth.
5.	Between points of buttocks.	14	Anterior iliac to patella.
6.	Point of buttock to external iliac.	15.	Patella to calcaneum.
7.	Between external iliacs.	16.	Calcaneum to plinth.
8, 9.	External iliacs to centre of top of shoulder blades.	17.	From between the shoulder blades to top of head.
		18.	Length of head.

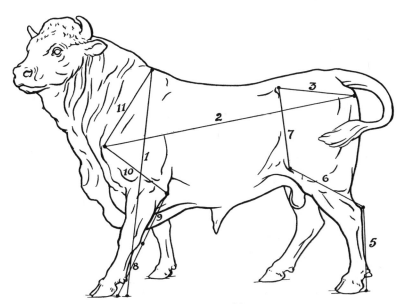

FIG. 122.—COMPARATIVE MEASUREMENTS.

1. Height of shoulders above plinth, $2\frac{1}{2}$ heads.
2. Length of body from point of arm to point of buttock, 3 heads.
3. Points of buttocks to external iliacs, 1 head.
4. Between external iliacs, nearly 1 head.
5. Plinth to calcaneum, 1 head.
6. Calcaneum to patella, nearly 1 head.
7. Patella to external iliac, about 1 head.
(This measurement differs according to the pose of the hind-leg.)

8. Plinth to pisiform, $\frac{3}{4}$ head.
9. Pisiform to elbow, nearly $\frac{3}{4}$ head.
10. Elbow to point of arm, $\frac{3}{4}$ head.
11. Point of arm to centre of top of shoulder blade, a little more than 1 head.
12. Centre of shoulders to summit of head, $1\frac{1}{3}$ heads.
13. Width of head above eyes, $\frac{1}{2}$ head.
14. Greatest width of shoulders, 1 head.
15. Greatest width of belly, $1\frac{1}{3}$ heads.

The measurement of the head is taken from the summit to the centre of the extremity of the muzzle.

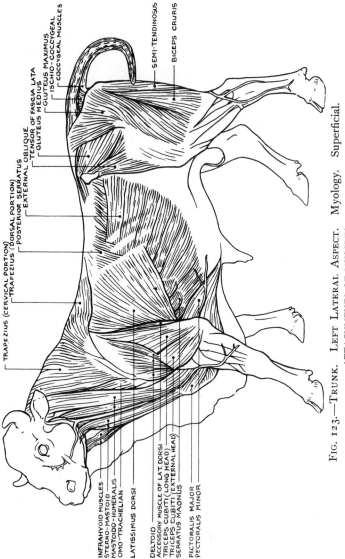

FIG. 123.—TRUNK. LEFT LATERAL ASPECT. MYOLOGY. SUPERFICIAL. ATTACHMENTS OF MUSCLES.

INFRAHYOID MUSCLES (origin) sternum : (insertion) hyoid bone and thyroid cartilage. STERNO-MASTOID (o.) anterior extremity of sternum : (i.) one portion into occipital bone, the other into inferior maxillary and aponeurosis of masseter muscle. MASTOIDO-HUMERALIS (o.) posterior surface of skull, and atlas : (i.) anterior border of humerus. OMO TRACHELIAN (o.) atlas : (i.) acromion process of spine of scapula and aponeurosis below that region. LATISSIMUS DORSI (o.) by aponeurosis from back, and from the eleventh rib : (i.) humerus. ACCESSORY MUSCLE OF LATISSIMUS DORSI (o.) from tendon of latissimus dorsi, and posterior border of scapula : (i.) olecranon process and aponeurosis of leg. TRICEPS CUBITI (long head) (o.) posterior border of scapula : (i.) olecranon process. TRICEPS CUBITI (external head) (o.) humerus : (i.) olecranon process. SERRATUS MAGNUS (o.) by digitations from first eight ribs : (i.) subscapula

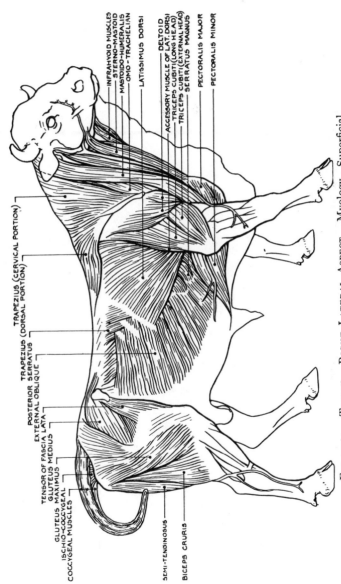

INFRAHYOID MUSCLES
STERNO-MASTOID
MASTOIDO-HUMERALIS
OMO-TRACHELIAN

LATISSIMUS DORSI

DELTOID
ACCESSORY MUSCLE OF LAT. DORSI
TRICEPS CUBITI (LONG HEAD)
TRICEPS CUBITI (EXTERNAL HEAD)
SERRATUS MAGNUS

PECTORALIS MAJOR

PECTORALIS MINOR

TRAPEZIUS (CERVICAL PORTION)
TRAPEZIUS (DORSAL PORTION)

POSTERIOR SERRATUS
EXTERNAL OBLIQUE

TENSOR OF FASCIA LATA
GLUTEUS MEDIUS
GLUTEUS MAXIMUS
ISCHIO-COCCYGEAL
COCCYGEAL MUSCLES

SEMI-TENDINOSUS

BICEPS CRURIS

FIG. 123A.—TRUNK. RIGHT LATERAL ASPECT. Myology—Superficial.

fossa near the spinal border. PECTORALIS MAJOR (o.) sternum : (i.) humerus and aponeurosis of leg. PECTORALIS MINOR (sterno-trochinian)
(o.) abdominal aponeurosis and posterior part of sternum : (i.) internal condyle of humerus.
TRAPEZIUS (cervical portion) (o.) superior cervical ligament and spines of foremost dorsal vertebræ : (i.) spine of scapula. TRAPEZIUS
(dorsal portion) (o.) spines of dorsal vertebræ : (i.) spine of scapula. POSTERIOR SERRATUS (o.) aponeurosis of back : (i.) last three ribs.
EXTERNAL OBLIQUE (o.) nine posterior ribs : (i.) abdominal aponeurosis. TENSOR OF FASCIA LATA (o.) external iliac spine : (i.) by
aponeurosis (fascia lata) into patella, and gluteus maximus. GLUTEUS MEDIUS (o.) iliac fossa, and aponeurosis of back : (i.) great trochanter
of femur. GLUTEUS MAXIMUS (o.) crest of sacrum, tuberosity of ischium, and ligament between those points : (i.) fascia lata and apo-
neurosis of leg. ISCHIO-COCCYGEAL (o.) ischium : (i.) first two coccygeal vertebræ. COCCYGEAL MUSCLES (superior, lateral, and inferior)
(o.) sacrum : (i.) coccygeal vertebræ. SEMI-TENDINOSUS (o.) tuberosity of ischium : (i.) aponeurosis of leg and anterior border of tibia.
BICEPS CRURIS (o.) tuberosity of ischium : (i.) aponeurosis of leg.

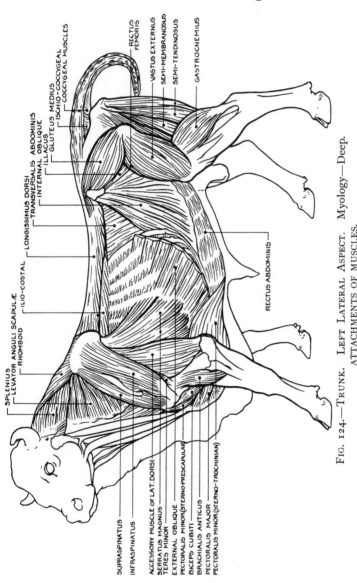

FIG. 124.—TRUNK. LEFT LATERAL ASPECT. MYOLOGY—DEEP.
ATTACHMENTS OF MUSCLES.

SUPRASPINATUS (origin) supraspinous fossa of scapula and cartilage of prolongation : (insertion) humerus. INFRASPINATUS (o.) infraspinous fossa of scapula and cartilage of prolongation : (i.) humerus. ACCESSORY MUSCLE OF LATISSIMUS DORSI (o.) tendon of latissimus dorsi, and posterior border of scapula : (i.) olecranon and aponeurosis of leg. SERRATUS MAGNUS (o.) by digitations from first eight ribs : (i.) subscapular fossa near its spinal border. TERES MINOR (o.) scapula : (i.) humerus. EXTERNAL OBLIQUE (o.) nine posterior ribs : (i.) abdominal aponeurosis. PECTORALIS MINOR (sterno-prescapular) (o.) sternum : (i.) inferior part of supraspinatus. BICEPS CUBITI (o.) coracoid process of scapula : (i.) radius. BRACHIALIS ANTICUS (o.) humerus : (i.) internal surface of radius and ulna. PECTORALIS MAJOR (o.) sternum : (i.) humerus and aponeurosis of leg. PECTORALIS MINOR (sterno-trochinian) (o.) abdominal aponeurosis and posterior part of sternum : (i.) internal condyle of humerus.

SPLENIUS (o.) superior cervical ligament and spines of foremost dorsal vertebræ : (i.) mastoid crest, and transverse processes of atlas

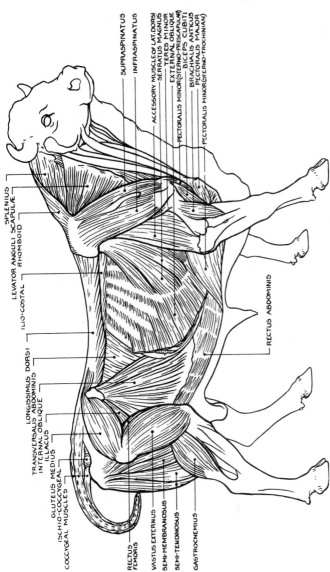

FIG. 124A.—TRUNK. RIGHT LATERAL ASPECT. MYOLOGY.—DEEP.

LEVATOR ANGULI SCAPULÆ (o.) transverse processes of lower cervical vertebræ : (i.) spinal border and three or four following vertebræ. of scapula. RHOMBOID (o.) cervical ligament and spinous processes of foremost cervical vertebræ : (i.) spinal border of scapula. ILIO-COSTAL (o.) ribs : (i.) transverse processes of lumbar vertebræ, and crest of ilium. LONGISSIMUS DORSI (o.) dorsal and lumbar vertebræ, and ribs : (i.) ilium, and sacrum. TRANSVERSALIS ABDOMINIS (o.) transverse processes of lumbar vertebræ : (i.) linea alba. INTERNAL OBLIQUE (o.) external iliac spine : (i.) internal surface of last costal cartilages, and abdominal aponeurosis. ILIACUS (o.) external iliac spine : (i.) femur. GLUTEUS MEDIUS (o.) iliac fossa and aponeurosis of back : (i.) great trochanter of femur. ISCHIO-COCCYGEAL (o.) ischium : (i.) first two coccygeal vertebræ. COCCYGEAL MUSCLES (o.) sacrum : (i.) coccygeal vertebræ. RECTUS FEMORIS (triceps cruris) (o.) iliac bone : (i.) patella. VASTUS EXTERNUS (triceps cruris) femur : (i.) patella. SEMI-MEMBRANOSUS (o.) ischium : (i.) femur, and tibia. SEMI-TENDINOSUS (o.) tuberosity of ischium : (i.) aponeurosis of leg and anterior border of tibia. GASTROCNEMIUS (o.) femur : (i.) by tendo-Achillis into calcaneum. RECTUS ABDOMINIS stretches between the pelvis and thorax.

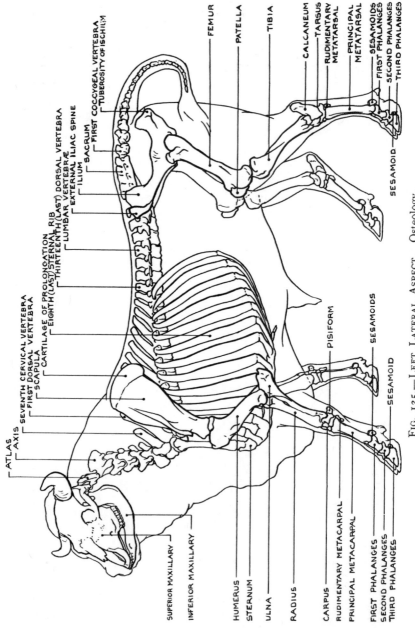

FIG. 125.—LEFT LATERAL ASPECT. Osteology.

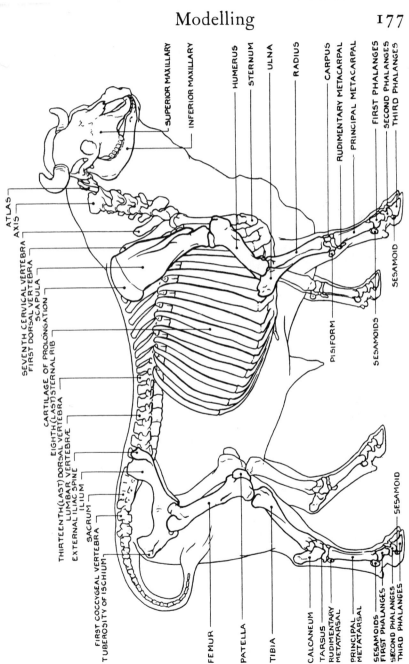

FIG. 125A.—RIGHT LATERAL ASPECT. Osteology.

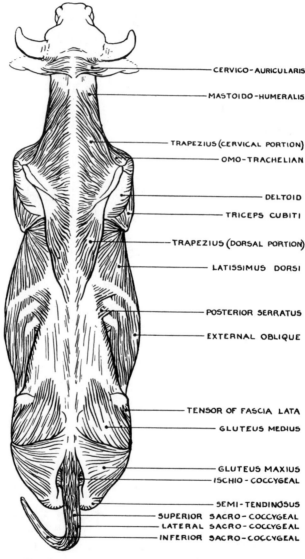

CERVICO-AURICULARIS

MASTOIDO-HUMERALIS

TRAPEZIUS (CERVICAL PORTION)
OMO-TRACHELIAN

DELTOID
TRICEPS CUBITI

TRAPEZIUS (DORSAL PORTION)

LATISSIMUS DORSI

POSTERIOR SERRATUS

EXTERNAL OBLIQUE

TENSOR OF FASCIA LATA
GLUTEUS MEDIUS

GLUTEUS MAXIUS
ISCHIO-COCCYGEAL

SEMI-TENDINOSUS
SUPERIOR SACRO-COCCYGEAL
LATERAL SACRO-COCCYGEAL
INFERIOR SACRO-COCCYGEAL

FIG. 126.—TRUNK. SUPERIOR ASPECT. Myology.

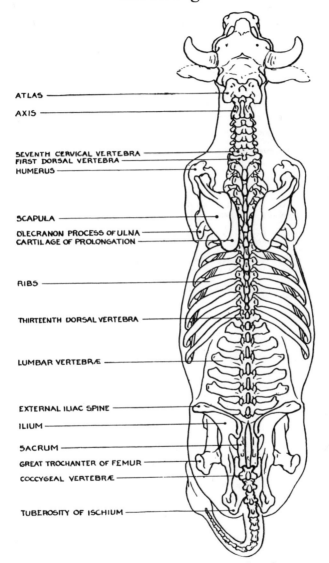

ATLAS

AXIS

SEVENTH CERVICAL VERTEBRA
FIRST DORSAL VERTEBRA
HUMERUS

SCAPULA

OLECRANON PROCESS OF ULNA
CARTILAGE OF PROLONGATION

RIBS

THIRTEENTH DORSAL VERTEBRA

LUMBAR VERTEBRÆ

EXTERNAL ILIAC SPINE

ILIUM

SACRUM

GREAT TROCHANTER OF FEMUR

COCCYGEAL VERTEBRÆ

TUBEROSITY OF ISCHIUM

FIG. 127.—TRUNK. SUPERIOR ASPECT. Osteology.

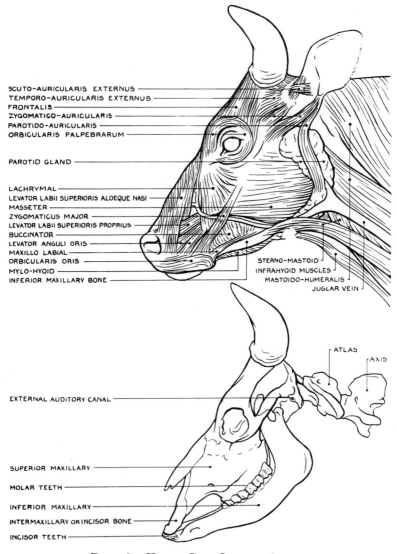

SCUTO-AURICULARIS EXTERNUS
TEMPORO-AURICULARIS EXTERNUS
FRONTALIS
ZYGOMATICO-AURICULARIS
PAROTIDO-AURICULARIS
ORBICULARIS PALPEBRARUM

PAROTID GLAND

LACHRYMAL
LEVATOR LABII SUPERIORIS ALOEQUE NASI
MASSETER
ZYGOMATICUS MAJOR
LEVATOR LABII SUPERIORIS PROPRIUS
BUCCINATOR
LEVATOR ANGULI ORIS
MAXILLO LABIAL
ORBICULARIS ORIS
MYLO-HYOID
INFERIOR MAXILLARY BONE

STERNO-MASTOID
INFRAHYOID MUSCLES
MASTOIDO-HUMERALIS
JUGLAR VEIN

ATLAS
AXIS

EXTERNAL AUDITORY CANAL

SUPERIOR MAXILLARY

MOLAR TEETH

INFERIOR MAXILLARY

INTERMAXILLARY OR INCISOR BONE

INCISOR TEETH

FIG. 128.—HEAD. LEFT LATERAL ASPECT.

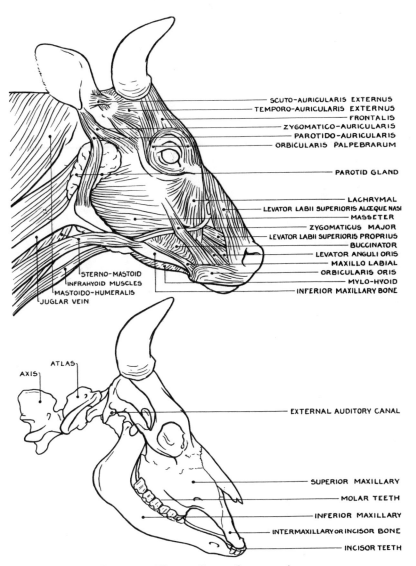

SCUTO-AURICULARIS EXTERNUS
TEMPORO-AURICULARIS EXTERNUS
FRONTALIS
ZYGOMATICO-AURICULARIS
PAROTIDO-AURICULARIS
ORBICULARIS PALPEBRARUM

PAROTID GLAND

LACHRYMAL
LEVATOR LABII SUPERIORIS ALŒQUE NASI
MASSETER
ZYGOMATICUS MAJOR
LEVATOR LABII SUPERIORIS PROPRIUS
BUCCINATOR
LEVATOR ANGULI ORIS
MAXILLO LABIAL
ORBICULARIS ORIS
MYLO-HYOID
INFERIOR MAXILLARY BONE

STERNO-MASTOID
INFRAHYOID MUSCLES
MASTOIDO-HUMERALIS
JUGLAR VEIN

ATLAS
AXIS

EXTERNAL AUDITORY CANAL

SUPERIOR MAXILLARY
MOLAR TEETH
INFERIOR MAXILLARY
INTERMAXILLARY OR INCISOR BONE
INCISOR TEETH

FIG. 129.—HEAD. RIGHT LATERAL ASPECT.

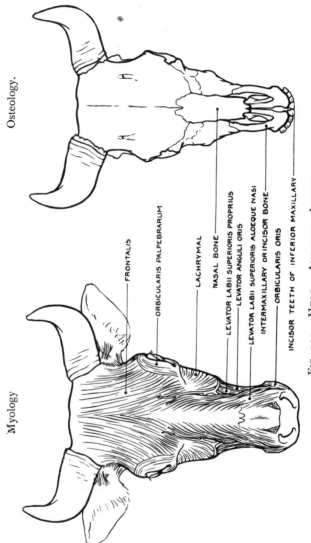

Osteology.

Myology

FRONTALIS

ORBICULARIS PALPEBRARUM

LACHRYMAL

NASAL BONE

LEVATOR LABII SUPERIORIS PROPRIUS

LEVATOR ANGULI ORIS

LEVATOR LABII SUPERIORIS ALOEQUE NASI

INTERMAXILLARY OR INCISOR BONE

ORBICULARIS ORIS

INCISOR TEETH OF INFERIOR MAXILLARY

FIG. 130.—HEAD. ANTERIOR ASPECT.

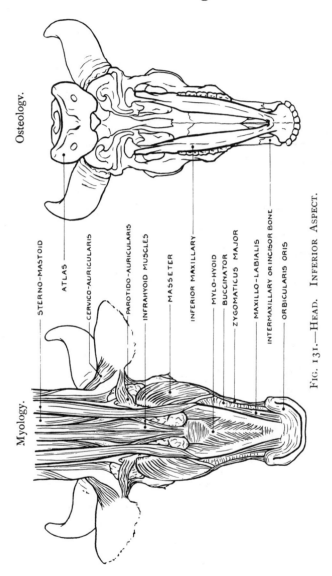

Osteology.

Myology.

STERNO-MASTOID

ATLAS

CERVICO-AURICULARIS

PAROTIDO-AURICULARIS

INFRAHYOID MUSCLES

MASSETER

INFERIOR MAXILLARY

MYLO-HYOID

BUCCINATOR

ZYGOMATICUS MAJOR

MAXILLO-LABIALIS

INTERMAXILLARY OR INCISOR BONE

ORBICULARIS ORIS

FIG. 131.—HEAD. INFERIOR ASPECT.

LEFT RIGHT

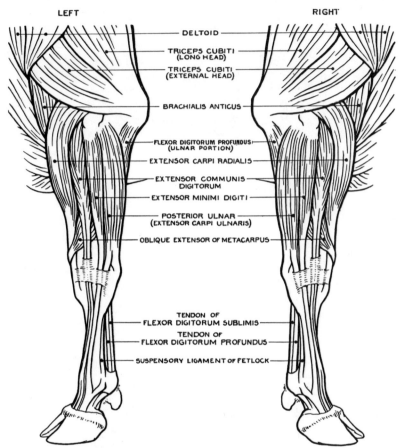

DELTOID

TRICEPS CUBITI
(LONG HEAD)

TRICEPS CUBITI
(EXTERNAL HEAD)

BRACHIALIS ANTICUS

FLEXOR DIGITORUM PROFUNDUS
(ULNAR PORTION)

EXTENSOR CARPI RADIALIS

EXTENSOR COMMUNIS
DIGITORUM

EXTENSOR MINIMI DIGITI

POSTERIOR ULNAR
(EXTENSOR CARPI ULNARIS)

OBLIQUE EXTENSOR OF METACARPUS

TENDON OF
FLEXOR DIGITORUM SUBLIMIS

TENDON OF
FLEXOR DIGITORUM PROFUNDUS

SUSPENSORY LIGAMENT OF FETLOCK

FIG. 132.—FORE-LEG. EXTERNAL ASPECT. Myology.

ATTACHMENTS OF MUSCLES.

DELTOID (origin) scapula : (insertion) humerus. TRICEPS CUBITI (long head) (o.) posterior border of scapula : (i.) olecranon process. TRICEPS CUBITI (external head) (o.) humerus : (i.) olecranon process. BRACHIALIS ANTICUS (o.) humerus : (i.) internal surfaces of radius and ulna. FLEXOR DIGITORUM PROFUNDUS (ulna portion) (o.) olecranon process : (i.) third phalanges (deep flexor of phalanges). EXTENSOR CARPI RADIALIS (anterior extensor of meta-carpus) (o.) external border of humerus : (i.) anterior surface of superior extremity of principal metacarpal. EXTENSOR COMMUNIS DIGITORUM (anterior extensor of phalanges) (o.) inferior part of external border of humerus, and external tuberosity of radius : (i.) muscle divides into two

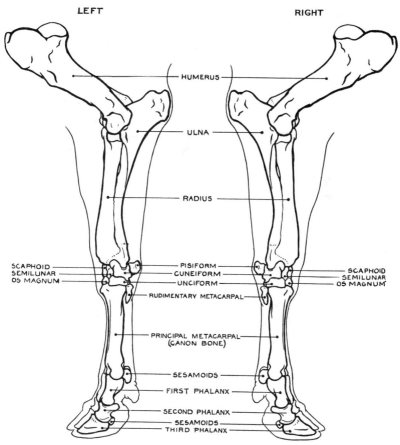

LEFT

RIGHT

HUMERUS

ULNA

RADIUS

SCAPHOID
SEMILUNAR
OS MAGNUM

PISIFORM
CUNEIFORM
UNCIFORM

SCAPHOID
SEMILUNAR
OS MAGNUM

RUDIMENTARY METACARPAL

PRINCIPAL METACARPAL
(CANON BONE)

SESAMOIDS

FIRST PHALANX

SECOND PHALANX
SESAMOIDS
THIRD PHALANX

FIG. 133.—FORE-LEG. EXTERNAL ASPECT. Osteology.

parts ; the tendon of anterior part (proper extensor of inner digit) is inserted into internal phalanges ; the divided tendon of the posterior part (common extensor of the two digits) is inserted into phalanges of both digits. EXTENSOR MINIMI DIGITI (proper extensor of external digit) (o.) external surface of superior extremity of radius : (i.) phalanges of external digit, after receiving reinforcing band from suspensory ligament of fetlock. POSTERIOR ULNAR (extensor carpi ulnaris) (o.) external condyle of humerus : (i.) pisiform, and external surface of superior extremity of principal metacarpal. OBLIQUE EXTENSOR OF METACARPUS (o.) shaft of radius and ulna : (i.) internal surface of superior extremity of principal metacarpal. FLEXOR DIGITORUM SUBLIMIS (superficial flexor of digits) (o.) internal condyle of humerus : (i.) tendon divides and is attached to the second phalanx of both digits.

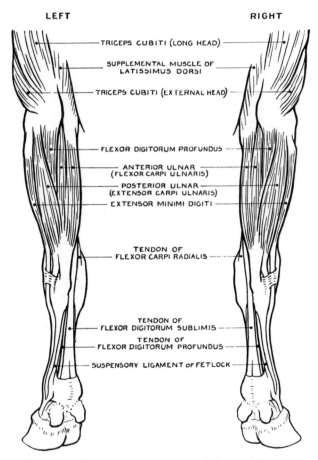

LEFT RIGHT

TRICEPS CUBITI (LONG HEAD)

SUPPLEMENTAL MUSCLE OF LATISSIMUS DORSI

TRICEPS CUBITI (EXTERNAL HEAD)

FLEXOR DIGITORUM PROFUNDUS

ANTERIOR ULNAR (FLEXOR CARPI ULNARIS)

POSTERIOR ULNAR (EXTENSOR CARPI ULNARIS)

EXTENSOR MINIMI DIGITI

TENDON OF FLEXOR CARPI RADIALIS

TENDON OF FLEXOR DIGITORUM SUBLIMIS

TENDON OF FLEXOR DIGITORUM PROFUNDUS

SUSPENSORY LIGAMENT of FETLOCK

FIG. 134.—FORE-LEG. POSTERIOR ASPECT. Myology.

ATTACHMENTS OF MUSCLES.

TRICEPS CUBITI (long head) (origin) scapula : (insertion) olecranon process. SUPPLE-
MENTAL MUSCLE OF LATISSIMUS DORSI (o.) tendon of latissimus dorsi : (i.) olecranon process,
and aponeurosis of leg. TRICEPS CUBITI (external head) (o.) humerus : (i.) olecranon process.
FLEXOR DIGITORUM PROFUNDUS (ulnar portion) (o.) olecranon process : (i.) third phalanges
(deep flexor of phalanges). ANTERIOR ULNAR (flexor carpi ulnaris) (o.) internal condyle of

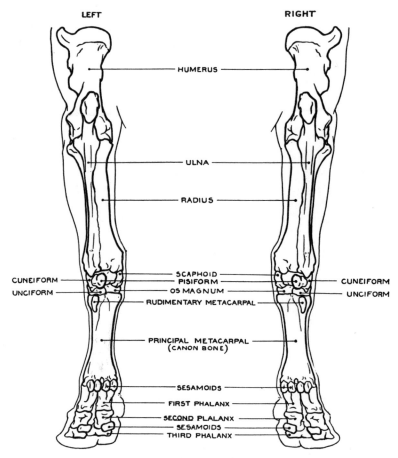

FIG. 135.—FORE-LEG. POSTERIOR ASPECT. Osteology.

humerus, and olecranon : (i.) pisiform. POSTERIOR ULNAR (extensor carpi ulnaris) (o.) external condyle of humerus: (i.) pisiform, and external surface of superior extremity of principal meta-carpal. EXTENSOR MINIMI DIGITI (proper extensor of external digit) (o.) external surface of superior extremity of radius : (i.) phalanges of external digit, after receiving reinforcing band from suspensory ligament of fetlock. FLEXOR DIGITORUM SUBLIMIS (superficial flexor of digits) (o.) internal condyle of humerus : (i.) tendon divides at its lower part, and is attached to the second phalanx of both digits.

Modelling

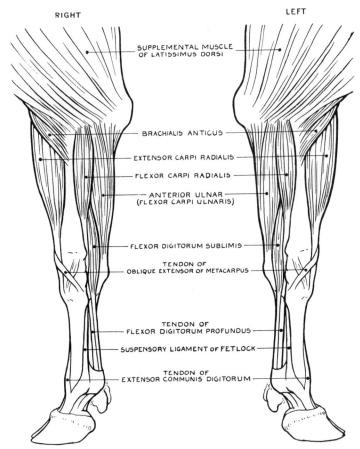

RIGHT LEFT

SUPPLEMENTAL MUSCLE
OF LATISSIMUS DORSI

BRACHIALIS ANTICUS

EXTENSOR CARPI RADIALIS

FLEXOR CARPI RADIALIS

ANTERIOR ULNAR
(FLEXOR CARPI ULNARIS)

FLEXOR DIGITORUM SUBLIMIS

TENDON OF
OBLIQUE EXTENSOR OF METACARPUS

TENDON OF
FLEXOR DIGITORUM PROFUNDUS

SUSPENSORY LIGAMENT of FETLOCK

TENDON OF
EXTENSOR COMMUNIS DIGITORUM

FIG. 136.—FORE-LEG. INTERNAL ASPECT. Myology.

ATTACHMENTS OF MUSCLES.

SUPPLEMENTAL MUSCLE OF LATISSIMUS DORSI (origin) tendon of latissimus dorsi :
(insertion) olecranon process, and aponeurosis of leg. BRACHIALIS ANTICUS (o.) external
aspect of humerus : (i.) internal surfaces of radius and ulna. EXTENSOR CARPI RADIALIS
(anterior extensor of metacarpus) (o.) external border of humerus : (i.) anterior surface of
superior extremity of principal metacarpal. FLEXOR CARPI RADIALIS (internal flexor of meta-
carpus) (o.) internal condyle of humerus : (i.) superior extremity of principal metacarpal.
ANTERIOR ULNAR (flexor carpi ulnaris) (o.) internal condyle of humerus, and olecranon :

Modelling

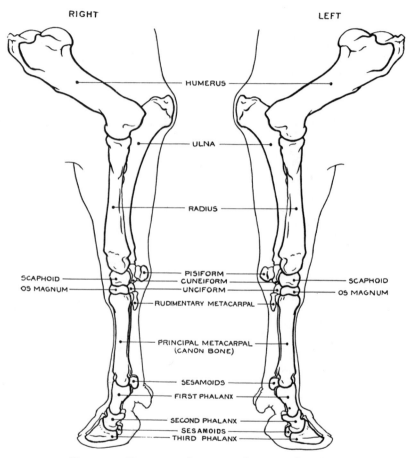

RIGHT

LEFT

HUMERUS

ULNA

RADIUS

SCAPHOID
OS MAGNUM

PISIFORM
CUNEIFORM
UNCIFORM
RUDIMENTARY METACARPAL

SCAPHOID
OS MAGNUM

PRINCIPAL METACARPAL
(CANON BONE)

SESAMOIDS
FIRST PHALANX

SECOND PHALANX
SESAMOIDS
THIRD PHALANX

FIG. 137.—FORE-LEG. INTERNAL ASPECT. Osteology.

(i.) pisiform. FLEXOR DIGITORUM SUBLIMIS (superficial flexor of digits) (o.) internal condyle of humerus : (i.) tendon divides in its lower part and is attached to the second phalanx of both digits. OBLIQUE EXTENSOR OF METACARPUS (o.) shaft of radius and ulna : (i.) internal surface of superior extremity of principal metacarpal. FLEXOR DIGITORUM PROFUNDUS (deep flexor of digits) (o.) olecranon process, and radius : (i.) third phalanx of both digits. EXTENSOR COMMUNIS DIGITORUM (proper extensor of inner digit) (o.) humerus : (i.) phalanges of internal digit, after receiving a reinforcing band from suspensory ligament of fetlock.

RIGHT LEFT

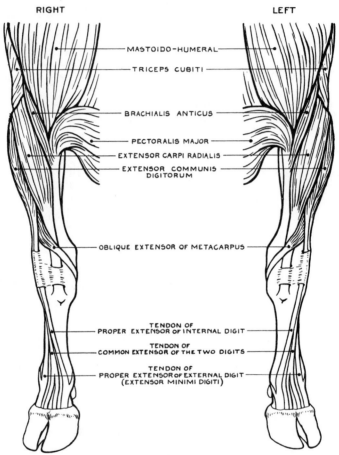

MASTOIDO–HUMERAL

TRICEPS CUBITI

BRACHIALIS ANTICUS

PECTORALIS MAJOR

EXTENSOR CARPI RADIALIS

EXTENSOR COMMUNIS DIGITORUM

OBLIQUE EXTENSOR OF METACARPUS

TENDON OF PROPER EXTENSOR OF INTERNAL DIGIT

TENDON OF COMMON EXTENSOR OF THE TWO DIGITS

TENDON OF PROPER EXTENSOR OF EXTERNAL DIGIT (EXTENSOR MINIMI DIGITI)

FIG. 138.—FORE-LEG. ANTERIOR ASPECT. Myology.

ATTACHMENTS OF MUSCLES.

MASTOIDO-HUMERAL (origin) skull, and neck : (insertion) anterior border of humerus. TRICEPS CUBITI (external head) (o.) humerus : (i.) olecranon process. BRACHIALIS ANTICUS (o.) humerus : (i.) internal surfaces of radius and ulna. PECTORALIS MAJOR (o.) sternum : (i.) humerus, and aponeurosis covering internal surface of leg. EXTENSOR CARPI RADIALIS (anterior extensor of metacarpus) (o.) external border of humerus : (i.) tubercle on anterior surface of principal metacarpal. EXTENSOR COMMUNIS DIGITORUM (anterior extensor of

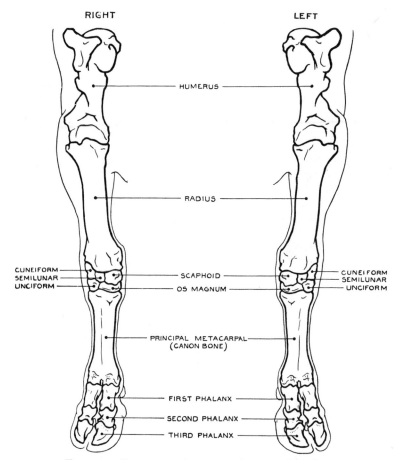

RIGHT LEFT

HUMERUS

RADIUS

CUNEIFORM
SEMILUNAR
UNCIFORM

SCAPHOID

OS MAGNUM

CUNEIFORM
SEMILUNAR
UNCIFORM

PRINCIPAL METACARPAL
(CANON BONE)

FIRST PHALANX

SECOND PHALANX

THIRD PHALANX

FIG. 139.—FORE-LEG. ANTERIOR ASPECT. Osteology.

phalanges) (o.) inferior part of external border of humerus, and external tuberosity of radius: (i.) muscle divides into two parts: the tendon of the anterior part (proper extensor of internal digit) is inserted into phalanges of internal digit; the divided tendon of the posterior part (common extensor of the two digits) is inserted into phalanges of both digits. OBLIQUE EXTENSOR OF METACARPUS (o.) shaft of radius and ulna: (i.) internal surface of superior extremity of principal metacarpal. EXTENSOR MINIMI DIGITI (proper extensor of external digit) (o.) external surface of superior extremity of radius: (i.) phalanges of external digit, after receiving reinforcing band from suspensory ligament of fetlock.

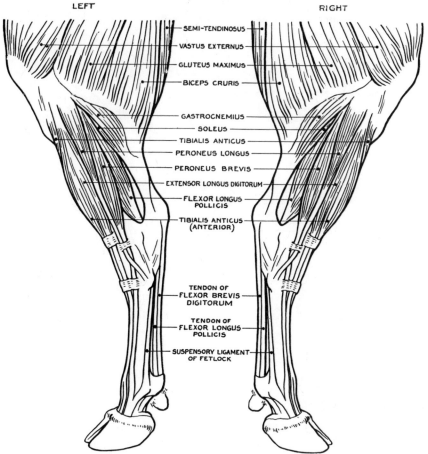

LEFT RIGHT

SEMI-TENDINOSUS

VASTUS EXTERNUS

GLUTEUS MAXIMUS

BICEPS CRURIS

GASTROCNEMIUS

SOLEUS

TIBIALIS ANTICUS

PERONEUS LONGUS

PERONEUS BREVIS

EXTENSOR LONGUS DIGITORUM

FLEXOR LONGUS
POLLICIS

TIBIALIS ANTICUS
(ANTERIOR)

TENDON OF
FLEXOR BREVIS
DIGITORUM

TENDON OF
FLEXOR LONGUS
POLLICIS

SUSPENSORY LIGAMENT
OF FETLOCK

FIG. 140.—HIND-LEG. EXTERNAL ASPECT. Myology.

ATTACHMENTS OF MUSCLES.

SEMI-TENDINOSUS (origin) tuberosity of ischium : (insertion) aponeurosis covering internal surface of leg, and anterior border of tibia. VASTUS EXTERNUS (triceps cruris) (o.) femur : (i.) tendon of rectus femoris, and patella. GLUTEUS MAXIMUS (o.) sacral crest, tuberosity of ischium, and ligament stretching between those points : (i.) fascia lata covering vastus externus, and aponeurosis of leg. BICEPS CRURIS (o.) tuberosity of ischium : (i.) aponeurosis blends with aponeurosis of leg. GASTROCNEMIUS (o.) shaft of femur : (i.) by tendo-Achillis into calcaneum. SOLEUS (o.) external tuberosity of tibia : (i.) tendon unites with that of gastrocnemius. TIBIALIS ANTICUS (o.) tibia : (i.) cuneiform bones and internal surface of superior extremity of principal metatarsal. PERONEUS LONGUS (o.) external tuberosity of tibia : (i.) external surface of rudimentary metatarsal. PERONEUS BREVIS (proper extensor

LEFT RIGHT

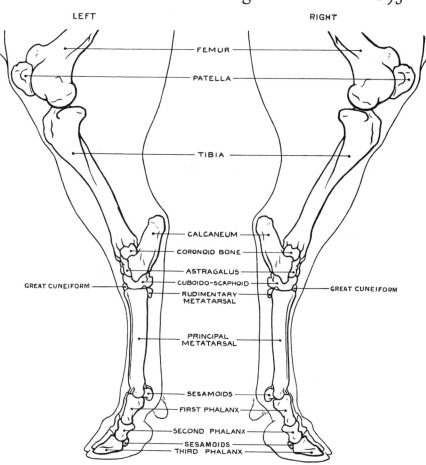

FEMUR

PATELLA

TIBIA

CALCANEUM

CORONOID BONE

ASTRAGALUS

CUBOIDO-SCAPHOID

GREAT CUNEIFORM RUDIMENTARY METATARSAL GREAT CUNEIFORM

PRINCIPAL METATARSAL

SESAMOIDS

FIRST PHALANX

SECOND PHALANX

SESAMOIDS

THIRD PHALANX

FIG. 141.—HIND-LEG. EXTERNAL ASPECT. Osteology.

of external digit): (o.) external tuberosity of tibia, and fibrous band which replaces fibula: (i.) phalanges of external digit, after receiving a reinforcing band from fetlock. EXTENSOR LONGUS DIGITORUM (anterior extensor of phalanges) (o.) external surface of inferior extremity of femur: (i.) divides in region of tarsus; the internal tendon (proper extensor of internal digit) is inserted into phalanges of internal digit, the external tendon (common extensor of the two digits) into phalanges of both digits. FLEXOR LONGUS POLLICIS (deep flexor of phalanges) (o.) tibia: (i.) posterior surfaces of phalanges. TIBIALIS ANTICUS (anterior portion) (o.) with extensor longus digitorum from the external surface of inferior extremity of femur: (i.) cuneiform bones and superior extremity of principal metatarsal. FLEXOR BREVIS DIGITORUM (superficial flexor of digits): (o.) femur: (i.) the tendon passes over the calcaneum and divides in its lower part to be inserted into the second phalanx of both digits.

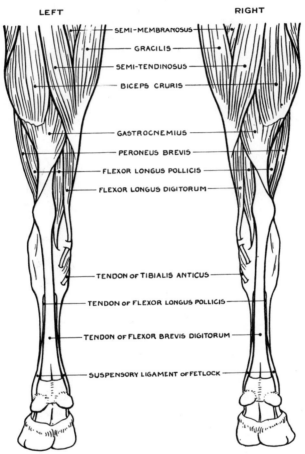

LEFT RIGHT

SEMI-MEMBRANOSUS
GRACILIS
SEMI-TENDINOSUS
BICEPS CRURIS

GASTROCNEMIUS
PERONEUS BREVIS
FLEXOR LONGUS POLLICIS
FLEXOR LONGUS DIGITORUM

TENDON OF TIBIALIS ANTICUS
TENDON OF FLEXOR LONGUS POLLICIS
TENDON OF FLEXOR BREVIS DIGITORUM
SUSPENSORY LIGAMENT OF FETLOCK

FIG. 142.—HIND-LEG. POSTERIOR ASPECT. Myology.

ATTACHMENTS OF MUSCLES.

SEMI-MEMBRANOSUS (posterior portion) (origin) inferior surface and tuberosity of ischium : (insertion) internal surface of superior extremity of tibia. GRACILIS (o.) pubis and neighbouring regions : (i.) internal surface of tibia. SEMI-TENDINOSUS (o.) tuberosity of ischium : (i.) aponeurosis covering internal surface of leg, and anterior border of tibia. BICEPS CRURIS (o.) tuberosity of ischium : (i.) aponeurosis blends with aponeurosis of leg. GASTROCNEMIUS (o.) shaft of femur : (i.) by tendo-Achillis into calcaneum. PERONEUS BREVIS (proper extensor

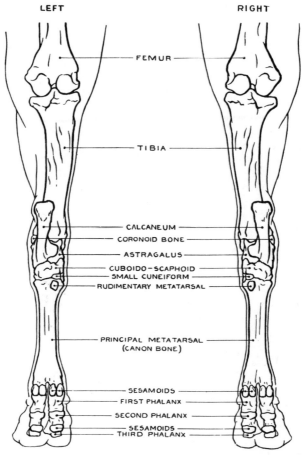

FIG. 143.—HIND-LEG. POSTERIOR ASPECT. Osteology.

of external digit) (o.) external tuberosity of tibia, and fibrous band which replaces fibula : (i.) phalanges of external digit. FLEXOR LONGUS POLLICIS (deep flexor of digits) (o.) tibia : (i.) posterior surfaces of phalanges. FLEXOR LONGUS DIGITORUM (o.) posterior surface of external tuberosity of tibia : (i.) tendon blends with that of flexor longus pollicis. TIBIALIS ANTICUS (o.) tibia : (i.) cuneiform bones and internal surface of superior extremity of principal metatarsal. FLEXOR BREVIS DIGITORUM (superficial flexor of digits) (o.) femur : (i.) the tendon passes over the calcaneum and divides in its lower part to be inserted into the second phalanx of both digits.

RIGHT LEFT

SEMI-MEMBRANOSUS
RECTUS FEMORIS
VASTUS INTERNUS
SARTORIUS
GRACILIS
SEMI-TENDINOSUS

GASTROCNEMIUS
POPLITEUS

FLEXOR LONGUS DIGITORUM
FLEXOR LONGUS POLLICIS
TIBIALIS ANTICUS
(ANTERIOR)

TENDON OF
FLEXOR BREVIS
DIGITORUM

TENDON OF
FLEXOR LONGUS
POLLICIS

SUSPENSORY LIGAMENT
OF FETLOCK

TENDON OF
EXTENSOR LONGUS
DIGITORUM

FIG. 144.—HIND-LEG. INTERNAL ASPECT. Myology.

ATTACHMENTS OF MUSCLES.

SEMI-MEMBRANOSUS (posterior portion) (origin) inferior surface and tuberosity of ischium : (insertion) internal tuberosity of tibia. RECTUS FEMORIS (triceps cruris) (o.) iliac bone : (i.) patella. VASTUS INTERNUS (triceps cruris) (o.) femur : (i.) patella. SARTORIUS (o.) inferior aspect of pelvis : (i.) aponeurosis blends with that of gracilis GRACILIS (o.) pubis and neighbouring regions : (i.) internal surface of tibia. SEMI-TENDINOSUS (o.) tuberosity of ischium : (i.) aponeurosis covering internal surface of leg, and anterior border of tibia. GASTROCNEMIUS (o.) shaft of femur : (i.) by tendo-Achillis into calcaneum. POPLITEUS (o.) external condyle of femur : (i.) posterior surface and internal border of tibia. FLEXOR LONGUS

RIGHT LEFT

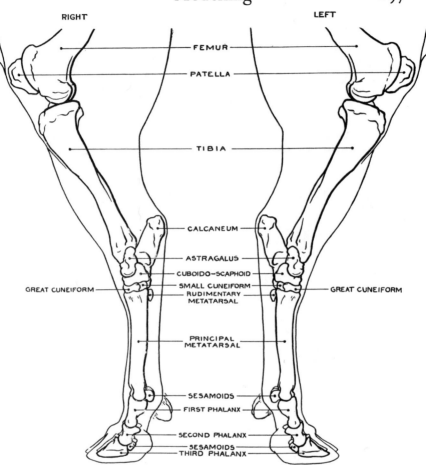

FEMUR

PATELLA

TIBIA

CALCANEUM

ASTRAGALUS

CUBOIDO–SCAPHOID

SMALL CUNEIFORM

GREAT CUNEIFORM RUDIMENTARY GREAT CUNEIFORM
METATARSAL

PRINCIPAL
METATARSAL

SESAMOIDS

FIRST PHALANX

SECOND PHALANX

SESAMOIDS
THIRD PHALANX

FIG. 145.—HIND-LEG. INTERNAL ASPECT. Osteology.

DIGITORUM (o.) posterior surface of external tuberosity of tibia : (i.) tendon blends with that of flexor longus pollicis. FLEXOR LONGUS POLLICIS (deep flexor of digits) (o.) tibia : (i.) posterior surfaces of phalanges. TIBIALIS ANTICUS (anterior portion) (o.) external surface of inferior extremity of femur : (i.) cuneiform bones and superior extremity of principal metatarsal. FLEXOR BREVIS DIGITORUM (superficial flexor of digits) (o.) femur : (i.) the tendon passes over the calcaneum and divides in its lower part to be inserted into the second phalanx of both digits. EXTENSOR LONGUS DIGITORUM (o.) external surface of inferior extremity of femur (i.) tendon forming the proper extensor of internal digit is inserted into the phalanges of that digit, after receiving a reinforcing band from fetlock.

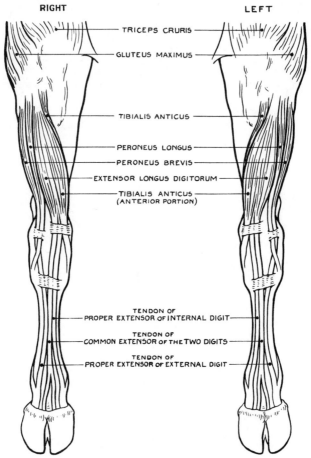

RIGHT LEFT

TRICEPS CRURIS

GLUTEUS MAXIMUS

TIBIALIS ANTICUS

PERONEUS LONGUS

PERONEUS BREVIS

EXTENSOR LONGUS DIGITORUM

TIBIALIS ANTICUS
(ANTERIOR PORTION)

TENDON OF
PROPER EXTENSOR OF INTERNAL DIGIT

TENDON OF
COMMON EXTENSOR OF THE TWO DIGITS

TENDON OF
PROPER EXTENSOR OF EXTERNAL DIGIT

FIG. 146.—HIND-LEG. ANTERIOR ASPECT. Myology.

ATTACHMENTS OF MUSCLES.

TRICEPS CRURIS (origin) rectus femoris arises from the iliac bone, vastus externus and vastus internus from the femur : (insertion) patella. GLUTEUS MAXIMUS (o.) sacral crest, tuberosity of ischium and ligament stretching between those points : (i.) fascia lata covering vastus externus, and aponeurosis of leg. TIBIALIS ANTICUS (o.) tibia : (i.) cuneiform bones and internal surface of superior extremity of principal metatarsal. PERONEUS LONGUS (o.) external tuberosity of tibia : (i.) external surface of rudimentary metatarsal. PERONEUS BREVIS (proper extensor of external digit) (o.) external tuberosity of tibia, and fibrous band which replaces

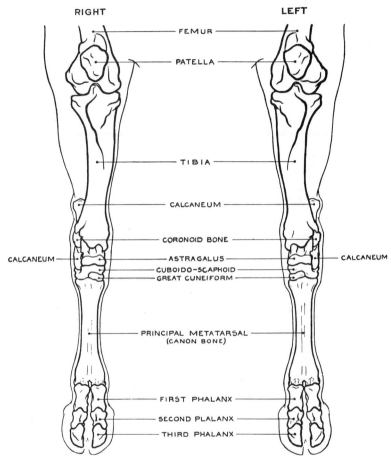

RIGHT LEFT

FEMUR

PATELLA

TIBIA

CALCANEUM

CORONOID BONE

CALCANEUM — ASTRAGALUS — CALCANEUM
CUBOIDO-SCAPHOID
GREAT CUNEIFORM

PRINCIPAL METATARSAL
(CANON BONE)

FIRST PHALANX

SECOND PLALANX

THIRD PHALANX

FIG. 147.—HIND-LEG. ANTERIOR ASPECT. Osteology.

fibula : (i.) phalanges of external digit, after receiving a reinforcing band from fetlock. EXTENSOR LONGUS DIGITORUM (anterior extensor of digits) (o.) external surface of inferior extremity ot femur : (i.) divides in region of tarsus ; the external tendon (common extensor of the two digits) is inserted into the phalanges of both digits, the internal tendon (proper extensor of internal digit) into the phalanges of internal digit, after receiving a reinforcing band from fetlock. TIBIALIS ANTICUS (anterior portion) (o.) with extensor longus digitorum from the external surface of inferior extremity of femur : (i.) cuneiform bones and internal surface of superior extremity of principal metatarsal.

CASTING IN PLASTER

FIG. 148.—NECESSARY REQUISITES FOR CASTING.

A. Large bowl for mixing plaster in.
B. Small bowl for use in hand.
C. Spoon for mixing plaster.
D. Small brush for oiling details of mould.
E. Large brush for washing mould.
F. Spatula for plaster work.
G. Spatula for removing clay from mould.

H. Soft brush for soaping mould.
I. Small chisel for chipping out.
J. Knife for trimming edges of mould.
K. Tool for drilling keyholes.
L. Piece of hard wood for use as mallet.
M. Large chisel for chipping out.

CASTING IN PLASTER

I SHALL limit myself here to the description of the method generally employed for the casting of a bust, a figure, and a high relief. Though by no method can one hope to arrive at perfection in work, which is purely a matter of practice, I hope, nevertheless, that these notes will prove useful. I have tried to omit nothing, for it is only by the greatest care given to details that it is possible to obtain a good cast.

I. *The casting of a bust.*

Division of the bust.—The method is the same whether the bust be life-size or in any other proportion. The modelling of the bust completed, it has to be framed in a band of clay $1\frac{1}{4}$ inches wide and about $\frac{1}{4}$ inch thick (Fig. 149).

This band of clay is prepared as follows. Make a roll of clay 1 inch thick and at least one foot long according to the size of the bust. Put the roll of clay on a straight and smooth board, beat it with the hand until it is absolutely flat and about $\frac{1}{4}$ inch thick. Pass then a large knife on the

surface to render it perfectly smooth and cut it lengthways with the knife, so that its width throughout is $1\frac{1}{4}$ inches. This done, fix it on the surface of the sides and top of the clay model so that the latter is divided into two parts—a front and a back part. Begin at the middle of the head and make the band pass down at about half an inch behind the ears, curving round and descending along the sides of the neck to the base of the bust, on either side, so that ultimately the back piece of the mould shall be the shallower part of the two. This band of clay must adhere truly throughout to the surface of the modelling, without being pressed too tightly against it, so that it should not stick too tenaciously, but so that there be no interstices between the band and the bust. Strengthen it by adding here and there from behind small slips of clay (see Fig. 150). The surface of this band will become the border of the anterior part of the mould.

Now cover all the posterior parts of the bust with soft paper moistened with water; this is to prevent any of the liquid plaster, when thrown on the face, falling on the back of the bust (Fig. 151).

Mixing the plaster.—In a pail put a small handful of red or yellow ochre and fill it half full with clean water which will be coloured accordingly, mix well, and then—for a bust life-size and without shoulders, as here represented—take in a basin about four pints of this coloured water and mix the plaster with it. In

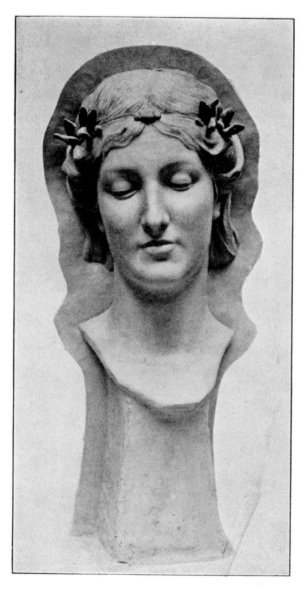

Fig. 149.—Photo showing Clay Band round the Bust.

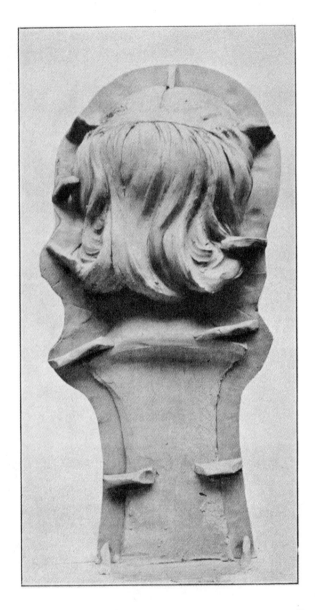

FIG. 150.—PHOTO SHOWING PIECES OF CLAY SUPPORTING THE BAND.

FIG. 151.—PHOTO SHOWING THE BACK OF BUST PROTECTED WITH
MOISTENED PAPER.

doing this be careful not to let the plaster fall in all at once, but only as a fine powder. To do this the best way is to take a good handful and, by moving the fingers, allow the plaster gradually to pass through them, moving the hand above the water, so that it shall not all fall at the same place. When the plaster begins to settle beneath the surface of the water, there is enough, for the mixed plaster must be sufficiently liquid to penetrate the smallest cavities of the modelling. Then stir the plaster well, being careful that the spoon goes to the bottom of the basin, until it is thoroughly and equally mixed with the water, and has a thin creamy consistency.

First layer of yellow plaster.—Fill a small basin with the plaster and use immediately; holding the basin in one hand, scoop the plaster out with the other and throw it on the bust. Enough force must be used to make sure that it penetrates the smallest anfractuosities. Begin with the top of the bust and work downwards gradually to the base and on either sides to the band of clay. This first layer should not be too thick; $\frac{1}{8}$ to $\frac{3}{8}$ of an inch will be sufficient, the only use of this yellow layer being to act as a warning when breaking the mould that one is approaching the surface of the cast. This yellow layer will be made at first fairly equal over the whole surface of the bust, but much thicker near the band of clay; then, when the plaster begins to set, add small lumps wherever there is a salient part, nose, chin,

tufts of hair, etc. ; then again here and there on the other parts, so that this first layer be not smooth, but, on the contrary, as rough as possible ; otherwise it may happen that during subsequent operations it become detached from the second layer (which will be of white plaster) ; being rough it grips the second layer better (Fig. 152).

This first layer finished, pass over it a little clay water, which is made thus : put in a plate or any other vessel a lump of clay about the size of the fist, flatten it and pour a glass of water over it ; dip a fair-sized brush in the water and rub it on the lump of clay, which makes the water muddy, then pass the brush lightly over the layer of yellow plaster, being careful not to do so near the borders of the mould, that is on the part near the band of clay, because it is necessary that there the two layers should be intimately clenched so as to remove all danger of the two separating before the chipping process. This light covering of clay water on the greater part of the yellow layer will facilitate the separation of the white layer when the mould is chipped off.

Second layer and irons.—Prepare the plaster for the second layer in the same way as for the first layer, but without the ochre, being always careful to let it fall in the water in a fine powder, to mix it well and to stir up the plaster with the spoon right to the bottom of the basin. Throw

FIG. 152.—PHOTO SHOWING FIRST LAYER OF PLASTER (Yellow).

this plaster on the first layer, giving it about half an inch thickness, and at the sides to the full thickness of the band of clay, for the border of a mould must always be extra strong. On this white layer fix with a little plaster the irons which will have been already prepared, arranging them so that this piece shall be of great strength and that one of them grip the mould all round as shown in the figure. (Fig. 153.

Over this add more plaster, so as to bind the irons together and give a total thickness to the mould of about $1\frac{1}{4}$ inches.

Preparation of the edges of the front piece.—The plaster having set, remove from behind the band of clay which framed the bust and with a knife trim where necessary this part of the plaster, and at the same time cut it so as to form an angle as shown in Fig. 154.

By this means and by means of the holes made in the mould, and described further on, the immobility of the front and back pieces when put together will be safeguarded. Avoid as far as possible letting the crumpled plaster resulting from the cutting fall on the clay of the bust, and should this happen, blow it off or use a light brush in such a way as not to tamper with the delicacy of the modelling. Better still, protect the surface with a piece of cloth before cutting. When the borders of the plaster are quite smooth, make at

intervals, with the instrument depicted in Fig. 148 the holes referred to above.

Apply the sharp pointed end of the instrument to the plaster and, using the hands flat against the handle, make it rotate. It will thus penetrate into the plaster to about $\frac{3}{8}$ of an inch deep, making a hole about 1 inch wide (see Fig. 154).

Next, pass equally over all this part a brush dipped in the clay water; this will prevent the plaster of the second piece or shell of the back of the bust adhering to the front piece.

This done, place sideways at intervals on the border of the mould and between the holes, small wedge-shaped pieces of clay, $\frac{1}{2}$ inch across and $\frac{1}{4}$ inch thick, the thin end being placed $\frac{1}{4}$ of an inch from the bust, the thick end jutting outwards to the border of the mould (see Fig. 154).

The idea of these slips of clay is that when the mould is complete and the two shells (the front and back) have to be separated, wooden wedges may be pushed into the places they occupy on which by striking lightly the two shells may easily be separated.

The front shell is now complete.

The Back Piece of the Mould.—It now remains to do for the back of the bust what has been done for the front, to throw on the clay a layer of yellow plaster, being careful

FIG. 153.—PHOTO SHOWING IRONS FIXED (Front).

FIG. 154.—PHOTO SHOWING PREPARATION OF EDGE OF FRONT PIECE.

to mix the ochre with the water, delaying the plaster and throwing it on the clay as before, and leaving the surface rough so that the second layer bites well on the first. In the same way the first layer will be brushed over with the clay-water but leaving the sides untouched, so that the two layers may here be firmly gripped together, and making the layer thicker at this part (Fig. 155).

On this yellow layer, a layer of white plaster will be put, the irons fixed (Fig. 156) and a final layer of white plaster will bind the whole together as in the case of the front shell.

The entire mould is now complete.

Opening of the Mould.—Before attempting this let the plaster set for at least half an hour. It is now that the wooden wedges, which should be blunt, are used. If they were too sharp, by striking them they would penetrate into the clay of the bust without separating the shells, and if over thick in forcing them in they would fret away the sides of the holes and break the mould. These wooden wedges are introduced into the places filled by the slips of clay, then by striking them lightly one after the other all round the mould and by allowing at intervals a little water to penetrate through the top of the mould, so that it finds its way between the clay of the bust and the mould, it will be easy to detach the back piece from the clay (Fig. 157).

The back piece removed there remains to empty the front piece of all the clay and of the armature of the bust.

Washing the Mould.—When the two shells are separated, place them under a tap and allow the water to run into the interior and with a large soft brush clean them well, so that there remains no trace of clay in them. If there are deep parts where the clay cannot be reached with the brush, use a small modelling tool to remove it, and afterwards a fine brush. The shell once clean allow it to dry for about a quarter of an hour until the interior surface is dull. Figures 158 and 159 show the two shells washed and it will be seen that the holes made in the front shell have come out in relief on the second shell.

Soaping and Oiling the Mould.—I have already described in the second volume, under the heading medals, the way to prepare the soap for this purpose. I will, however, repeat it here.

Put one pint of boiling water in a saucepan and add to it two good tablespoonfuls of black soft soap of unadulterated quality. Let this boil, and stir it until the soap is quite dissolved. When cold keep it in a corked bottle. I strongly recommend you to use no other preparation, as unless the soap is boiled there will be unevennesses on the cast, for soft soap is never quite dissolved when put in cold water. Nor

Fig. 155.—Photo showing First Layer Plaster (Yellow) on Back of Bust.

FIG. 156.—PHOTO SHOWING IRONS FIXED (Back)

Fig. 157.—Photo showing the Method of Opening the Mould.

FIG. 158.—PHOTO SHOWING FRONT PIECE OF MOULD.

FIG. 159.—PHOTO SHOWING BACK PIECE OF MOULD.

would I advise you to use hard soap by rubbing a wet brush on it and painting the mould with the froth; this will cause an undesirable thickness in the mould and corresponding bluntness in the proof.

You may use the boiled soap hot or cold; it is of no matter; only it must be liquid, and should it be too thick, add more boiling water to thin it.

Pour now into each of the shells about a cupful of the soap, or perhaps a little more, and using a large soft brush spread it over all the surfaces and into the deep parts of the shells, repeating the process several times. A quarter of an hour will not be too long to ensure the soap penetrating everywhere into the plaster. The liquid is then poured off and after having given the shells enough time to absorb the soap left on the surface, remove with a soft brush whatever traces of soap remain in the hollows, and let them lie flat until the surface appears dry; that is for about a quarter of an hour. Now take a very small quantity of olive oil in the hollow of your hand, and rub a thoroughly dry, soft brush into it, so that the hairs of the brush are just moistened at the extremities. If too much oil should have been taken up forming diminutive drops on the end of the brush, you must wipe them off with a clean linen rag. Pass this brush gently over the surface of the soaped mould until you perceive a diffuse sheen on the surface of the plaster.

When the two shells have thus been thoroughly washed, all traces of clay removed, soaped and oiled, place them in water for about twenty minutes, or if there be no receptacle big enough, use a gardener's syringe to wet them thoroughly inside and outside. If this precaution be not taken, there will be small holes in the cast, caused by the dryness of the mould tending to absorb the moisture of the cast and leaving air bubbles in place. Many plaster workers neglect this, the result being that when working on the cast, the surface of which may appear perfectly smooth, in scraping the surface lightly a quantity of air-holes are met with, causing great annoyance. It is evident that it is quite out of the question putting very large pieces of a sculptural mould in water, and when using the syringe, the mould must be given as much water as it will absorb. A few air bubbles in a large work have never the importance that they have in a bust, or still more in works of small proportion, such as a medal.

Remove the pieces of the mould from the water, allowing them to drip thoroughly for a few minutes by standing until the surfaces are quite dry ; then put the pieces together and bind them strongly with a cord, making them fit closely one to the other. So that this cord shall be taut around the mould, press a few wedge-shaped pieces of wood between the cord and the plaster, or employ any means which will ensure the two shells being intimately joined.

Running in the Cast.—Mix enough plaster to give a first coating all over the inside of the mould. For a bust with little chest, such as the one given here, about five or six pints of water will be sufficient. Stir the plaster with a spoon so that it be well mixed, then, placing the mould head downwards, pour all the plaster in the interior (Fig. 160), then turn the mould in all directions so that the plaster penetrates into all the cavities.

At the end of two or three minutes of this, empty the plaster back into the basin, and empty it again from the basin into the mould, keeping up always the movement of rotation of the mould, so that the layer of plaster shall have about the same thickness throughout, and continuing until the plaster begins to run less freely. Mix at once the same quantity of plaster and pour it into the mould, before the first layer is quite set, and turn the mould as before so that the plaster runs all over the interior, emptying it into the basin and back in to the mould while it is liquid. This operation may be repeated three or four times according to the thickness to be given to the cast. This thickness obtained, allow the plaster to set for at least half an hour; still longer is better. When there are very deep parts in the mould, into which it may be thought that the plaster will not run, these may be filled with plaster before the two shells are attached together by means of a

small brush; this plaster will become fixed to that which is run in afterwards.

Chipping off the Mould.—Now begins the operation of the removal, that is to say the chipping of the mould. For this different size chisels and a wooden mallet are necessary.

Put the mould, in which now the plaster has replaced the clay, on a strong table or stool, standing perfectly straight so that the mould remain steady while it is being struck. The chisels used must not be too sharp ; otherwise they will penetrate too easily through the mould, and the risk will be that they may reach the cast. With the mallet and chisel begin by digging out the irons front and back ; then chip away the upper part of the mould, removing all the white plaster (Fig. 161), a process greatly facilitated over the greater part, by the washing of clay-water previously passed over the first or yellow layer.

Continue thus all round the bust, leaving, however, a certain quantity of white plaster between the chest and chin, so as to give the head an added support during the operation. When all the white layer has been removed, with another chisel, the blade of which is not so wide and, still more, not so sharp, and which must be held at right angles with the mould, chip away the yellow plaster, striking lightly but at the same time rather sharply, so that the plaster separates by cracking rather than by cutting. Great care is required so that the chisel shall not enter too deeply, for fear of touching the

FIG. 160.—PHOTO SHOWING MOULD TIED UP AND BEING FILLED.

Fig. 161.—Photo showing the White Plaster partly removed.

FIG. 162.—PHOTO SHOWING YELLOW PLASTER PARTLY REMOVED, AND
WHITE SUPPORTING PLASTER LEFT UNDER CHIN.

cast (Fig. 162). When the cast has been freed throughout elsewhere, remove the support left between the chest and chin. There only remains now to remove with a scraper the mark of the join between the two pieces of the mould.

II. *The Casting of a figure.*

Bands of clay and first layer (yellow).—The method employed for casting a figure, though more complicated, is the same as for a bust.

Figure 163 shows how to fix the bands of clay around the model, their purpose being as before to divide the mould into two pieces. When these bands of clay are fixed and strengthened from behind by lumps of clay (Fig. 164) cover all the back with soft moistened paper as shown in Fig. 166.

Next in water tinted with ochre mix enough plaster to cover all the front of the figure; this plaster being well stirred and of the proper liquid consistency, throw it with one hand, using enough force to ensure its penetrating all the parts of the figure; this layer being generally not more than $\frac{1}{4}$ to $\frac{3}{8}$ of an inch in thickness. When the plaster begins to set place lumps here and there to ensure the surface being as rough as possible and increase the thickness near the band of clay (Fig. 165).

When a staff is placed in the hand as in the annexed study, it can be left in the mould, and it will be caught in the

plaster and found in the same position it occupied in the clay model.

The yellow layer being sufficiently set, brush it over with clay-water, keeping well away from the external borders of the mould.

Placing the external irons.—As it is of great importance that the front piece of the mould be particularly strong, this piece having to serve as a support for the two back pieces, it must therefore be strengthened with irons placed throughout the length of the figure. Thus, after having added over the yellow layer a layer of white plaster, about $\frac{3}{8}$ of an inch thick, leaving the surface rough, the irons will be placed over this layer as shown in Fig. 167 and fixed with a little plaster.

It will be seen in this figure that one of the irons starts from the middle of the figure to act as a support for the mould of the arm, which must be done in any case when there is in the pose an isolated part as the arm in the example given.

The irons fixed, add more white plaster over them so as to obtain finally a rather strong mass.

Cutting the joins.—When the plaster of the front shell is sufficiently set, remove from behind the clay band and with a knife trim the parts of the plaster which were touching the band and cut it in such a way that it forms an obtuse angle ;

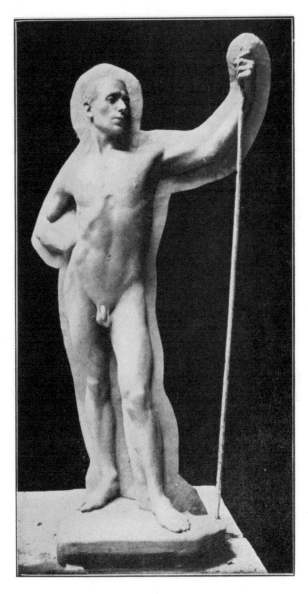

FIG. 163.—PHOTO SHOWING CLAY BANDS.

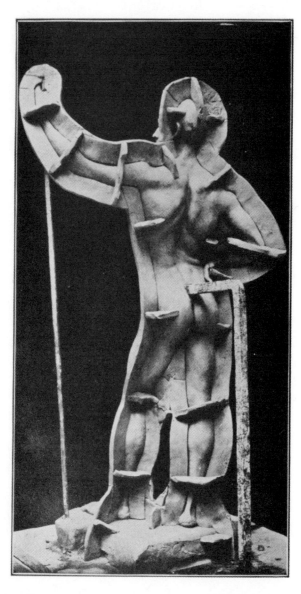

FIG. 164.—PHOTO SHOWING PIECES OF CLAY SUPPORTING THE BANDS.

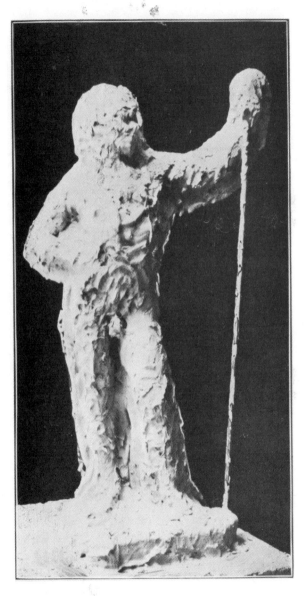

Fig. 165.—Photo showing First Layer of Plaster (Yellow).

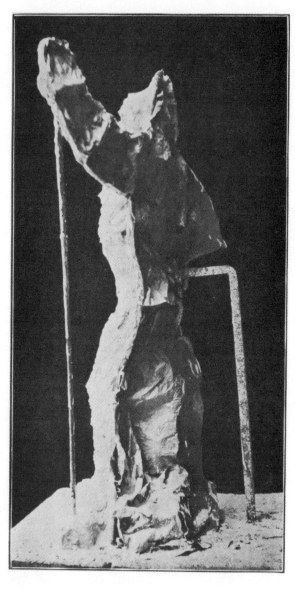

FIG. 166.—Photo showing Back of Figure Protected with
Moistened Paper.

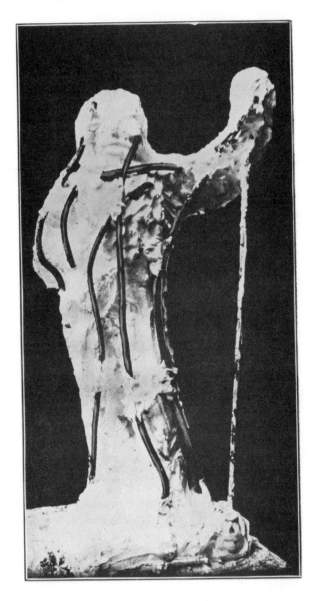

Fig. 167.—Photo showing Irons Fixed (Front).

this is done by removing more on the external edge, starting from about the middle of the thickness of the plaster. Fig. 168 shows clearly the way to cut the border of the shell. When the plaster is smooth, make keyholes all round the border and wash the whole with clay-water to prevent the back pieces when completed adhering to the front piece. Then as was done with the bust place slips of clay at intervals between the keyholes, for the subsequent introduction of the wedges of wood during the process of separation. (See Fig. 168.)

The back pieces.—Begin by surrounding with a little clay the part of the iron support, where it enters the figure, this support being square; if it were not thus surrounded, it would be clenched by the plaster of the lower piece and it would be very difficult to remove the latter; the clay thus added should be given a more or less round shape. Next, at the level where the iron supports enter the clay of the figure, put a band of clay crossways, over the two free borders of the plaster of the front piece (Fig. 168), supporting it by adding above two lumps of clay.

Next in the lower space formed by this band of clay, the surface of the plaster and the plinth, throw a layer of yellow plaster, leaving the surface rough, and when set brushing it over with clay-water, always excepting the parts near the joins. There remains to add a slight layer of white

plaster to receive one or two irons and to finish with a final layer of plaster as shown in Fig. 169.

Remove now the band of clay and trim the edge of the plaster, but this time without making any keyholes, which would only hinder the removal of the upper piece when completed. Pass clay-water over the edge.

This figure shows half-way up the arm a band of clay, which will allow later of the making of a special piece for the arm. The reason of this piece is that the arm being at some distance from the remainder of the figure, it might happen that in running the plaster into the mould, it should not reach there. This band fixed on the arm, carry out over the remainder of the back the same process as for the lower part of the figure : a layer of yellow plaster, rough surface, a wash with clay-water, a slight layer of white plaster, placing the two irons, and filling up with more plaster.

When the plaster is set, remove the band of clay across the arm, trim the free border of the plaster, without key-holes, pass clay-water over it and make the third piece, which is that of the arm, in the same way as the preceding pieces ; but no iron will be necessary for this.

The mould is now complete.

Opening the Mould.—Figure 170 shows that the first piece to remove is that of the arm, which being the smallest can be easily detached by introducing a chisel in the joins,

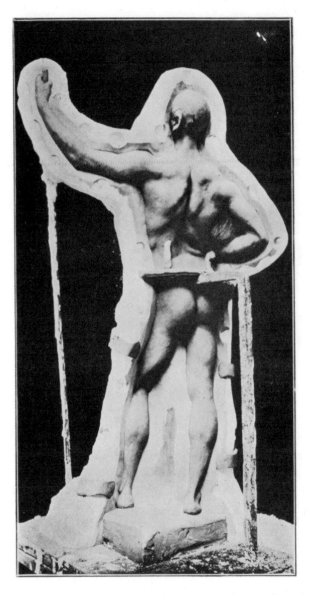

Fig. 168.—Photo showing Divisions of Back with Clay Band.

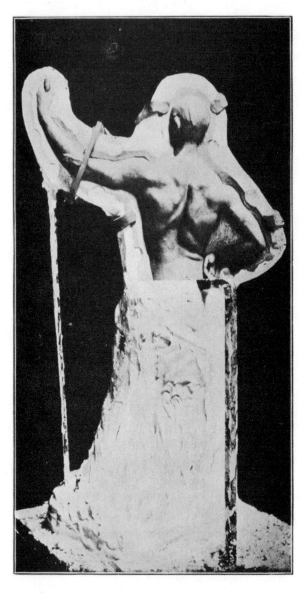

FIG. 169.—PHOTO SHOWING LOWER PIECE COMPLETED, AND DIVISION
OF ARMS.

FIG. 170.—PHOTO SHOWING THE OPENING OF THE MOULD.

weighing slightly on it at intervals and allowing water to run from a sponge on the places where the chisel has been used.

The next piece to remove is that of the upper part of the back, by introducing the wooden wedges where the slips of clay were placed. By striking slightly on the wedges and using water, the piece will easily come away. Figure 170 shows also this part of the process.

Do the same for the lower piece.

If the iron support of the figure is too near the mould, it will be almost impossible to move away that piece ; in this case remove the front shell, emptying it beforehand of the clay and armature in the upper part, thus freeing the clay of the legs, which can now be removed with the armature disengaging the lower piece of the back, which can then be easily taken away. But if the iron support is placed far enough away from the mould, this operation is not necessary and the lower piece will be removed in the same way as the upper piece. Figure 171 shows this piece detached from the clay.

Where the above process is not necessary it now remains to remove the clay in the ordinary way. To do this use a spatula, being careful not to dig too deeply with it; otherwise the mould may be damaged. When the piping of the armature of the figure is reached there must be no hesitation

about breaking it; to try to preserve it would only create difficulties in the removal of the clay and there would be the further risk of damaging the mould (Fig. 172). In a large figure the armature must always be broken up as the clay is removed.

Figures 173 and 174 show the four pieces of the mould finished and washed as was done for the bust.

It will be noticed that a groove runs round the entire back piece of the arm and a similar groove round the front piece: these grooves are about $\frac{1}{8}$ of an inch deep and situated $\frac{1}{8}$ of an inch from the cavity of the mould. I shall explain further on the reason of these grooves, which must, however, be made at present. It will also be seen in these figures (173 and 174) that the join of the front piece, which has been cut at an angle, from within outwards, is represented on the back piece by an angle in a contrary direction. This disposition ensures that when these two pieces are put together, there shall be no possible movement, which would infallibly happen if the joins were cut straight.

If it is necessary to leave the mould for a time before proceeding with the cast, one cannot be too careful to bind the pieces strongly together, so as to prevent their swelling, for if this were to happen they would no longer fit truly.

Soaping and Oiling the Mould.—As for the bust, spread

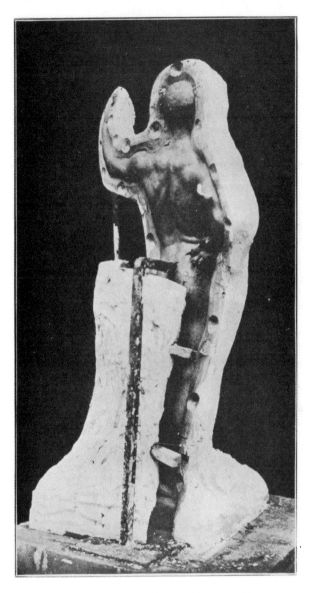

FIG. 171.—PHOTO SHOWING THE LOWER PIECE OF BACK DETACHED.

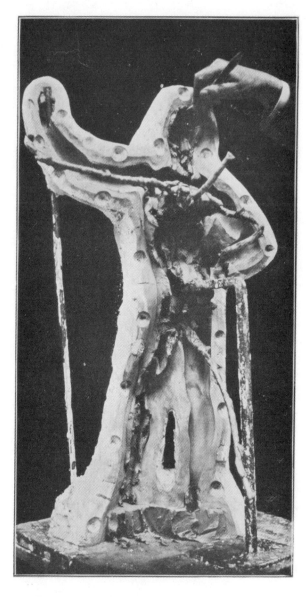

Fig. 172.—Photo showing the Removal of Clay and Armature.

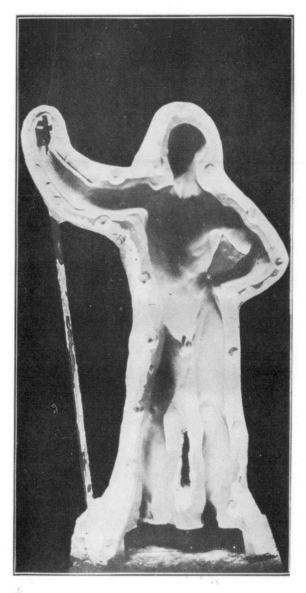

Fig. 173.—Photo showing Front Piece of Mould.

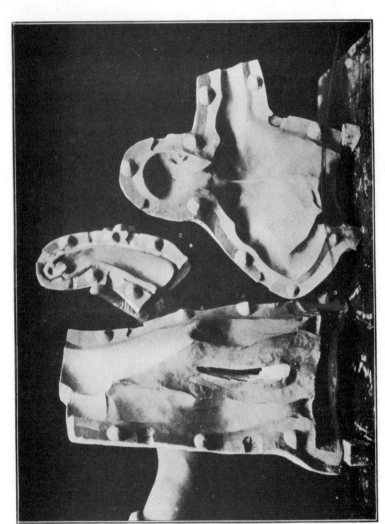

Fig. 174.—Photo showing Back Pieces of Mould.

over all the shells a certain quantity of soap, prepared as described before, using a fair size brush, and leaving it on for a quarter of an hour or more. Should the plaster of the mould be dry, having been kept for several days, it will be necessary to allow the soap to remain in the mould longer. The soap must never be used until the interior surface of the mould is quite dry after the washing. When the soap remaining on the surface has been removed with a brush, and when there is no further trace of dampness, pass the oil over the surface lightly with a very soft brush, being careful that no great quantity is used. This done place all the pieces in water for at least twenty minutes.

Placing Irons of the Armature of the Cast.—This figure (176) shows the direction that the irons must have in the interior of the mould ; shape them at first so that they occupy the centre of the limbs and this position may be found correctly by supporting them with pieces of clay. The lower end of those of the legs must be bent at a right angle so that later they may be solidly fixed into the plinth (Fig. 175). If this precaution were neglected, the cast, notwithstanding the irons in the legs, would easily break, and it is only by fixing these irons strongly into the plinth, that they have the strength necesssry to support the figure. When their positions have been properly established, remove them and the pieces of clay used as temporary supports, being

careful to sponge thoroughly those parts of the mould against which these pieces of clay have rested. Next heat the irons slightly and pass over them a coat of Brunswick-black, so that they may not cause rust spots in the cast. When the

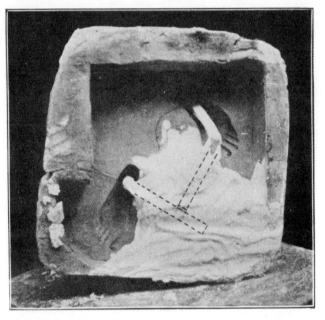

Fig. 175.

Brunswick-black is quite dry, cover the irons with a little plaster left rough which must be allowed to set, as shown in Figure 177.

Next place the irons in the front shell, beginning with those of the legs. For this, cover the mould of the plinth

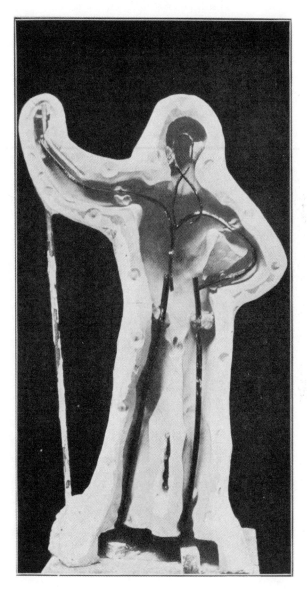

Fig. 176.—Photo showing Irons temporarily placed with Clay.

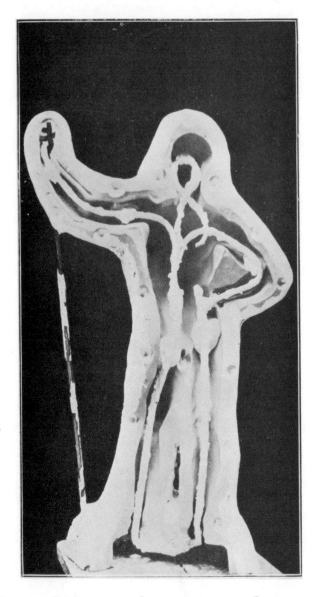

FIG. 177.—PHOTO SHOWING IRONS COVERED WITH PLASTER AND
FIXED IN MOULD.

with a layer of plaster sufficient to secure the ends of the irons, care being taken not to stop up the holes of the legs through which the plaster will have to be poured (Fig. 175).

Then give the irons the proper direction, well in the centre of the legs, supporting them at the level of the hips with plaster which will adhere to the mould. Do the same for the arms ; but these plaster supports must in all cases be placed so as not to impede the free flow of the liquid plaster later on.

When these plaster supports are set, place all the pieces of the mould together and bind them with cords, using wooden wedges as for the bust. See that these wooden wedges under the cords are placed in opposite directions over the upper and lower parts of the mould ; that is with the thick end downward in the case of the upper part, and the contrary in the case of the lower. Figures 178 and 179 show the way this should be carried out.

If the cords are damped they will bind the pieces together still more intimately.

Fill with clay the hole made in the mould by the iron support of the figure ; otherwise when the liquid plaster is poured into the mould it will escape by this opening.

Running the Plaster into the Mould.—The mould being well soaped and oiled, soaked in water, the irons fixed and the

whole firmly bound together, the next step is to run into the mould the plaster for the cast.

As it is very difficult for a beginner to cast a hollow replica, I should recommend him to make a solid one as this entails less risk.

Before proceeding with the filling of the general cavity it is necessary, however, to cast first the small piece of the arm. To do this mix enough plaster to fill the front and back pieces of this part, known technically as "the cap," and when the plaster is flush with the rim of the free piece and beginning to set, add just a little more in this piece and apply the two pieces together. The use of the grooves made in these pieces now becomes apparent. When the two pieces are pressed well together, the superfluous plaster runs away into the grooves, and this part of the mould is thus sure of being entirely filled. After this bind the two pieces of the arm together.

Now mix enough plaster to fill the mould; place the mould head downwards and pour the plaster in through the openings left at the place of the feet of the figure. Shake the mould, turning it in all directions so that the plaster penetrates everywhere, and after two or three minutes of this empty the plaster from the mould back into the basin. All this must be done as rapidly as possible. Again pour the plaster from the basin, if it has not become too thick, back into

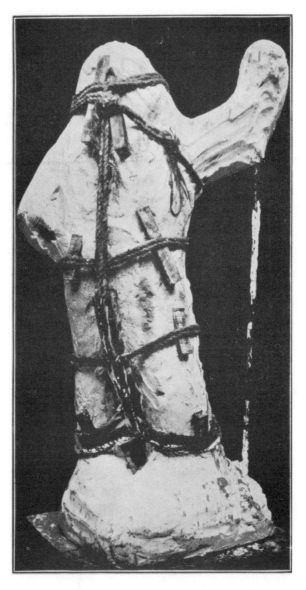

Fig. 178.—Photo showing Mould tied up (Front).

Fig. 179.—Photo showing Mould tied up (Back).

FIG. 180.—PHOTO SHOWING MOULD PARTLY REMOVED.

the mould, filling it and still turning it all the time. Allow it to rest for a minute, and in case it is not quite full, add plaster until flush with the sides of the plinth. Let the plaster set for half an hour.

Removing the pieces of the Mould. When the plaster is set, place the whole on a strong stool and remove first the cords, then the irons, chipping away the plaster around them, then the remainder of the white plaster, and finally the yellow layer. Leave some of the white plaster around the legs and beneath the chin until the upper part is shelled out, so as to prevent these parts being broken when those above them are struck (Fig. 180).

III. *The Casting of a High Relief.*

The casting of a bust and of a figure having been fully gone into, there remains little to be said, on that of a relief, which has not already been touched on.

The clay relief (Fig. 181) has a projection of about $2\frac{1}{2}$ inches.

This relief having no detached parts will be cast in one piece. It is therefore only necessary to cover it with a layer of yellow plaster, as for the bust and the figure, leaving this first layer rough, and making it thicker over the background than over the figure itself (Fig. 182). Brush this layer over with clay-water, without touching the borders of the mould,

always so that the next layer of plaster shall grip well at the latter. Then on a layer of white plaster fix the irons necessary to give strength to the mould (Fig. 183), and add a third layer of white plaster to bind the whole together.

When the plaster has properly set, in the case of this figure which measures only 3 feet in height, it is easy to detach the mould. Make a cutting in the clay at the upper part, about $1\frac{1}{2}$ to 2 inches deep, right across, and fill it with water, which by permeating between the clay of the relief and the plaster of the mould will already help to separate the one from the other. At the lower part of the mould introduce a chisel, and bear lightly on it, placing a thin piece of wood between the blade of the chisel and the mould, so that the latter shall not be damaged. Do the same all round, keeping meanwhile the cutting at the top full of water. In this way the mould will gradually separate from the clay. In the case of a relief on a large scale and very deep, one cannot proceed thus, and it is necessary, the mould being complete, to remove the clay and its armature from behind, taking away first the wooden back, then the cross-pieces and the clay, leaving finally the mould standing alone. But before doing all this, arrange strong wooden supports nailed to the floor and fixed to the back of the mould with plaster.

The mould complete, wash it to remove all traces of

FIG. 181.—PHOTO OF RELIEF IN CLAY.

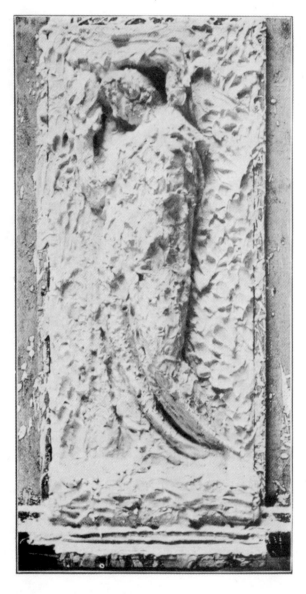

FIG. 182.—PHOTO SHOWING FIRST LAYER OF PLASTER (Yellow).

FIG. 183.—PHOTO SHOWING IRONS FIXED.

clay, and, once dry, soap it in the same way as for the bust and the figure (Fig. 184). In the case of a relief of the size given here, it can be placed on a table and the soap thrown in ; but if its proportions are such that it must remain standing, use a large brush to rub the soap all over the surface, frequently dipping it in the liquid and continuing for about a quarter of an hour. When there is no further trace of soap, oil the surface, and, in the case of a large relief, syringe it well with water. If the relief be a small one it can simply be placed in water for ten minutes.

Allow it once more to dry, and then run the plaster in the interior. For a relief easily handled, this may be done by placing the mould on a table ; but for a larger one the plaster must be thrown with the hand as for the figure, using a long brush to push the plaster into the deeper parts. In both cases a first layer of plaster $\frac{1}{2}$ inch thick is given, leaving the surface rough. But here the second layer must be added at once, without waiting for the first to set. In both cases canvas or tow may be used, dipping it in the plaster, and applying on the surface of the cast. Then add more plaster until a thickness is obtained of $1\frac{1}{2}$ inches for a high relief and of $\frac{3}{4}$ of an inch for a small one.

The cast of a small relief may be strengthened by means of a few irons passed over with Brunswick-black, to prevent rusting, and for a larger relief by laths of wood placed all

round to form a frame and then cross-ways in the shape of a chess-board.

These pieces of wood are fixed with canvas dipped in plaster placed over them and joining the plaster already in the mould. When this is set, another layer of plaster is added. By this means a very strong and light cast will be obtained.

Before chipping the mould of a large relief, place on the side of the cast supports similar to those placed previously to keep the mould vertical, and when these are fixed the others are removed. Thus there will be no danger while chipping the mould of knocking down the entire fabric. For a small relief all that is necessary is to place it against some strong support, which will facilitate the process.

The mould is chipped in the same way as for the bust and the figure, taking away first of all the irons, then the white layer until the yellow layer is reached, and finally the cast (Fig. 185).

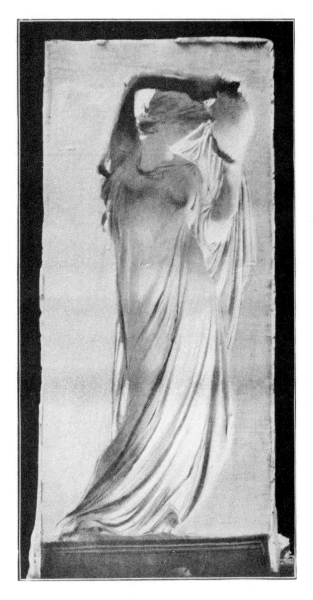

Fig. 184.—Photo showing Mould prepared for filling.

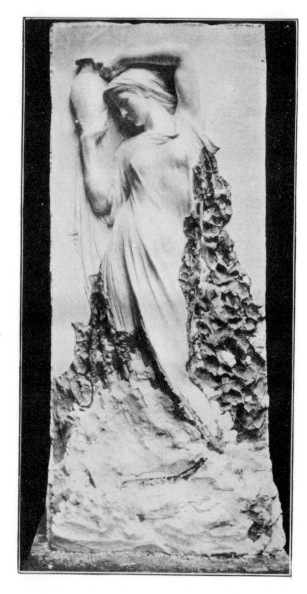

FIG. 185.—PHOTO SHOWING MOULD PARTLY REMOVED.

A FINAL WORD

Study is the application of the mind to an end which it is proposed to define. Everyone knows what fecundity there is in study for the perfecting of our reason ; that is, everyone says so, for we are at a time when, in art matters, study is rare, of summary and altogether insufficient duration. In the way of study what is certain is that it is necessary, a point I will insist upon in spite of its apparent truism ; and that the artist, however gifted he may be, cannot be freed from it. To try and relieve study of what may be irksome in it is a pure chimera. In the past there was less haste and study was more profound ; nowadays it is rendered easy, a grave peril for the mind, which becomes superficial and fickle. Study may be often a kind of lure at which students allow themselves to be caught ; they grasp at its semblance, and then it only serves them to disguise ignorance under an audacious cleverness. I

hold that one is too often mistaken on the direction given to study; that in rendering it easy, it is weakened; that in rendering it hasty, it is destroyed. I believe that study must be methodical, and above all that it must be slow and gradual.

The period at which a student leaves his school is for him a period of transition, when his mind is still uncertain and would require a strong hand to guide it. There is then a void in his art-life which it has been sought to hasten onwards without foresight, and which is suddenly disturbed and perhaps destroyed beyond hope. Is this not what happens to many of our young artists, whose minds are gifted, and whose early efforts had been admired?

It would be well to prolong the period of training so that the young artist should not enter in this uncertain mood and full of misgivings the career so difficult which is open before him on his leaving the art-school. The more the student is driven to haste, the less has he the strength to overcome obstacles. The period of training must be protracted at least in proportion to the sum of knowledge which to-day is expected of the student; but far from this, it has been curtailed, which seems hardly reasonable, especially in the case of those destined to become teachers,

In schools generally the most diversified minds are

subjected to the same laws of study; all personal senti-
ment is put aside by the inflexible universality of the
tasks and the teaching. Regulations are everything.
Students are trained to acquire all and to do all, and it
follows that most often they get to know very little. It is
answered that they have acquired enough to teach in
elementary classes. What shortsightedness! Those who say
this know no more than the particular student in question,
otherwise they would have realised that in teaching the
elementary part is the most difficult and the most delicate,
that which demands the most experience; for in teaching
the young it is the very essence of the principles to be
developed in the future that are to be inculcated. If these
principles are false, what will happen? Later this student
will be at sea when he comes under the direction of some-
one who is competent, and will have to begin everything over
again. How difficult is it not after having taken unsuitable
nourishment for years to cure the bad effects it has produced;
it is as difficult for the student whose early training has
been spoilt to find, and for the master to put him in, the right
way. However gifted a student may be, a master cannot
in a couple of years put into his mind and into his hands
that which is necessary to him on leaving the school, to
enable him to dispense with all aid. There is no technical

training for even the most ordinary artisans which does not require a longer period for them to become proficient in their work, than is generally given to the study of art. This is a positive fact which it is time to change, otherwise degeneration will be the penalty.

Students who receive scholarships should be chosen with great discrimination, so as to push forward, by increasing the length of the studies, only those who by their aptitudes are likely to honour the nation from which they receive encouragement. In this way one would shield from a life of misery those who have not the aptitude necessary to become superior in any branch of art. Better let them be good artisans, certain to live by their work and who would be excellent auxiliaries to those better gifted by nature. There is no reason why these should not perfect their taste by the study of drawing and of modelling, but such studies should not be allowed to interrupt their career ; for in being lured away from it for some years, and having aspired to higher aims, which they do not feel the impossibility of reaching, they will at last lose the desire to return to their first trade, and will strive all their lives against misery without any chance of success.

These reservations being made, I wish, before closing these pages, to pay a high tribute to the seriousness with

which English art students of to-day approach their work, to the originality of purpose they bring into it, and to the high standard of efficiency to which many attain, and of which my long experience enables me to say that it is perhaps rarely bettered in any other country.

But how much more surely would this result be achieved, if, with these remarkable aptitudes, sufficient time were given to the students to become thoroughly proficient in all the branches of their studies.

A CATALOGUE OF
SELECTED DOVER BOOKS
IN ALL FIELDS OF INTEREST

A CATALOG OF SELECTED DOVER
BOOKS IN ALL FIELDS OF INTEREST

THE ART NOUVEAU STYLE, edited by Roberta Waddell. 579 rare photographs of works in jewelry, metalwork, glass, ceramics, textiles, architecture and furniture by 175 artists—Mucha, Seguy, Lalique, Tiffany, many others. 288pp. 8⅜ × 11¼.
23515-7 Pa. $8.95

AMERICAN COUNTRY HOUSES OF THE GILDED AGE (Sheldon's "Artistic Country-Seats"), A. Lewis. All of Sheldon's fascinating and historically important photographs and plans. New text by Arnold Lewis. Approx. 200 illustrations. 128pp. 9⅜ × 12¼.
24301-X Pa. $7.95

THE WAY WE LIVE NOW, Anthony Trollope. Trollope's late masterpiece, marks shift to bitter satire. Character Melmotte "his greatest villain." Reproduced from original edition with 40 illustrations. 416pp. 6⅛ × 9¼.
24360-5 Pa. $7.95

BENCHLEY LOST AND FOUND, Robert Benchley. Finest humor from early 30's, about pet peeves, child psychologists, post office and others. Mostly unavailable elsewhere. 73 illustrations by Peter Arno and others. 183pp. 5⅜ × 8½.
22410-4 Pa. $3.50

ISOMETRIC PERSPECTIVE DESIGNS AND HOW TO CREATE THEM, John Locke. Isometric perspective is the picture of an object adrift in imaginary space. 75 mindboggling designs. 52pp. 8¼ × 11.
24123-8 Pa. $2.50

PERSPECTIVE FOR ARTISTS, Rex Vicat Cole. Depth, perspective of sky and sea, shadows, much more, not usually covered. 391 diagrams, 81 reproductions of drawings and paintings. 279pp. 5⅜ × 8½.
22487-2 Pa. $4.00

MOVIE-STAR PORTRAITS OF THE FORTIES, edited by John Kobal. 163 glamor, studio photos of 106 stars of the 1940s: Rita Hayworth, Ava Gardner, Marlon Brando, Clark Gable, many more. 176pp. 8⅜ × 11¼.
23546-7 Pa. $6.95

STARS OF THE BROADWAY STAGE, 1940-1967, Fred Fehl. Marlon Brando, Uta Hagen, John Kerr, John Gielgud, Jessica Tandy in great shows—*South Pacific, Galileo, West Side Story*, more. 240 black-and-white photos. 144pp. 8⅜ × 11¼.
24398-2 Pa. $8.95

ILLUSTRATED DICTIONARY OF HISTORIC ARCHITECTURE, edited by Cyril M. Harris. Extraordinary compendium of clear, concise definitions for over 5000 important architectural terms complemented by over 2000 line drawings. 592pp. 7½ × 9⅝.
24444-X Pa. $14.95

THE EARLY WORK OF FRANK LLOYD WRIGHT, F.L. Wright. 207 rare photos of Oak Park period, first great buildings: Unity Temple, Dana house, Larkin factory. Complete photos of Wasmuth edition. New Introduction. 160pp. 8⅜ × 11¼.
24381-8 Pa. $7.50

LIVING MY LIFE, Emma Goldman. Candid, no holds barred account by foremost American anarchist: her own life, anarchist movement, famous contemporaries, ideas and their impact. 944pp. 5⅜ × 8½. 22543-7, 22544-5 Pa., Two-vol. set $13.00

UNDERSTANDING THERMODYNAMICS, H.C. Van Ness. Clear, lucid treatment of first and second laws of thermodynamics. Excellent supplement to basic textbook in undergraduate science or engineering class. 103pp. 5⅜ × 8.
63277-6 Pa. $3.50

SMOCKING: TECHNIQUE, PROJECTS, AND DESIGNS, Dianne Durand. Foremost smocking designer provides complete instructions on how to smock. Over 10 projects, over 100 illustrations. 56pp. 8¼ × 11. 23788-5 Pa. $2.00

AUDUBON'S BIRDS IN COLOR FOR DECOUPAGE, edited by Eleanor H. Rawlings. 24 sheets, 37 most decorative birds, full color, on one side of paper. Instructions, including work under glass. 56pp. 8¼ × 11. 23492-4 Pa. $3.50

THE COMPLETE BOOK OF SILK SCREEN PRINTING PRODUCTION, J.I. Biegeleisen. For commercial user, teacher in advanced classes, serious hobbyist. Most modern techniques, materials, equipment for optimal results. 124 illustrations. 253pp. 5⅝ × 8½. 21100-2 Pa. $4.50

A TREASURY OF ART NOUVEAU DESIGN AND ORNAMENT, edited by Carol Belanger Grafton. 577 designs for the practicing artist. Full-page, spots, borders, bookplates by Klimt, Bradley, others. 144pp. 8⅜ × 11¼. 24001-0 Pa. $5.00

ART NOUVEAU TYPOGRAPHIC ORNAMENTS, Dan X. Solo. Over 800 Art Nouveau florals, swirls, women, animals, borders, scrolls, wreaths, spots and dingbats, copyright-free. 100pp. 8⅛ × 11. 24366-4 Pa. $4.00

HAND SHADOWS TO BE THROWN UPON THE WALL, Henry Bursill. Wonderful Victorian novelty tells how to make flying birds, dog, goose, deer, and 14 others, each explained by a full-page illustration. 32pp. 6½ × 9¼. 21779-5 Pa. $1.50

AUDUBON'S BIRDS OF AMERICA COLORING BOOK, John James Audubon. Rendered for coloring by Paul Kennedy. 46 of Audubon's noted illustrations: red-winged black-bird, cardinal, etc. Original plates reproduced in full-color on the covers. Captions. 48pp. 8¼ × 11. 23049-X Pa. $2.25

SILK SCREEN TECHNIQUES, J.I. Biegeleisen, M.A. Cohn. Clear, practical, modern, economical. Minimal equipment (self-built), materials, easy methods. For amateur, hobbyist, 1st book. 141 illustrations. 185pp. 6⅛ × 9¼. 20433-2 Pa. $3.95

101 PATCHWORK PATTERNS, Ruby S. McKim. 101 beautiful, immediately useable patterns, full-size, modern and traditional. Also general information, estimating, quilt lore. 140 illustrations. 124pp. 7⅞ × 10¾. 20773-0 Pa. $3.50

READY-TO-USE FLORAL DESIGNS, Ed Sibbett, Jr. Over 100 floral designs (most in three sizes) of popular individual blossoms as well as bouquets, sprays, garlands. 64pp. 8¼ × 11. 23976-4 Pa. $2.95

AMERICAN WILD FLOWERS COLORING BOOK, Paul Kennedy. Planned coverage of 46 most important wildflowers, from Rickett's collection; instructive as well as entertaining. Color versions on covers. Captions. 48pp. 8¼ × 11.
 20095-7 Pa. $2.25

CARVING DUCK DECOYS, Harry V. Shourds and Anthony Hillman. Detailed instructions and full-size templates for constructing 16 beautiful, marvelously practical decoys according to time-honored South Jersey method. 70pp. 9¼ × 12¼.
 24083-5 Pa. $4.95

TRADITIONAL PATCHWORK PATTERNS, Carol Belanger Grafton. Cardboard cut-out pieces for use as templates to make 12 quilts: Buttercup, Ribbon Border, Tree of Paradise, nine more. Full instructions. 57pp. 8¼ × 11.
 23015-5 Pa. $3.50

25 KITES THAT FLY, Leslie Hunt. Full, easy-to-follow instructions for kites made from inexpensive materials. Many novelties. 70 illustrations. 110pp. 5⅜ × 8½.
22550-X Pa. $1.95

PIANO TUNING, J. Cree Fischer. Clearest, best book for beginner, amateur. Simple repairs, raising dropped notes, tuning by easy method of flattened fifths. No previous skills needed. 4 illustrations. 201pp. 5⅜ × 8½.
23267-0 Pa. $3.50

EARLY AMERICAN IRON-ON TRANSFER PATTERNS, edited by Rita Weiss. 75 designs, borders, alphabets, from traditional American sources. 48pp. 8¼ × 11.
23162-3 Pa. $1.95

CROCHETING EDGINGS, edited by Rita Weiss. Over 100 of the best designs for these lovely trims for a host of household items. Complete instructions, illustrations. 48pp. 8¼ × 11.
24031-2 Pa. $2.00

FINGER PLAYS FOR NURSERY AND KINDERGARTEN, Emilie Poulsson. 18 finger plays with music (voice and piano); entertaining, instructive. Counting, nature lore, etc. Victorian classic. 53 illustrations. 80pp. 6½ × 9¼. 22588-7 Pa. $1.95

BOSTON THEN AND NOW, Peter Vanderwarker. Here in 59 side-by-side views are photographic documentations of the city's past and present. 119 photographs. Full captions. 122pp. 8¼ × 11.
24312-5 Pa. $6.95

CROCHETING BEDSPREADS, edited by Rita Weiss. 22 patterns, originally published in three instruction books 1939-41. 39 photos, 8 charts. Instructions. 48pp. 8¼ × 11.
23610-2 Pa. $2.00

HAWTHORNE ON PAINTING, Charles W. Hawthorne. Collected from notes taken by students at famous Cape Cod School; hundreds of direct, personal *apercus*, ideas, suggestions. 91pp. 5⅜ × 8½.
20653-X Pa. $2.50

THERMODYNAMICS, Enrico Fermi. A classic of modern science. Clear, organized treatment of systems, first and second laws, entropy, thermodynamic potentials, etc. Calculus required. 160pp. 5⅜ × 8½.
60361-X Pa. $4.00

TEN BOOKS ON ARCHITECTURE, Vitruvius. The most important book ever written on architecture. Early Roman aesthetics, technology, classical orders, site selection, all other aspects. Morgan translation. 331pp. 5⅜ × 8½. 20645-9 Pa. $5.50

THE CORNELL BREAD BOOK, Clive M. McCay and Jeanette B. McCay. Famed high-protein recipe incorporated into breads, rolls, buns, coffee cakes, pizza, pie crusts, more. Nearly 50 illustrations. 48pp. 8¼ × 11.
23995-0 Pa. $2.00

THE CRAFTSMAN'S HANDBOOK, Cennino Cennini. 15th-century handbook, school of Giotto, explains applying gold, silver leaf; gesso; fresco painting, grinding pigments, etc. 142pp. 6⅛ × 9¼.
20054-X Pa. $3.50

FRANK LLOYD WRIGHT'S FALLINGWATER, Donald Hoffmann. Full story of Wright's masterwork at Bear Run, Pa. 100 photographs of site, construction, and details of completed structure. 112pp. 9¼ × 10.
23671-4 Pa. $6.50

OVAL STAINED GLASS PATTERN BOOK, C. Eaton. 60 new designs framed in shape of an oval. Greater complexity, challenge with sinuous cats, birds, mandalas framed in antique shape. 64pp. 8¼ × 11.
24519-5 Pa. $3.50

CHILDREN'S BOOKPLATES AND LABELS, Ed Sibbett, Jr. 6 each of 12 types based on *Wizard of Oz, Alice,* nursery rhymes, fairy tales. Perforated; full color. 24pp. 8¼ × 11. 23538-6 Pa. $2.95

READY-TO-USE VICTORIAN COLOR STICKERS: 96 Pressure-Sensitive Seals, Carol Belanger Grafton. Drawn from authentic period sources. Motifs include heads of men, women, children, plus florals, animals, birds, more. Will adhere to any clean surface. 8pp. 8½ × 11. 24551-9 Pa. $2.95

CUT AND FOLD PAPER SPACESHIPS THAT FLY, Michael Grater. 16 colorful, easy-to-build spaceships that really fly. Star Shuttle, Lunar Freighter, Star Probe, 13 others. 32pp. 8¼ × 11. 23978-0 Pa. $2.50

CUT AND ASSEMBLE PAPER AIRPLANES THAT FLY, Arthur Baker. 8 aerodynamically sound, ready-to-build paper airplanes, designed with latest techniques. Fly *Pegasus, Daedalus, Songbird,* 5 other aircraft. Instructions. 32pp. 9¼ × 11¼. 24302-8 Pa. $3.95

SIDELIGHTS ON RELATIVITY, Albert Einstein. Two lectures delivered in 1920-21: *Ether and Relativity* and *Geometry and Experience.* Elegant ideas in non-mathematical form. 56pp. 5⅜ × 8½. 24511-X Pa. $2.25

FADS AND FALLACIES IN THE NAME OF SCIENCE, Martin Gardner. Fair, witty appraisal of cranks and quacks of science: Velikovsky, orgone energy, Bridey Murphy, medical fads, etc. 373pp. 5⅜ × 8½. 20394-8 Pa. $5.50

VACATION HOMES AND CABINS, U.S. Dept. of Agriculture. Complete plans for 16 cabins, vacation homes and other shelters. 105pp. 9 × 12. 23631-5 Pa. $4.50

HOW TO BUILD A WOOD-FRAME HOUSE, L.O. Anderson. Placement, foundations, framing, sheathing, roof, insulation, plaster, finishing—almost everything else. 179 illustrations. 223pp. 7⅞ × 10¾. 22954-8 Pa. $5.50

THE MYSTERY OF A HANSOM CAB, Fergus W. Hume. Bizarre murder in a hansom cab leads to engrossing investigation. Memorable characters, rich atmosphere. 19th-century bestseller, still enjoyable, exciting. 256pp. 5⅜ × 8. 21956-9 Pa. $4.00

MANUAL OF TRADITIONAL WOOD CARVING, edited by Paul N. Hasluck. Possibly the best book in English on the craft of wood carving. Practical instructions, along with 1,146 working drawings and photographic illustrations. 576pp. 6½ × 9¼. 23489-4 Pa. $8.95

WHITTLING AND WOODCARVING, E.J Tangerman. Best book on market; clear, full. If you can cut a potato, you can carve toys, puzzles, chains, etc. Over 464 illustrations. 293pp. 5⅜ × 8½. 20965-2 Pa. $4.95

AMERICAN TRADEMARK DESIGNS, Barbara Baer Capitman. 732 marks, logos and corporate-identity symbols. Categories include entertainment, heavy industry, food and beverage. All black-and-white in standard forms. 160pp. 8⅜ × 11. 23259-X Pa. $6.00

DECORATIVE FRAMES AND BORDERS, edited by Edmund V. Gillon, Jr. Largest collection of borders and frames ever compiled for use of artists and designers. Renaissance, neo-Greek, Art Nouveau, Art Deco, to mention only a few styles. 396 illustrations. 192pp. 8⅜ × 11¼. 22928-9 Pa. $6.00

CATALOG OF DOVER BOOKS

THE MURDER BOOK OF J.G. REEDER, Edgar Wallace. Eight suspenseful stories by bestselling mystery writer of 20s and 30s. Features the donnish Mr. J.G. Reeder of Public Prosecutor's Office. 128pp. 5⅜ × 8½. (Available in U.S. only)
24374-5 Pa. $3.50

ANNE ORR'S CHARTED DESIGNS, Anne Orr. Best designs by premier needlework designer, all on charts: flowers, borders, birds, children, alphabets, etc. Over 100 charts, 10 in color. Total of 40pp. 8¼ × 11. 23704-4 Pa. $2.25

BASIC CONSTRUCTION TECHNIQUES FOR HOUSES AND SMALL BUILDINGS SIMPLY EXPLAINED, U.S. Bureau of Naval Personnel. Grading, masonry, woodworking, floor and wall framing, roof framing, plastering, tile setting, much more. Over 675 illustrations. 568pp. 6½ × 9¼. 20242-9 Pa. $8.95

MATISSE LINE DRAWINGS AND PRINTS, Henri Matisse. Representative collection of female nudes, faces, still lifes, experimental works, etc., from 1898 to 1948. 50 illustrations. 48pp. 8⅜ × 11¼. 23877-6 Pa. $2.50

HOW TO PLAY THE CHESS OPENINGS, Eugene Znosko-Borovsky. Clear, profound examinations of just what each opening is intended to do and how opponent can counter. Many sample games. 147pp. 5⅜ × 8½. 22795-2 Pa. $2.95

DUPLICATE BRIDGE, Alfred Sheinwold. Clear, thorough, easily followed account: rules, etiquette, scoring, strategy, bidding; Goren's point-count system, Blackwood and Gerber conventions, etc. 158pp. 5⅜ × 8½. 22741-3 Pa. $3.00

SARGENT PORTRAIT DRAWINGS, J.S. Sargent. Collection of 42 portraits reveals technical skill and intuitive eye of noted American portrait painter, John Singer Sargent. 48pp. 8¼ × 11⅛. 24524-1 Pa. $2.95

ENTERTAINING SCIENCE EXPERIMENTS WITH EVERYDAY OBJECTS, Martin Gardner. Over 100 experiments for youngsters. Will amuse, astonish, teach, and entertain. Over 100 illustrations. 127pp. 5⅜ × 8½. 24201-3 Pa. $2.50

TEDDY BEAR PAPER DOLLS IN FULL COLOR: A Family of Four Bears and Their Costumes, Crystal Collins. A family of four Teddy Bear paper dolls and nearly 60 cut-out costumes. Full color, printed one side only. 32pp. 9¼ × 12¼.
24550-0 Pa. $3.50

NEW CALLIGRAPHIC ORNAMENTS AND FLOURISHES, Arthur Baker. Unusual, multi-useable material: arrows, pointing hands, brackets and frames, ovals, swirls, birds, etc. Nearly 700 illustrations. 80pp. 8⅜ × 11¼.
24095-9 Pa. $3.50

DINOSAUR DIORAMAS TO CUT & ASSEMBLE, M. Kalmenoff. Two complete three-dimensional scenes in full color, with 31 cut-out animals and plants. Excellent educational toy for youngsters. Instructions; 2 assembly diagrams. 32pp. 9¼ × 12¼. 24541-1 Pa. $3.95

SILHOUETTES: A PICTORIAL ARCHIVE OF VARIED ILLUSTRATIONS, edited by Carol Belanger Grafton. Over 600 silhouettes from the 18th to 20th centuries. Profiles and full figures of men, women, children, birds, animals, groups and scenes, nature, ships, an alphabet. 144pp. 8⅜ × 11¼. 23781-8 Pa. $4.50

THE BOOK OF WOOD CARVING, Charles Marshall Sayers. Still finest book for beginning student. Fundamentals, technique; gives 34 designs, over 34 projects for panels, bookends, mirrors, etc. 33 photos. 118pp. 7¾ × 10⅝. 23654-4 Pa. $3.95

CARVING COUNTRY CHARACTERS, Bill Higginbotham. Expert advice for beginning, advanced carvers on materials, techniques for creating 18 projects—mirthful panorama of American characters. 105 illustrations. 80pp. 8⅜ × 11.
24135-1 Pa. $2.50

300 ART NOUVEAU DESIGNS AND MOTIFS IN FULL COLOR, C.B. Grafton. 44 full-page plates display swirling lines and muted colors typical of Art Nouveau. Borders, frames, panels, cartouches, dingbats, etc. 48pp. 9⅜ × 12¼.
24354-0 Pa. $6.00

SELF-WORKING CARD TRICKS, Karl Fulves. Editor of *Pallbearer* offers 72 tricks that work automatically through nature of card deck. No sleight of hand needed. Often spectacular. 42 illustrations. 113pp. 5⅜ × 8½. 23334-0 Pa. $2.25

CUT AND ASSEMBLE A WESTERN FRONTIER TOWN, Edmund V. Gillon, Jr. Ten authentic full-color buildings on heavy cardboard stock in H-O scale. Sheriff's Office and Jail, Saloon, Wells Fargo, Opera House, others. 48pp. 9¼ × 12¼.
23736-2 Pa. $3.95

CUT AND ASSEMBLE AN EARLY NEW ENGLAND VILLAGE, Edmund V. Gillon, Jr. Printed in full color on heavy cardboard stock. 12 authentic buildings in H-O scale: Adams home in Quincy, Mass., Oliver Wight house in Sturbridge, smithy, store, church, others. 48pp. 9¼ × 12¼. 23536-X Pa. $3.95

THE TALE OF TWO BAD MICE, Beatrix Potter. Tom Thumb and Hunca Munca squeeze out of their hole and go exploring. 27 full-color Potter illustrations. 59pp. 4¼ × 5½. (Available in U.S. only) 23065-1 Pa. $1.50

CARVING FIGURE CARICATURES IN THE OZARK STYLE, Harold L. Enlow. Instructions and illustrations for ten delightful projects, plus general carving instructions. 22 drawings and 47 photographs altogether. 39pp. 8⅜ × 11.
23151-8 Pa. $2.50

A TREASURY OF FLOWER DESIGNS FOR ARTISTS, EMBROIDERERS AND CRAFTSMEN, Susan Gaber. 100 garden favorites lushly rendered by artist for artists, craftsmen, needleworkers. Many form frames, borders. 80pp. 8¼ × 11.
24096-7 Pa. $3.50

CUT & ASSEMBLE A TOY THEATER/THE NUTCRACKER BALLET, Tom Tierney. Model of a complete, full-color production of Tchaikovsky's classic. 6 backdrops, dozens of characters, familiar dance sequences. 32pp. 9⅜ × 12¼.
24194-7 Pa. $4.50

ANIMALS: 1,419 COPYRIGHT-FREE ILLUSTRATIONS OF MAMMALS, BIRDS, FISH, INSECTS, ETC., edited by Jim Harter. Clear wood engravings present, in extremely lifelike poses, over 1,000 species of animals. 284pp. 9 × 12.
23766-4 Pa. $8.95

MORE HAND SHADOWS, Henry Bursill. For those at their 'finger ends," 16 more effects—Shakespeare, a hare, a squirrel, Mr. Punch, and twelve more—each explained by a full-page illustration. Considerable period charm. 30pp. 6½ × 9¼.
21384-6 Pa. $1.95

JAPANESE DESIGN MOTIFS, Matsuya Co. Mon, or heraldic designs. Over 4000 typical, beautiful designs: birds, animals, flowers, swords, fans, geometrics; all beautifully stylized. 213pp. 11⅛ × 8¼. 22874-6 Pa. $6.95

THE TALE OF BENJAMIN BUNNY, Beatrix Potter. Peter Rabbit's cousin coaxes him back into Mr. McGregor's garden for a whole new set of adventures. All 27 full-color illustrations. 59pp. 4¼ × 5½. (Available in U.S. only) 21102-9 Pa. $1.50

THE TALE OF PETER RABBIT AND OTHER FAVORITE STORIES BOXED SET, Beatrix Potter. Seven of Beatrix Potter's best-loved tales including Peter Rabbit in a specially designed, durable boxed set. 4¼ × 5½. Total of 447pp. 158 color illustrations. (Available in U.S. only) 23903-9 Pa. $10.50

PRACTICAL MENTAL MAGIC, Theodore Annemann. Nearly 200 astonishing feats of mental magic revealed in step-by-step detail. Complete advice on staging, patter, etc. Illustrated. 320pp. 5⅜ × 8½. 24426-1 Pa. $5.95

CELEBRATED CASES OF JUDGE DEE (DEE GOONG AN), translated by Robert Van Gulik. Authentic 18th-century Chinese detective novel; Dee and associates solve three interlocked cases. Led to van Gulik's own stories with same characters. Extensive introduction. 9 illustrations. 237pp. 5⅜ × 8½. 23337-5 Pa. $4.50

CUT & FOLD EXTRATERRESTRIAL INVADERS THAT FLY, M. Grater. Stage your own lilliputian space battles.By following the step-by-step instructions and explanatory diagrams you can launch 22 full-color fliers into space. 36pp. 8¼ × 11. 24478-4 Pa. $2.95

CUT & ASSEMBLE VICTORIAN HOUSES, Edmund V. Gillon, Jr. Printed in full color on heavy cardboard stock, 4 authentic Victorian houses in H-O scale: Italian-style Villa, Octagon, Second Empire, Stick Style. 48pp. 9¼ × 12¼. 23849-0 Pa. $3.95

BEST SCIENCE FICTION STORIES OF H.G. WELLS, H.G. Wells. Full novel *The Invisible Man*, plus 17 short stories: "The Crystal Egg," "Aepyornis Island," "The Strange Orchid," etc. 303pp. 5⅜ × 8½. (Available in U.S. only) 21531-8 Pa. $3.95

TRADEMARK DESIGNS OF THE WORLD, Yusaku Kamekura. A lavish collection of nearly 700 trademarks, the work of Wright, Loewy, Klee, Binder, hundreds of others. 160pp. 8⅜ × 8. (Available in U.S. only) 24191-2 Pa. $5.00

THE ARTIST'S AND CRAFTSMAN'S GUIDE TO REDUCING, ENLARGING AND TRANSFERRING DESIGNS, Rita Weiss. Discover, reduce, enlarge, transfer designs from any objects to any craft project. 12pp. plus 16 sheets special graph paper. 8¼ × 11. 24142-4 Pa. $3.25

TREASURY OF JAPANESE DESIGNS AND MOTIFS FOR ARTISTS AND CRAFTSMEN, edited by Carol Belanger Grafton. Indispensable collection of 360 traditional Japanese designs and motifs redrawn in clean, crisp black-and-white, copyright-free illustrations. 96pp. 8¼ × 11. 24435-0 Pa. $3.95

CHANCERY CURSIVE STROKE BY STROKE, Arthur Baker. Instructions and illustrations for each stroke of each letter (upper and lower case) and numerals. 54 full-page plates. 64pp. 8¼ × 11. 24278-1 Pa. $2.50

THE ENJOYMENT AND USE OF COLOR, Walter Sargent. Color relationships, values, intensities; complementary colors, illumination, similar topics. Color in nature and art. 7 color plates, 29 illustrations. 274pp. 5⅜ × 8½. 20944-X Pa. $4.50

SCULPTURE PRINCIPLES AND PRACTICE, Louis Slobodkin. Step-by-step approach to clay, plaster, metals, stone; classical and modern. 253 drawings, photos. 255pp. 8¼ × 11. 22960-2 Pa. $7.00

VICTORIAN FASHION PAPER DOLLS FROM HARPER'S BAZAR, 1867-1898, Theodore Menten. Four female dolls with 28 elegant high fashion costumes, printed in full color. 32pp. 9¼ × 12¼. 23453-3 Pa. $3.50

FLOPSY, MOPSY AND COTTONTAIL: A Little Book of Paper Dolls in Full Color, Susan LaBelle. Three dolls and 21 costumes (7 for each doll) show Peter Rabbit's siblings dressed for holidays, gardening, hiking, etc. Charming borders, captions. 48pp. 4¼ × 5½. 24376-1 Pa. $2.00

NATIONAL LEAGUE BASEBALL CARD CLASSICS, Bert Randolph Sugar. 83 big-leaguers from 1909-69 on facsimile cards. Hubbell, Dean, Spahn, Brock plus advertising, info, no duplications. Perforated, detachable. 16pp. 8¼ × 11.
24308-7 Pa. $2.95

THE LOGICAL APPROACH TO CHESS, Dr. Max Euwe, et al. First-rate text of comprehensive strategy, tactics, theory for the amateur. No gambits to memorize, just a clear, logical approach. 224pp. 5⅜ × 8½. 24353-2 Pa. $4.50

MAGICK IN THEORY AND PRACTICE, Aleister Crowley. The summation of the thought and practice of the century's most famous necromancer, long hard to find. Crowley's best book. 436pp. 5⅜ × 8½. (Available in U.S. only)
23295-6 Pa. $6.50

THE HAUNTED HOTEL, Wilkie Collins. Collins' last great tale; doom and destiny in a Venetian palace. Praised by T.S. Eliot. 127pp. 5⅜ × 8½.
24333-8 Pa. $3.00

ART DECO DISPLAY ALPHABETS, Dan X. Solo. Wide variety of bold yet elegant lettering in handsome Art Deco styles. 100 complete fonts, with numerals, punctuation, more. 104pp. 8⅜ × 11. 24372-9 Pa. $4.00

CALLIGRAPHIC ALPHABETS, Arthur Baker. Nearly 150 complete alphabets by outstanding contemporary. Stimulating ideas; useful source for unique effects. 154 plates. 157pp. 8⅜ × 11¼. 21045-6 Pa. $4.95

ARTHUR BAKER'S HISTORIC CALLIGRAPHIC ALPHABETS, Arthur Baker. From monumental capitals of first-century Rome to humanistic cursive of 16th century, 33 alphabets in fresh interpretations. 88 plates. 96pp. 9 × 12.
24054-1 Pa. $3.95

LETTIE LANE PAPER DOLLS, Sheila Young. Genteel turn-of-the-century family very popular then and now. 24 paper dolls. 16 plates in full color. 32pp. 9¼ × 12¼. 24089-4 Pa. $3.50

TWENTY-FOUR ART NOUVEAU POSTCARDS IN FULL COLOR FROM CLASSIC POSTERS, Hayward and Blanche Cirker. Ready-to-mail postcards reproduced from rare set of poster art. Works by Toulouse-Lautrec, Parrish, Steinlen, Mucha, Cheret, others. 12pp. 8¼× 11. 24389-3 Pa. $2.95

READY-TO-USE ART NOUVEAU BOOKMARKS IN FULL COLOR, Carol Belanger Grafton. 30 elegant bookmarks featuring graceful, flowing lines, foliate motifs, sensuous women characteristic of Art Nouveau. Perforated for easy detaching. 16pp. 8¼ × 11. 24305-2 Pa. $2.95

FRUIT KEY AND TWIG KEY TO TREES AND SHRUBS, William M. Harlow. Fruit key covers 120 deciduous and evergreen species; twig key covers 160 deciduous species. Easily used. Over 300 photographs. 126pp. 5⅜ × 8½. 20511-8 Pa. $2.25

LEONARDO DRAWINGS, Leonardo da Vinci. Plants, landscapes, human face and figure, etc., plus studies for Sforza monument, *Last Supper*, more. 60 illustrations. 64pp. 8¼ × 11⅛. 23951-9 Pa. $2.75

CLASSIC BASEBALL CARDS, edited by Bert R. Sugar. 98 classic cards on heavy stock, full color, perforated for detaching. Ruth, Cobb, Durocher, DiMaggio, H. Wagner, 99 others. Rare originals cost hundreds. 16pp. 8¼ × 11. 23498-3 Pa. $2.95

TREES OF THE EASTERN AND CENTRAL UNITED STATES AND CANADA, William M. Harlow. Best one-volume guide to 140 trees. Full descriptions, woodlore, range, etc. Over 600 illustrations. Handy size. 288pp. 4½ × 6⅜. 20395-6 Pa. $3.50

JUDY GARLAND PAPER DOLLS IN FULL COLOR, Tom Tierney. 3 Judy Garland paper dolls (teenager, grown-up, and mature woman) and 30 gorgeous costumes highlighting memorable career. Captions. 32pp. 9¼ × 12¼.

 24404-0 Pa. $3.50

GREAT FASHION DESIGNS OF THE BELLE EPOQUE PAPER DOLLS IN FULL COLOR, Tom Tierney. Two dolls and 30 costumes meticulously rendered. Haute couture by Worth, Lanvin, Paquin, other greats late Victorian to WWI. 32pp. 9¼ × 12¼. 24425-3 Pa. $3.50

FASHION PAPER DOLLS FROM GODEY'S LADY'S BOOK, 1840-1854, Susan Johnston. In full color: 7 female fashion dolls with 50 costumes. Little girl's, bridal, riding, bathing, wedding, evening, everyday, etc. 32pp. 9¼ × 12¼.

 23511-4 Pa. $3.50

THE BOOK OF THE SACRED MAGIC OF ABRAMELIN THE MAGE, translated by S. MacGregor Mathers. Medieval manuscript of ceremonial magic. Basic document in Aleister Crowley, Golden Dawn groups. 268pp. 5⅜ × 8½.

 23211-5 Pa. $5.00

PETER RABBIT POSTCARDS IN FULL COLOR: 24 Ready-to-Mail Cards, Susan Whited LaBelle. Bunnies ice-skating, coloring Easter eggs, making valentines, many other charming scenes. 24 perforated full-color postcards, each measuring 4¼ × 6, on coated stock. 12pp. 9 × 12. 24617-5 Pa. $2.95

CELTIC HAND STROKE BY STROKE, A. Baker. Complete guide creating each letter of the alphabet in distinctive Celtic manner. Covers hand position, strokes, pens, inks, paper, more. Illustrated. 48pp. 8¼ × 11. 24336-2 Pa. $2.50

HOW THE OTHER HALF LIVES, Jacob A. Riis. Journalistic record of filth, degradation, upward drive in New York immigrant slums, shops, around 1900. New edition includes 100 original Riis photos, monuments of early photography. 233pp. 10 × 7⅞. 22012-5 Pa. $7.95

CHINA AND ITS PEOPLE IN EARLY PHOTOGRAPHS, John Thomson. In 200 black-and-white photographs of exceptional quality photographic pioneer Thomson captures the mountains, dwellings, monuments and people of 19th-century China. 272pp. 9⅜ × 12¼. 24393-1 Pa. $12.95

GODEY COSTUME PLATES IN COLOR FOR DECOUPAGE AND FRAMING, edited by Eleanor Hasbrouk Rawlings. 24 full-color engravings depicting 19th-century Parisian haute couture. Printed on one side only. 56pp. 8¼ × 11. 23879-2 Pa. $3.95

ART NOUVEAU STAINED GLASS PATTERN BOOK, Ed Sibbett, Jr. 104 projects using well-known themes of Art Nouveau: swirling forms, florals, peacocks, and sensuous women. 60pp. 8¼ × 11. 23577-7 Pa. $3.00

QUICK AND EASY PATCHWORK ON THE SEWING MACHINE: Susan Aylsworth Murwin and Suzzy Payne. Instructions, diagrams show exactly how to machine sew 12 quilts. 48pp. of templates. 50 figures. 80pp. 8¼ × 11. 23770-2 Pa. $3.50

THE STANDARD BOOK OF QUILT MAKING AND COLLECTING, Marguerite Ickis. Full information, full-sized patterns for making 46 traditional quilts, also 150 other patterns. 483 illustrations. 273pp. 6⅞ × 9⅝. 20582-7 Pa. $5.95

LETTERING AND ALPHABETS, J. Albert Cavanagh. 85 complete alphabets lettered in various styles; instructions for spacing, roughs, brushwork. 121pp. 8¾ × 8. 20053-1 Pa. $3.75

LETTER FORMS: 110 COMPLETE ALPHABETS, Frederick Lambert. 110 sets of capital letters; 16 lower case alphabets; 70 sets of numbers and other symbols. 110pp. 8⅞ × 11. 22872-X Pa. $4.50

ORCHIDS AS HOUSE PLANTS, Rebecca Tyson Northen. Grow cattleyas and many other kinds of orchids—in a window, in a case, or under artificial light. 63 illustrations. 148pp. 5⅜ × 8½. 23261-1 Pa. $2.95

THE MUSHROOM HANDBOOK, Louis C.C. Krieger. Still the best popular handbook. Full descriptions of 259 species, extremely thorough text, poisons, folklore, etc. 32 color plates; 126 other illustrations. 560pp. 5⅜ × 8½. 21861-9 Pa. $8.50

THE DORÉ BIBLE ILLUSTRATIONS, Gustave Doré. All wonderful, detailed plates: Adam and Eve, Flood, Babylon, life of Jesus, etc. Brief King James text with each plate. 241 plates. 241pp. 9 × 12. 23004-X Pa. $6.95

THE BOOK OF KELLS: Selected Plates in Full Color, edited by Blanche Cirker. 32 full-page plates from greatest manuscript-icon of early Middle Ages. Fantastic, mysterious. Publisher's Note. Captions. 32pp. 9¾ × 12¼. 24345-1 Pa. $4.50

THE PERFECT WAGNERITE, George Bernard Shaw. Brilliant criticism of the Ring Cycle, with provocative interpretation of politics, economic theories behind the Ring. 136pp. 5⅜ × 8½. (Available in U.S. only) 21707-8 Pa. $3.00

THE RIME OF THE ANCIENT MARINER, Gustave Doré, S.T. Coleridge. Doré's finest work, 34 plates capture moods, subtleties of poem. Full text. 77pp. 9¼ × 12.
22305-1 Pa. $4.95

SONGS OF INNOCENCE, William Blake. The first and most popular of Blake's famous "Illuminated Books," in a facsimile edition reproducing all 31 brightly colored plates. Additional printed text of each poem. 64pp. 5¼ × 7.
22764-2 Pa. $3.00

AN INTRODUCTION TO INFORMATION THEORY, J.R. Pierce. Second (1980) edition of most impressive non-technical account available. Encoding, entropy, noisy channel, related areas, etc. 320pp. 5⅜ × 8½.
24061-4 Pa. $4.95

THE DIVINE PROPORTION: A STUDY IN MATHEMATICAL BEAUTY, H.E. Huntley. "Divine proportion" or "golden ratio"in poetry, Pascal's triangle, philosophy, psychology, music, mathematical figures, etc. Excellent bridge between science and art. 58 figures. 185pp. 5⅜ × 8½.
22254-3 Pa. $3.95

THE DOVER NEW YORK WALKING GUIDE: From the Battery to Wall Street, Mary J. Shapiro. Superb inexpensive guide to historic buildings and locales in lower Manhattan: Trinity Church, Bowling Green, more. Complete Text; maps. 36 illustrations. 48pp. 3⅞ × 9¼.
24225-0 Pa. $1.75

NEW YORK THEN AND NOW, Edward B. Watson, Edmund V. Gillon, Jr. 83 important Manhattan sites: on facing pages early photographs (1875-1925) and 1976 photos by Gillon. 172 illustrations. 171pp. 9¼ × 10.
23361-8 Pa. $7.95

HISTORIC COSTUME IN PICTURES, Braun & Schneider. Over 1450 costumed figures from dawn of civilization to end of 19th century. English captions. 125 plates. 256pp. 8⅜ × 11¼.
23150-X Pa. $7.50

VICTORIAN AND EDWARDIAN FASHION: A Photographic Survey, Alison Gernsheim. First fashion history completely illustrated by contemporary photographs. Full text plus 235 photos, 1840-1914, in which many celebrities appear. 240pp. 6½ × 9¼.
24205-6 Pa. $6.00

CHARTED CHRISTMAS DESIGNS FOR COUNTED CROSS-STITCH AND OTHER NEEDLECRAFTS, Lindberg Press. Charted designs for 45 beautiful needlecraft projects with many yuletide and wintertime motifs. 48pp. 8¼ × 11.
24356-7 Pa. $1.95

101 FOLK DESIGNS FOR COUNTED CROSS-STITCH AND OTHER NEEDLE-CRAFTS, Carter Houck. 101 authentic charted folk designs in a wide array of lovely representations with many suggestions for effective use. 48pp. 8¼ × 11.
24369-9 Pa. $1.95

FIVE ACRES AND INDEPENDENCE, Maurice G. Kains. Great back-to-the-land classic explains basics of self-sufficient farming. The one book to get. 95 illustrations. 397pp. 5⅜ × 8½.
20974-1 Pa. $4.95

A MODERN HERBAL, Margaret Grieve. Much the fullest, most exact, most useful compilation of herbal material. Gigantic alphabetical encyclopedia, from aconite to zedoary, gives botanical information, medical properties, folklore, economic uses, and much else. Indispensable to serious reader. 161 illustrations. 888pp. 6½ × 9¼. (Available in U.S. only)
22798-7, 22799-5 Pa., Two-vol. set $16.45

REASON IN ART, George Santayana. Renowned philosopher's provocative, seminal treatment of basis of art in instinct and experience. Volume Four of *The Life of Reason*. 230pp. 5⅜ × 8. 24358-3 Pa. $4.50

LANGUAGE, TRUTH AND LOGIC, Alfred J. Ayer. Famous, clear introduction to Vienna, Cambridge schools of Logical Positivism. Role of philosophy, elimination of metaphysics, nature of analysis, etc. 160pp. 5⅜ × 8½. (USCO)
20010-8 Pa. $2.75

BASIC ELECTRONICS, U.S. Bureau of Naval Personnel. Electron tubes, circuits, antennas, AM, FM, and CW transmission and receiving, etc. 560 illustrations. 567pp. 6½ × 9¼. 21076-6 Pa. $8.95

THE ART DECO STYLE, edited by Theodore Menten. Furniture, jewelry, metalwork, ceramics, fabrics, lighting fixtures, interior decors, exteriors, graphics from pure French sources. Over 400 photographs. 183pp. 8⅜ × 11¼.
22824-X Pa. $6.95

THE FOUR BOOKS OF ARCHITECTURE, Andrea Palladio. 16th-century classic covers classical architectural remains, Renaissance revivals, classical orders, etc. 1738 Ware English edition. 216 plates. 110pp. of text. 9½ × 12¾.
21308-0 Pa. $10.00

THE WIT AND HUMOR OF OSCAR WILDE, edited by Alvin Redman. More than 1000 ripostes, paradoxes, wisecracks: Work is the curse of the drinking classes, I can resist everything except temptations, etc. 258pp. 5⅜ × 8½. (USCO)
20602-5 Pa. $3.50

THE DEVIL'S DICTIONARY, Ambrose Bierce. Barbed, bitter, brilliant witticisms in the form of a dictionary. Best, most ferocious satire America has produced. 145pp. 5⅜ × 8½. 20487-1 Pa. $2.50

ERTÉ'S FASHION DESIGNS, Erté. 210 black-and-white inventions from *Harper's Bazar*, 1918-32, plus 8pp. full-color covers. Captions. 88pp. 9 × 12.
24203-X Pa. $6.50

ERTÉ GRAPHICS, Erté. Collection of striking color graphics: *Seasons, Alphabet, Numerals, Aces* and *Precious Stones*. 50 plates, including 4 on covers. 48pp. 9⅜ × 12¼. 23580-7 Pa. $6.95

PAPER FOLDING FOR BEGINNERS, William D. Murray and Francis J. Rigney. Clearest book for making origami sail boats, roosters, frogs that move legs, etc. 40 projects. More than 275 illustrations. 94pp. 5⅜ × 8½. 20713-7 Pa. $1.95

ORIGAMI FOR THE ENTHUSIAST, John Montroll. Fish, ostrich, peacock, squirrel, rhinoceros, Pegasus, 19 other intricate subjects. Instructions. Diagrams. 128pp. 9 × 12. 23799-0 Pa. $4.95

CROCHETING NOVELTY POT HOLDERS, edited by Linda Macho. 64 useful, whimsical pot holders feature kitchen themes, animals, flowers, other novelties. Surprisingly easy to crochet. Complete instructions. 48pp. 8¼ × 11.
24296-X Pa. $1.95

CROCHETING DOILIES, edited by Rita Weiss. Irish Crochet, Jewel, Star Wheel, Vanity Fair and more. Also luncheon and console sets, runners and centerpieces. 51 illustrations. 48pp. 8¼ × 11. 23424-X Pa. $2.00

YUCATAN BEFORE AND AFTER THE CONQUEST, Diego de Landa. Only significant account of Yucatan written in the early post-Conquest era. Translated by William Gates. Over 120 illustrations. 162pp. 5⅜ × 8½. 23622-6 Pa. $3.50

ORNATE PICTORIAL CALLIGRAPHY, E.A. Lupfer. Complete instructions, over 150 examples help you create magnificent "flourishes" from which beautiful animals and objects gracefully emerge. 8⅛ × 11. 21957-7 Pa. $2.95

DOLLY DINGLE PAPER DOLLS, Grace Drayton. Cute chubby children by same artist who did Campbell Kids. Rare plates from 1910s. 30 paper dolls and over 100 outfits reproduced in full color. 32pp. 9¼ × 12¼. 23711-7 Pa. $2.95

CURIOUS GEORGE PAPER DOLLS IN FULL COLOR, H. A. Rey, Kathy Allert. Naughty little monkey-hero of children's books in two doll figures, plus 48 full-color costumes: pirate, Indian chief, fireman, more. 32pp. 9¼ × 12¼. 24386-9 Pa. $3.50

GERMAN: HOW TO SPEAK AND WRITE IT, Joseph Rosenberg. Like *French, How to Speak and Write It.* Very rich modern course, with a wealth of pictorial material. 330 illustrations. 384pp. 5⅜ × 8½. (USUKO) 20271-2 Pa. $4.75

CATS AND KITTENS: 24 Ready-to-Mail Color Photo Postcards, D. Holby. Handsome collection; feline in a variety of adorable poses. Identifications. 12pp. on postcard stock. 8¼ × 11. 24469-5 Pa. $2.95

MARILYN MONROE PAPER DOLLS, Tom Tierney. 31 full-color designs on heavy stock, from *The Asphalt Jungle, Gentlemen Prefer Blondes,* 22 others. 1 doll. 16 plates. 32pp. 9⅜ × 12¼. 23769-9 Pa. $3.50

FUNDAMENTALS OF LAYOUT, F.H. Wills. All phases of layout design discussed and illustrated in 121 illustrations. Indispensable as student's text or handbook for professional. 124pp. 8⅛ × 11. 21279-3 Pa. $4.50

FANTASTIC SUPER STICKERS, Ed Sibbett, Jr. 75 colorful pressure-sensitive stickers. Peel off and place for a touch of pizzazz: clowns, penguins, teddy bears, etc. Full color. 16pp. 8¼ × 11. 24471-7 Pa. $2.95

LABELS FOR ALL OCCASIONS, Ed Sibbett, Jr. 6 labels each of 16 different designs—baroque, art nouveau, art deco, Pennsylvania Dutch, etc.—in full color. 24pp. 8¼ × 11. 23688-9 Pa. $2.95

HOW TO CALCULATE QUICKLY: RAPID METHODS IN BASIC MATHEMATICS, Henry Sticker. Addition, subtraction, multiplication, division, checks, etc. More than 8000 problems, solutions. 185pp. 5 × 7¼. 20295-X Pa. $2.95

THE CAT COLORING BOOK, Karen Baldauski. Handsome, realistic renderings of 40 splendid felines, from American shorthair to exotic types. 44 plates. Captions. 48pp. 8¼ × 11. 24011-8 Pa. $2.25

THE TALE OF PETER RABBIT, Beatrix Potter. The inimitable Peter's terrifying adventure in Mr. McGregor's garden, with all 27 wonderful, full-color Potter illustrations. 55pp. 4¼ × 5½. (Available in U.S. only) 22827-4 Pa. $1.50

BASIC ELECTRICITY, U.S. Bureau of Naval Personnel. Batteries, circuits, conductors, AC and DC, inductance and capacitance, generators, motors, transformers, amplifiers, etc. 349 illustrations. 448pp. 6½ × 9¼. 20973-3 Pa. $7.95

READY-TO-USE BORDERS, Ted Menten. Both traditional and unusual interchangeable borders in a tremendous array of sizes, shapes, and styles. 32 plates. 64pp. 8¼ × 11.
23782-6 Pa. $2.95

THE WHOLE CRAFT OF SPINNING, Carol Kroll. Preparing fiber, drop spindle, treadle wheel, other fibers, more. Highly creative, yet simple. 43 illustrations. 48pp. 8¼ × 11.
23968-3 Pa. $2.50

HIDDEN PICTURE PUZZLE COLORING BOOK, Anna Pomaska. 31 delightful pictures to color with dozens of objects, people and animals hidden away to find. Captions. Solutions. 48pp. 8¼ × 11.
23909-8 Pa. $2.25

QUILTING WITH STRIPS AND STRINGS, H.W. Rose. Quickest, easiest way to turn left-over fabric into handsome quilt. 46 patchwork quilts; 31 full-size templates. 48pp. 8¼ × 11.
24357-5 Pa. $3.25

NATURAL DYES AND HOME DYEING, Rita J. Adrosko. Over 135 specific recipes from historical sources for cotton, wool, other fabrics. Genuine premodern handicrafts. 12 illustrations. 160pp. 5⅜ × 8½.
22688-3 Pa. $2.95

CARVING REALISTIC BIRDS, H.D. Green. Full-sized patterns, step-by-step instructions for robins, jays, cardinals, finches, etc. 97 illustrations. 80pp. 8¼ × 11.
23484-3 Pa. $3.00

GEOMETRY, RELATIVITY AND THE FOURTH DIMENSION, Rudolf Rucker. Exposition of fourth dimension, concepts of relativity as Flatland characters continue adventures. Popular, easily followed yet accurate, profound. 141 illustrations. 133pp. 5⅜ × 8½.
23400-2 Pa. $2.75

READY-TO-USE SMALL FRAMES AND BORDERS, Carol B. Grafton. Graphic message? Frame it graphically with 373 new frames and borders in many styles: Art Nouveau, Art Deco, Op Art. 64pp. 8¼ × 11.
24375-3 Pa. $2.95

CELTIC ART: THE METHODS OF CONSTRUCTION, George Bain. Simple geometric techniques for making Celtic interlacements, spirals, Kellstype initials, animals, humans, etc. Over 500 illustrations. 160pp. 9 × 12. (Available in U.S. only)
22923-8 Pa. $6.00

THE TALE OF TOM KITTEN, Beatrix Potter. Exciting text and all 27 vivid, full-color illustrations to charming tale of naughty little Tom getting into mischief again. 58pp. 4¼ × 5½.
24502-0 Pa. $1.50

WOODEN PUZZLE TOYS, Ed Sibbett, Jr. Transfer patterns and instructions for 24 easy-to-do projects: fish, butterflies, cats, acrobats, Humpty Dumpty, 19 others. 48pp. 8¼ × 11.
23713-3 Pa. $2.50

MY FAMILY TREE WORKBOOK, Rosemary A. Chorzempa. Enjoyable, easy-to-use introduction to genealogy designed specially for children. Data pages plus text. Instructive, educational, valuable. 64pp. 8¼ × 11.
24229-3 Pa. $2.25

Prices subject to change without notice.
Available at your book dealer or write for free catalog to Dept. GI, Dover Publications, Inc., 31 East 2nd St. Mineola, N.Y. 11501. Dover publishes more than 175 books each year on science, elementary and advanced mathematics, biology, music, art, literary history, social sciences and other areas.